Yorkshire Dales Landscapes

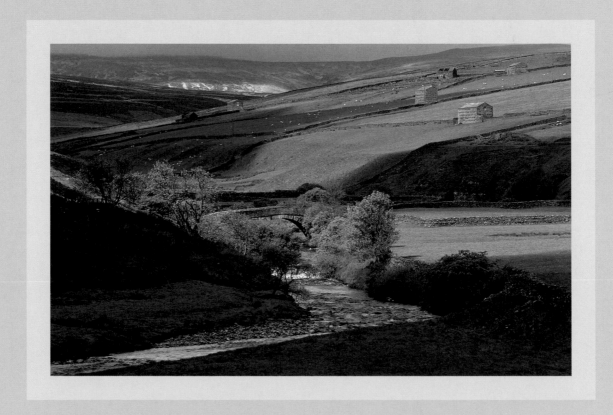

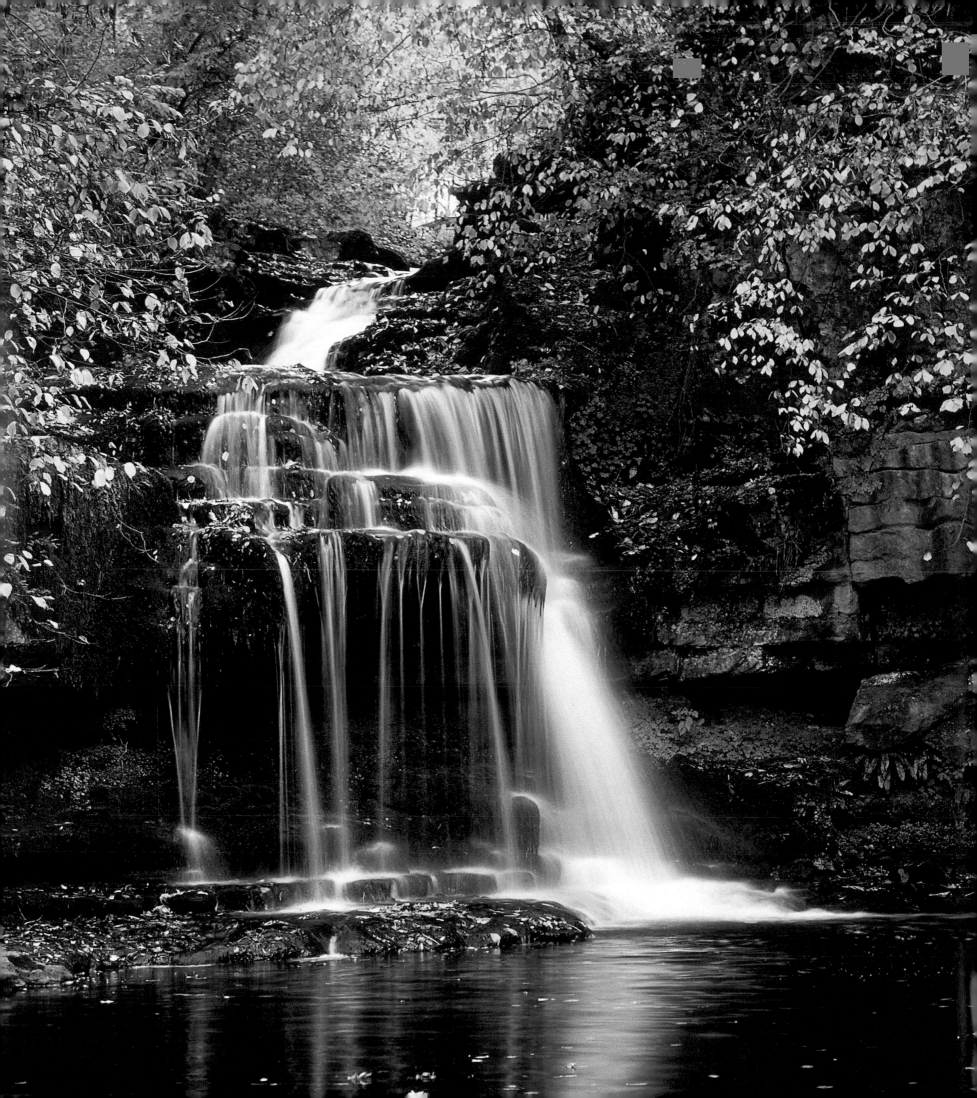

Yorkshire Dales Landscapes

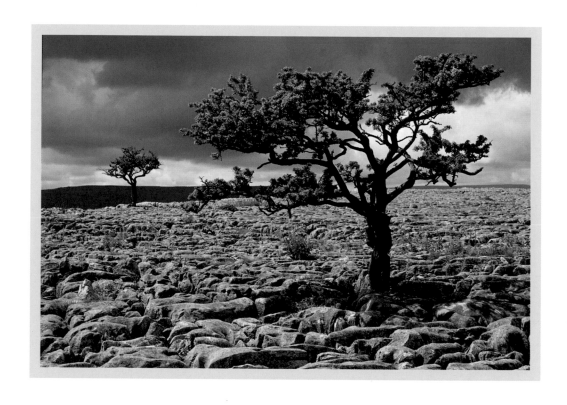

Dave Coates

MYRIAD BOOKS

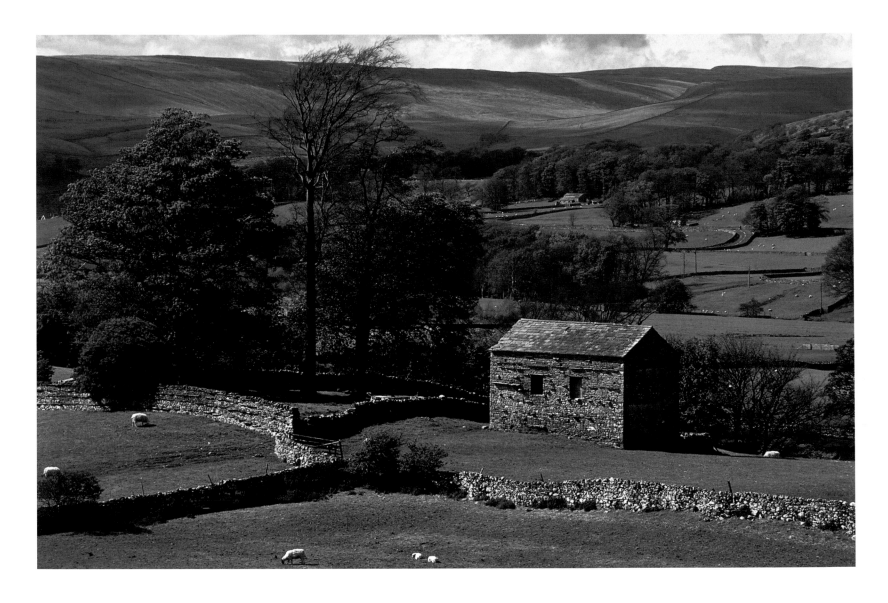

First published in 2004 by Myriad Books Limited
35 Bishopsthorpe Road, London SE26 4PA

Photographs and text copyright © Dave Coates

Dave Coates has asserted his right under the Copyright, Designs and Patents Act,
1988, to be identified as the author of this work

ISBN 1 904154 344

Designed by Jerry Goldie

Printed in China

Contents

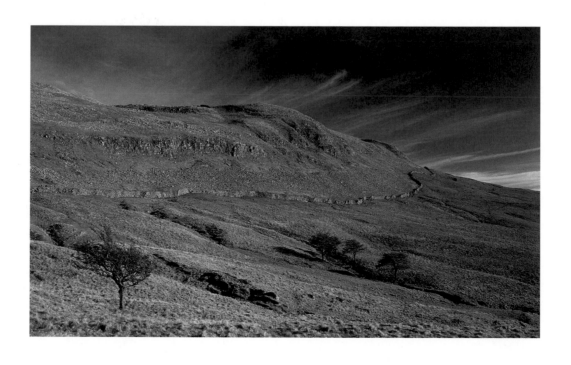

Yorkshire Dales Landscapes

My first experience of the Yorkshire Dales was as a child, being taken there on day trips in the car to Wharfedale. Subsequently, as a cyclist in my teens, I used to roam far and wide across the Dales from my home in Harrogate. It was a proud boast of mine, to be able to cycle up any of the Dales' hills without having to get off my bike and push. During that formative period I also took part in fell-walking, camping and a certain amount of potholing and rock-climbing. At that time, the first 35mm-camera came along; it was a Bruan Super Paxette. The twin pursuits of landscape photography and life in the great outdoors were to become my over-riding interest, although I probably did not appreciate that at the time.

Married life and my job took me away from serious photography and the Dales for a number of years until, in the mid 80s, I joined my local camera club at Northallerton. One evening a member presented a slide show on one of the Yorkshire Dales. That set me thinking and it was not long before my wife and I were spending much of our spare time in the Dales, either in the car or more often wandering on foot across the dales and fells. One slide show followed another and gradually a great affection for the Dales' landscape and its flora developed in me.

Creating this book has made me look more closely at the different parts of the Yorkshire Dales. It has not been possible to cover every nook and cranny. To be honest, one could not do justice to the Dales in a book twice this size. I have confined myself mainly to the area of the national park and even then there are bound to be many corners that have not been included, so if your particular favourite spot is not there, please do not be too disappointed.

Landscape work is, photographically speaking, my first love. Therefore this book is primarily about the landscape as I have seen and photographed it. I have included examples of some of the flora, for two reasons really. Firstly, for the beauty with which nature has endowed so many wild flowers and secondly because of the way in which plants and flowers enrich the landscape itself.

For me, each dale or area of the Dales has its own special qualities which stand out from those elsewhere. At the same time those qualities are not exclusive to any one dale or area, but tend to come to the surface in varying degrees. For example, Swaledale may stand out for its barns and meadows but those same barns and meadows appear throughout the whole area. In preparing the book and selecting the photographs, I have tried to reflect this factor.

To bring some sort of order to the book we travel around the dales in five chapters, moving geographically in a clockwise direction, starting with Swaledale. We then look in turn at Wensleydale, Wharfedale, Malham and The Three Peaks before ending up in the lovely little valley of Crummackdale. In this journey through the Dales I hope to bring you something of how I see and interpret one of the most beautiful areas in Britain.

Dave Coates

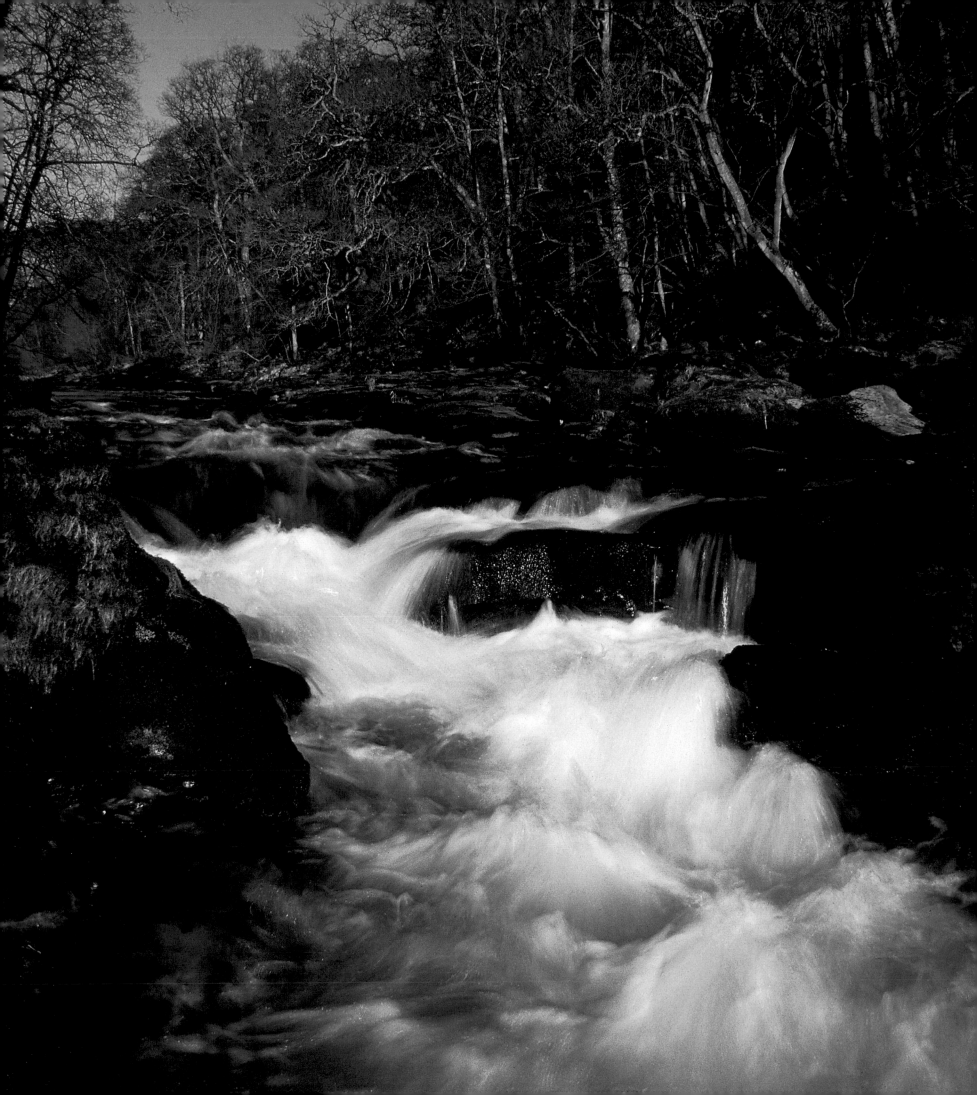

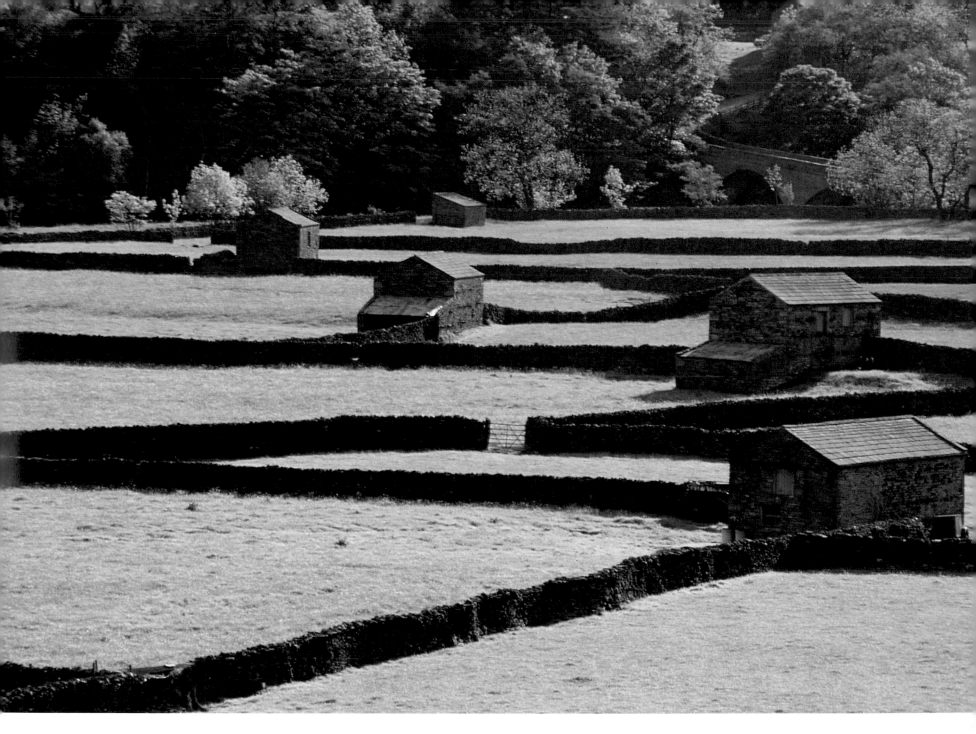

Chapter 1

Swaledale

Swaledale is the most northerly of the main dales. This dale is famous for its spring meadows and the wonderful array of field barns. The glacial action that formed the dale has left the farmers with areas of good bottom land, such as those at Gunnerside and Muker. Over the years, this land has been turned into patterns of fields bounded by the famous drystone walls, which now reach up the sides of the fells. The dale also has its wild flowers, waterfalls and some little tributary valleys, like Oxnop Ghyll. There is an intimate quality about the dale because it is fairly narrow so the fellsides are never far away.

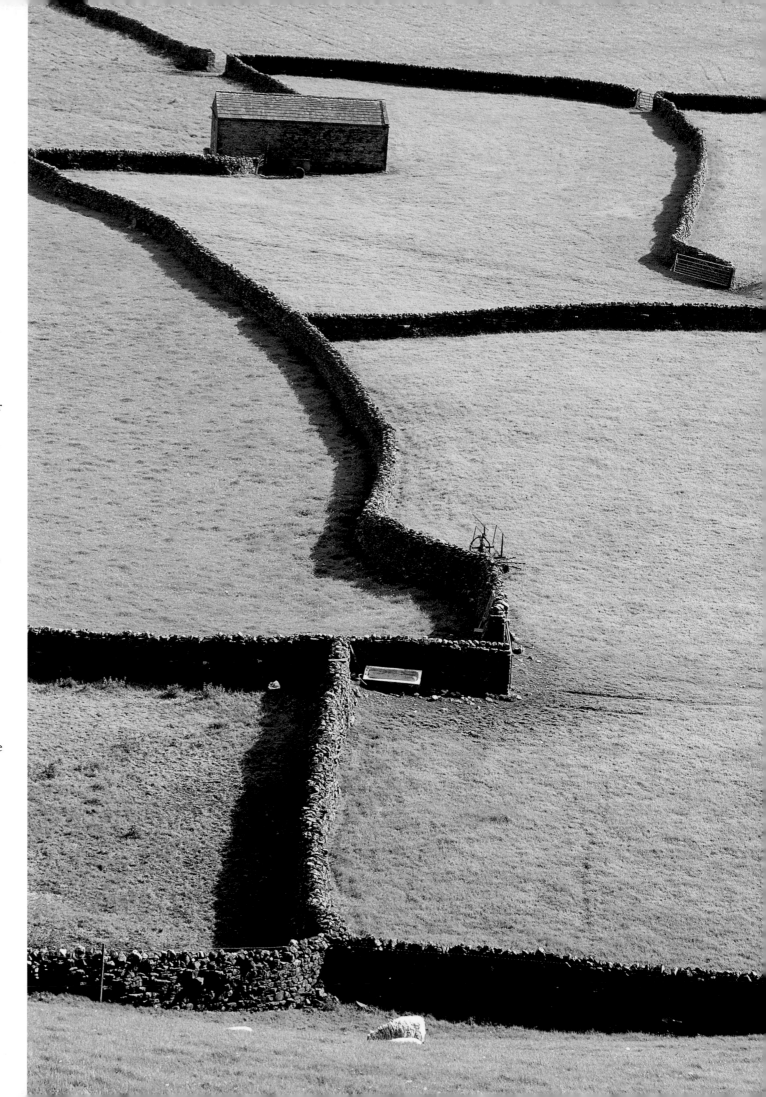

Barns and meadows of Gunnerside Bottoms

Without any doubt one of the visitor's favourite places in Swaledale – and there are many – is Gunnerside Bottoms. This is a fertile stretch of old glacial flood plain that has been turned into a patchwork quilt of fields. Each field is bordered by drystone walls and many have their own traditional field barn. It is seen here at its best in evening light, in early June when the meadows are in full flower.

Field patterns of Gunnerside

There often seems to be little reason for the random and crooked shapes of the fields. But what has resulted is a scene of real beauty – a wonderful example of how a combination of the landscape and livestock farming has created a scene of real beauty.

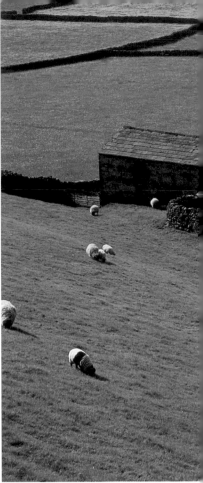

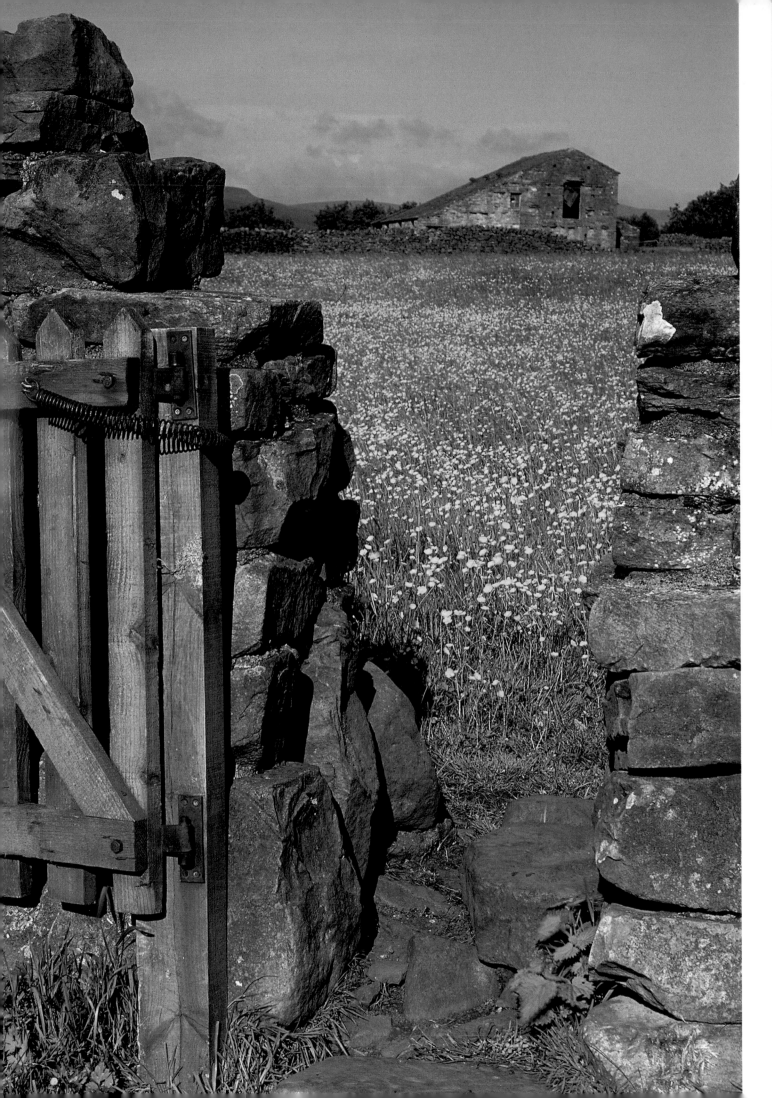

Open stile leading through the meadows

A number of footpaths thread through this maze of fields and barns. Access to the fields is usually by means of simple gate stiles like this one. But watch out for the gate closing behind you – some of them have quite powerful return springs which have resulted in many a hapless walker getting a sharp rap on the ankles as the gate swings closed after them!

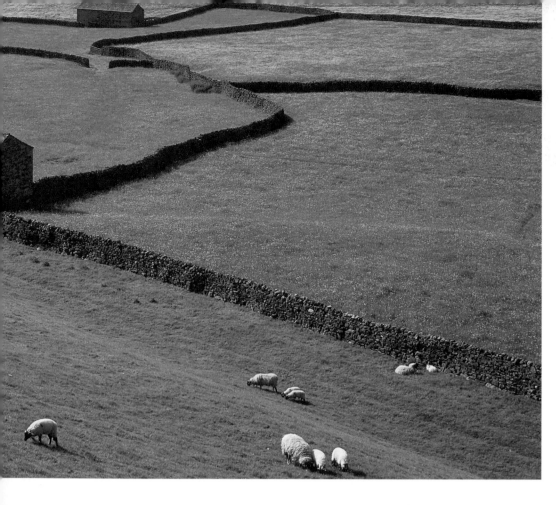

Early morning with the sheep grazing

The Dales' landscape is not a preserved relic of the past – it is fully worked by farmers today. Here, in the early morning, sheep graze on the slopes at the side of the levels while the meadows themselves are used to grow fodder for the ensuing winter.

Meadow land overlooked by Gunnerside

The wonderful carpet of flowers seen here lasts into early summer and is a great example of conserving the beautiful landscape. Farmers are now subsidised for missing an early cut of the meadows, so that the flowers can blossom at their best before haymaking takes place. In this way, both farming and tourism work hand-in-hand and the Dales' heritage is preserved.

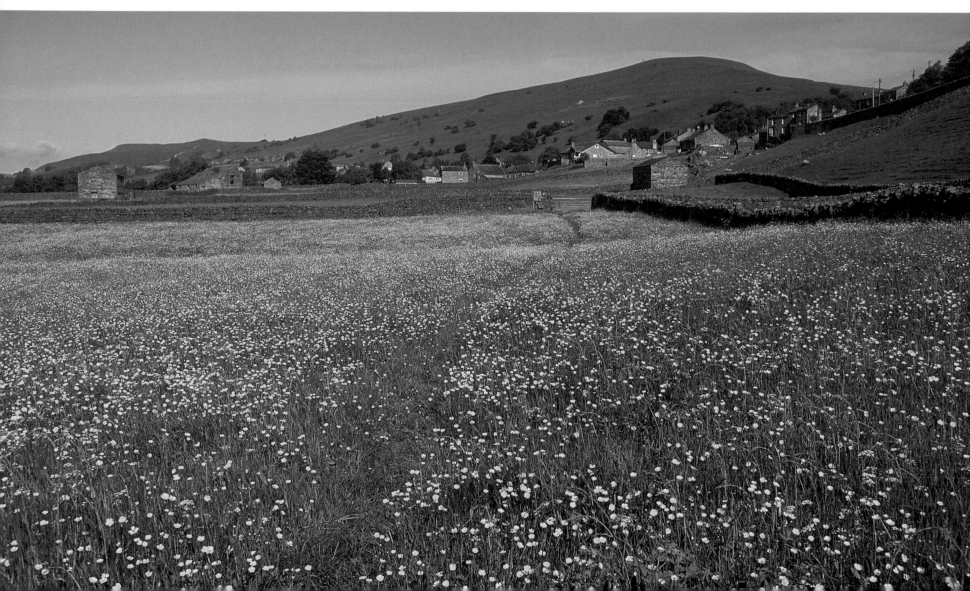

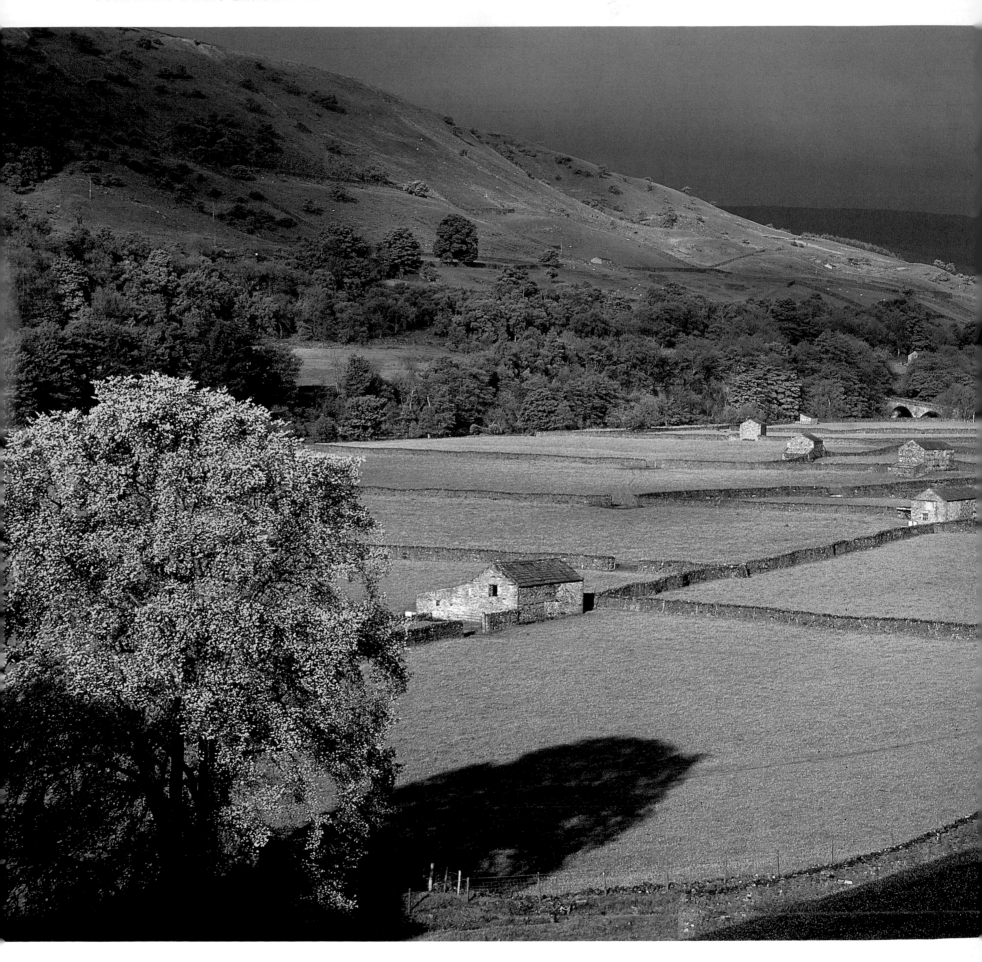

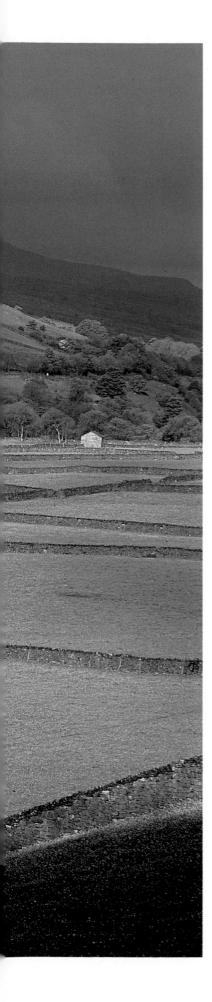

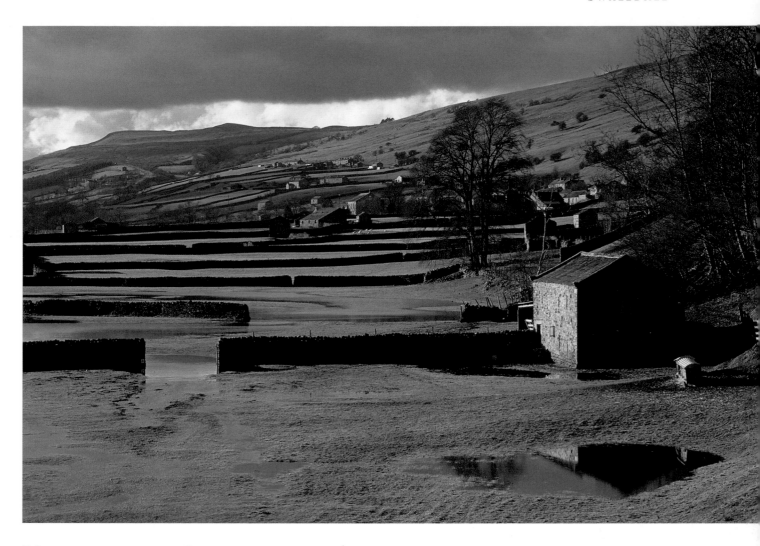

More rain to come?

Glacial plains, such as those which occur in many parts of the Dales, are prone to flooding. This photograph, taken in the depths of winter, followed several days of heavy rain. As a result, the meadows are well and truly saturated with many stretches of land under standing water. The rain has just disappeared allowing patches of sunlight to illuminate the landscape as well as the village of Gunnerside.

Storm clouds gathering over the meadows

Even on a spring morning the weather can change and give an oppressive feeling to the landscape. Here, in early morning in late May, the sun shines in from the east while threatening storm clouds gather from the west. The result is a landscape of beauty and drama.

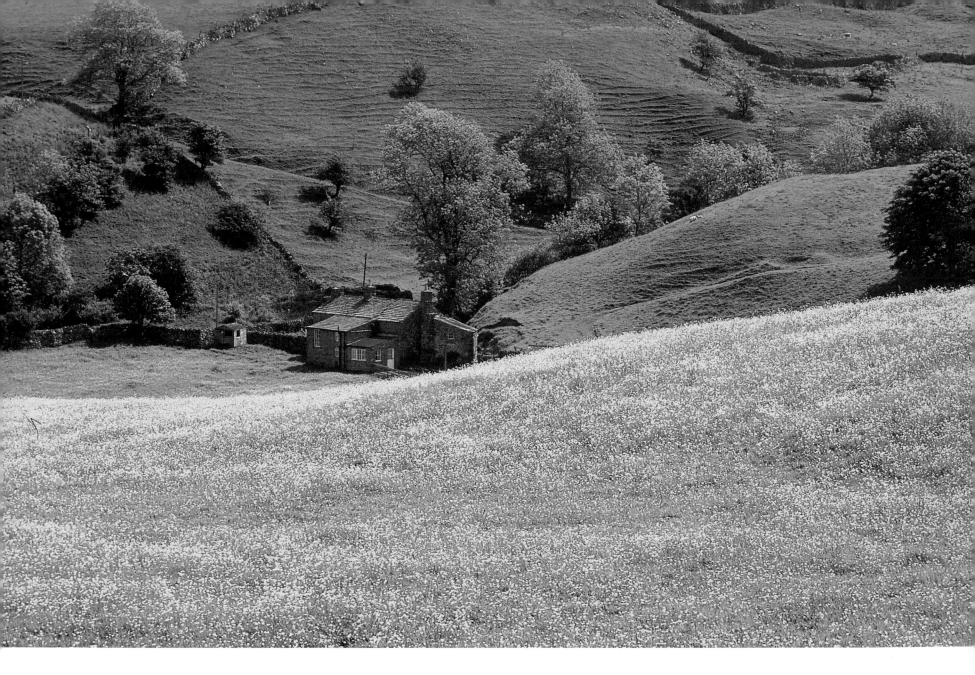

Oxnop Ghyll and its meadow land

Small tributary dales leading away from the main dales often have their own visual treats for the visitor who has time to wander off the beaten track. Oxnop Ghyll is no exception. Here the meadows fill the foreground, while the farmstead nestles in a dip under the lea of the fellside. The farm has been sited here not just for shelter but also to be near a source of running water from the stream behind.

Wood cranesbill *(Geranium sylvaticum)*

You don't have to go very far across the meadows before you find examples of the many wild flowers of the Dales. Here by the roadside is a clump of wood cranesbill which adds many sweeps of colour to the verges in June. The plant is a member of the geranium family and is so-called because when the petals have fallen off the flower head looks like the bill of a crane.

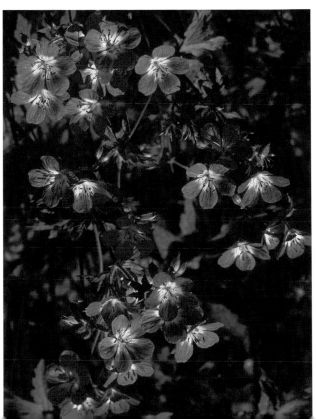

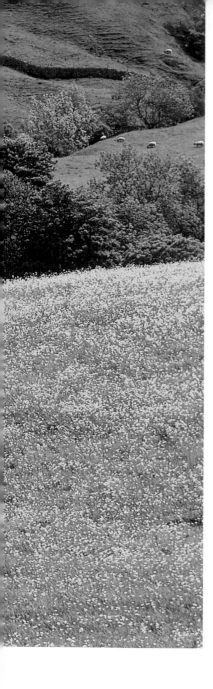

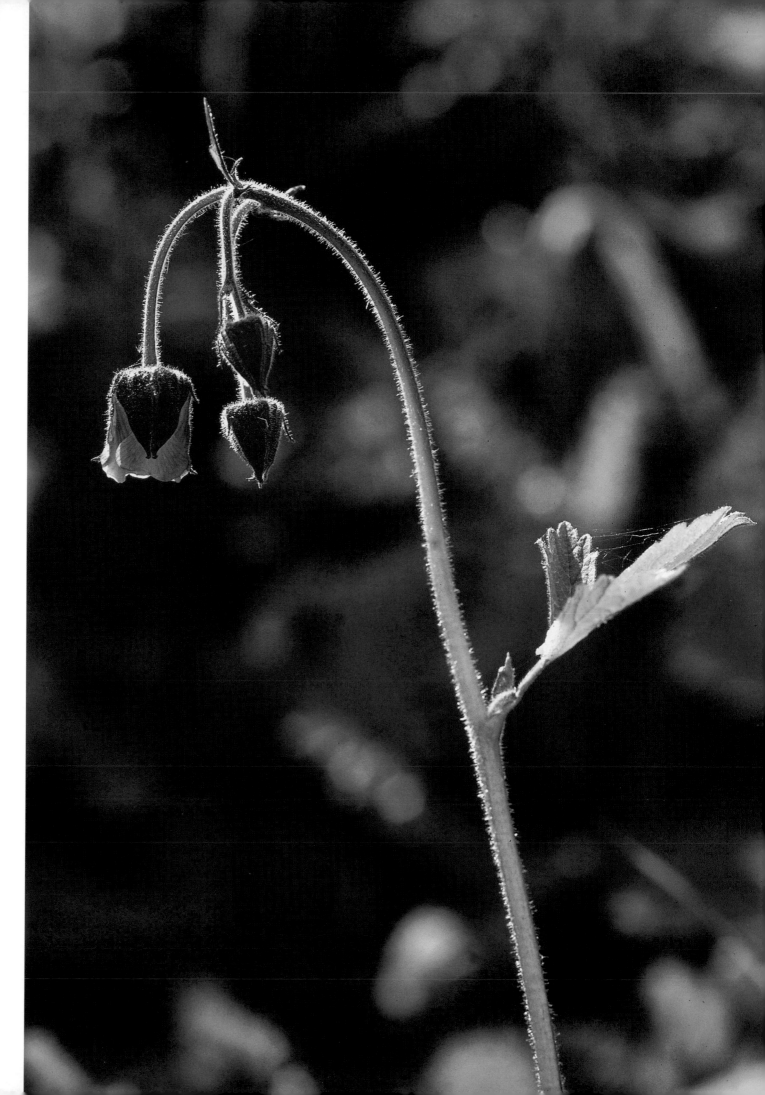

Water avens

(Geum rivale)

Not all wild flowers are
brightly coloured and
one such example is the
water avens which
grows in damp patches
on the verges, especially
near ditches. Seen here
in the early morning
light it is a thing of
beauty with its lovely
subtle colouring
enhanced by lighting
around the rim.

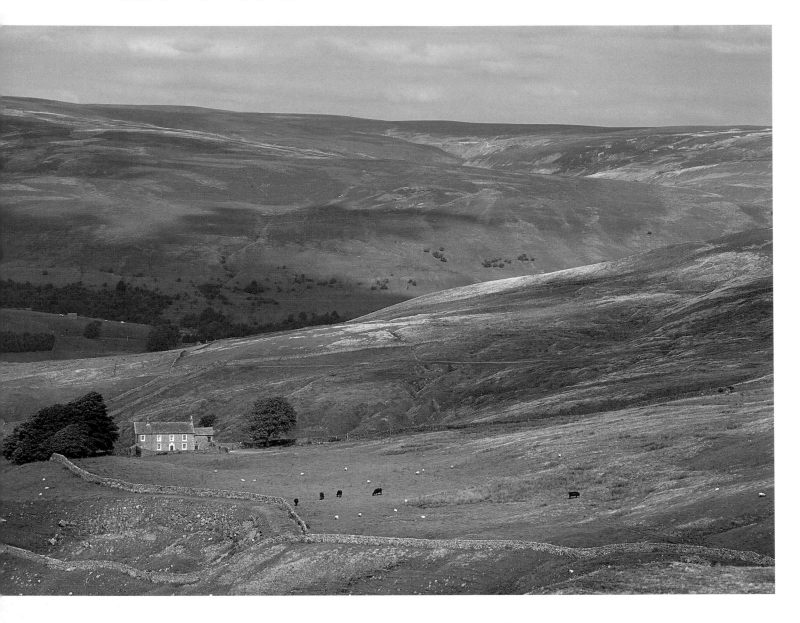

Gill Head towards Satron Side

This is the view from the road to Askrigg in Wensleydale as it winds up Oxnop Ghyll. The undulating and rolling fells of Swaledale are clearly visible. In the foreground, the farmstead with its fields stands on a high point but is sheltered by a stand of mature trees. In the middle distance is Satron Side and in the far distance the heather-covered moors are on the other side of Swaledale.

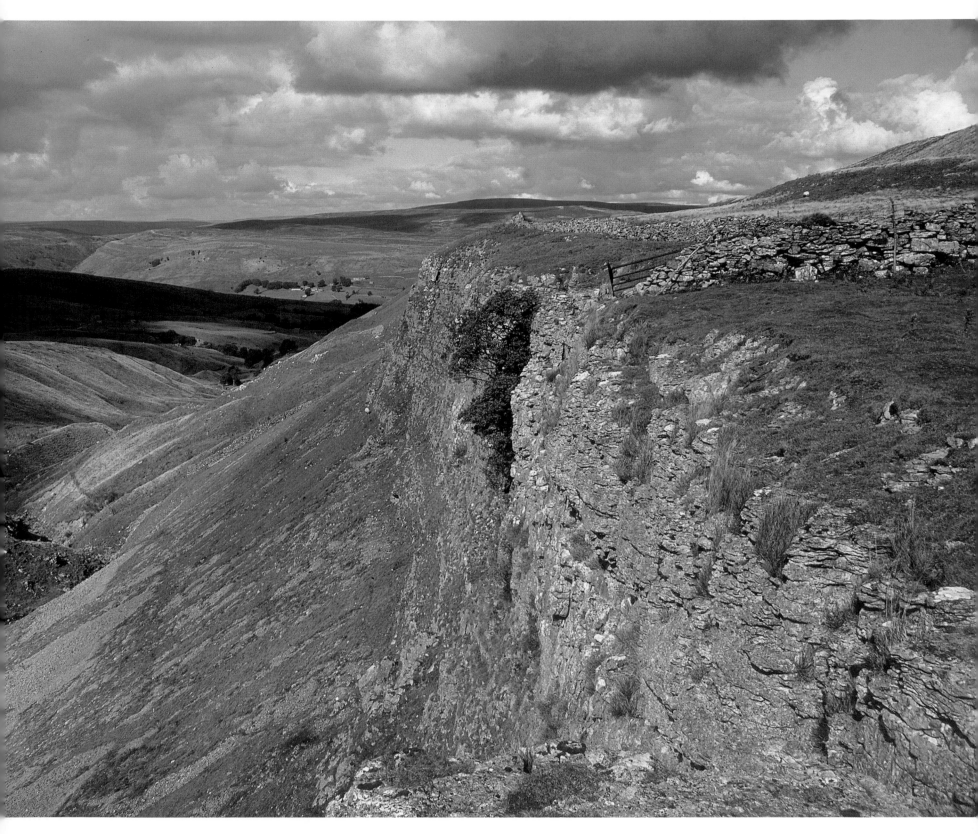

Oxnop Scar, towards Muker

If you take the gated and little used road along the eastern side of Oxnop Ghyll you will enjoy this magnificent view.
On the right are the limestone crags of Oxnop Scar with the contrasting screes of shale below. The light and shade
caused by passing clouds helps to emphasise features in the landscape. In the distance is Swaledale and beyond it
Swinner Gill and the Kisdon Fells.

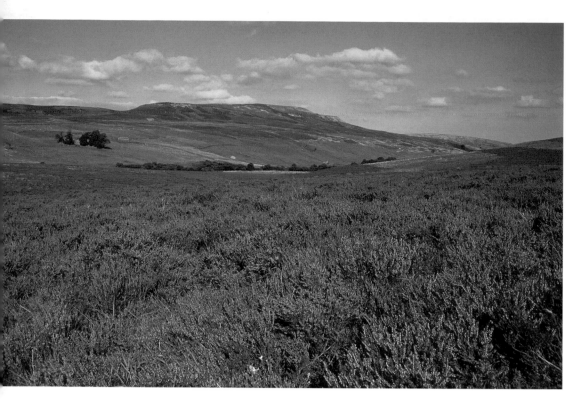

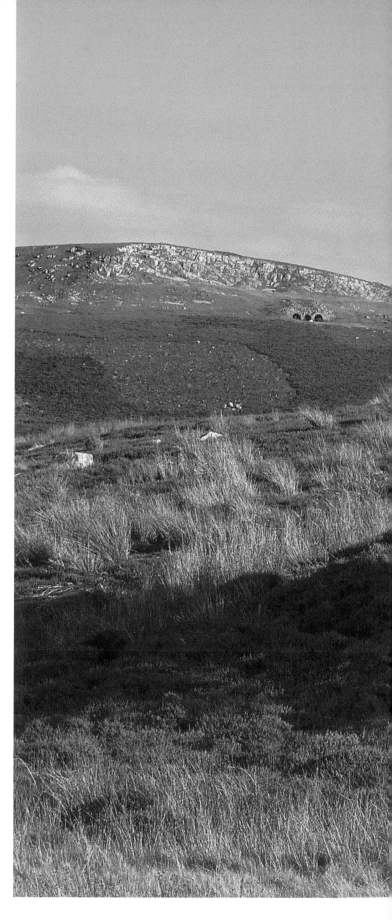

Heather moors with Calver Hill behind

After the meadows have been cut, the display of colour in the Dale moves upwards
away from the fields as the heather carpets the fells in a purple haze. In the
foreground are the moors near Surrender Bridge and Calver Hill is in the distance.

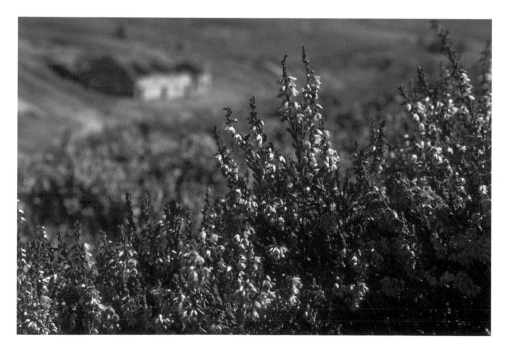

Ling heather *(Calluna vulgaris)*

This small plant, with its beautiful purple flowers, grows profusely all over the Dales
especially in areas of boggy heath and moorland.

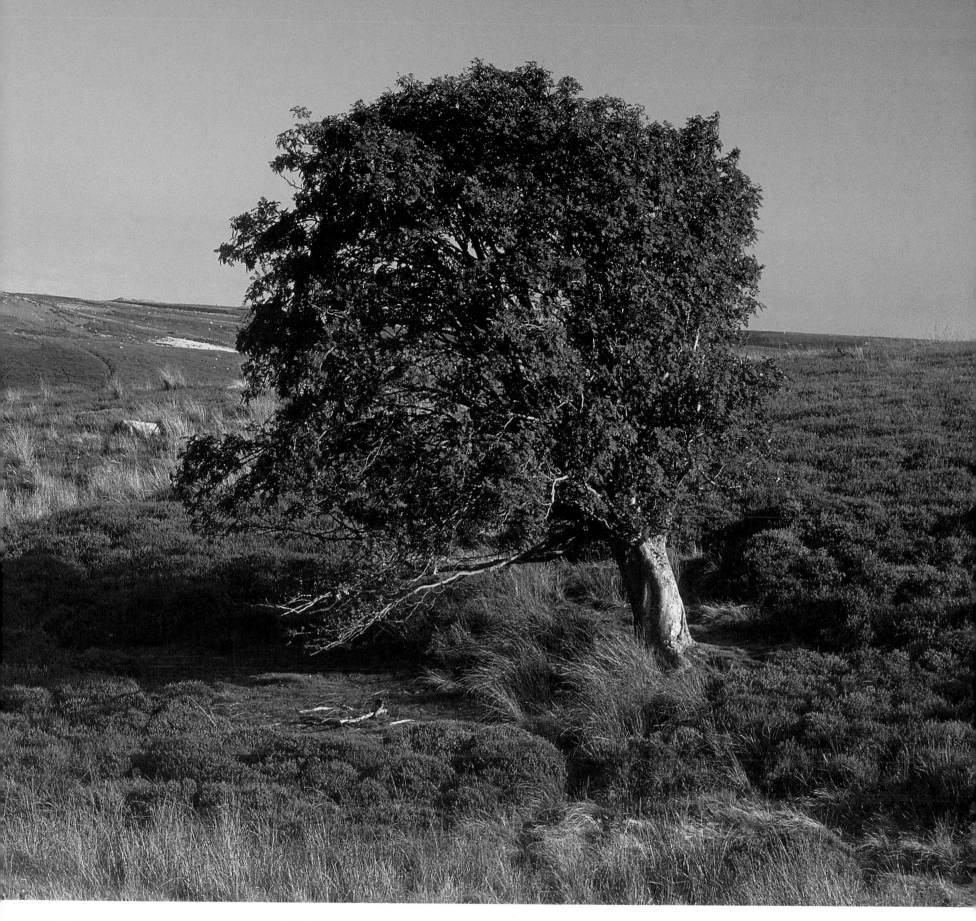

Lone rowan tree among the heather on Grinton Moor

Here, a lone rowan tree is displaying its berries at the same time as the heather adds a further touch of colour to the August landscape on Grinton Moor with the fells rising to the limestone crags in the distance. These solitary trees are so exposed to the elements that they are invariably bent by the prevailing winds.

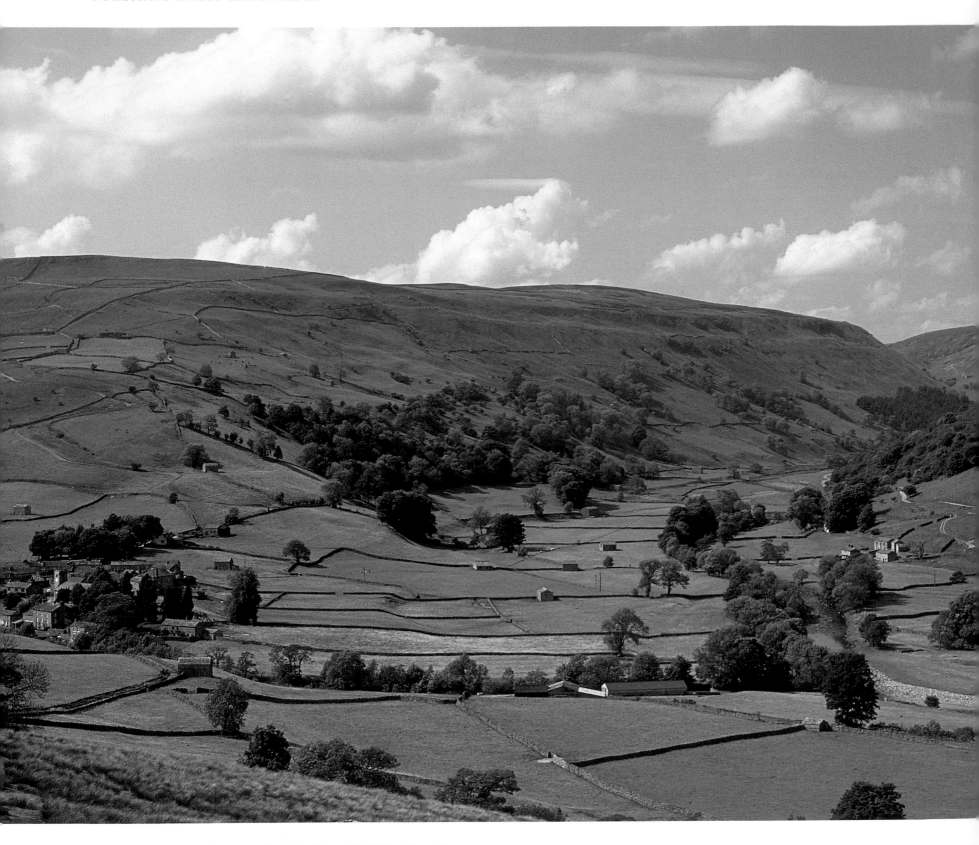

Muker with Kisdon Fell behind

The land around Muker in Swaledale can rival even the famous Gunnerside for the beauty of its spring meadows. This photograph is taken from Muker Side looking into the dale; the village of Muker lies to the left of the picture. The view is of a broad sweep of glorious spring meadows stretching out across the valley floor and up the lower slopes of the surrounding fells. The scattering of farmsteads and field barns complements the rest of the scene.

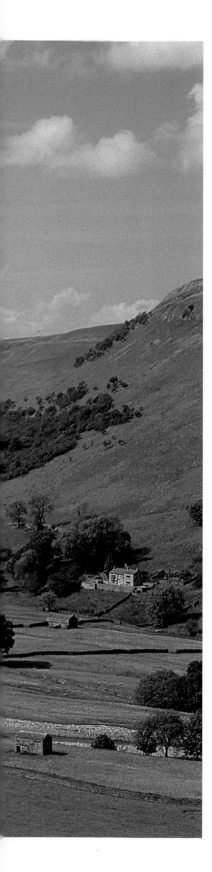

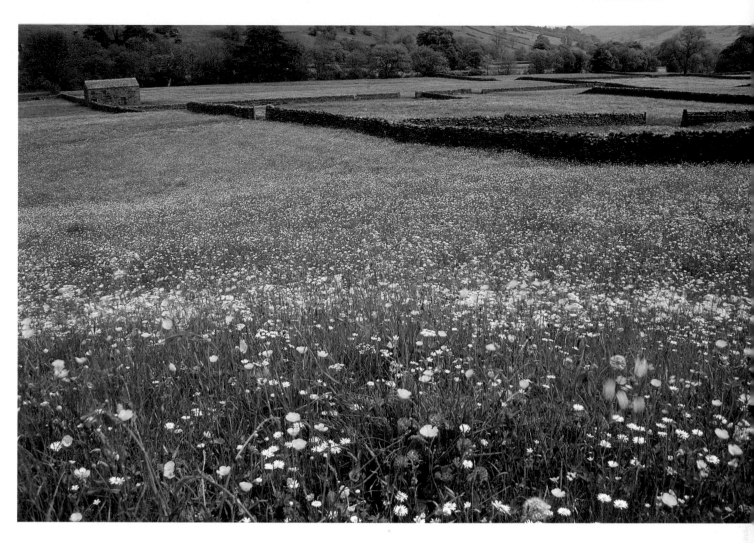

Meadows and drystone walls near Muker

In early June, as you leave Muker by the footpath which leads to Swinner Gill, you find broad sweeping meadows which are full of the widest possible variety of flowers. There are carpets of daisies and buttercups mixed in with stitchwort, clover, wood cranesbill, eyebright and many others.

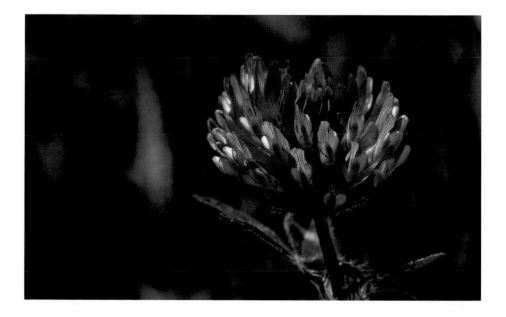

Clover *(Trifolium pratense)*

As we wander through the meadows I am sure that we often overlook the common flowers, just taking them for granted. But even the humble clover has its own beauty that the camera can bring out. This single head stands proudly, glowing with the light shining through its petals, so that you can see every vein.

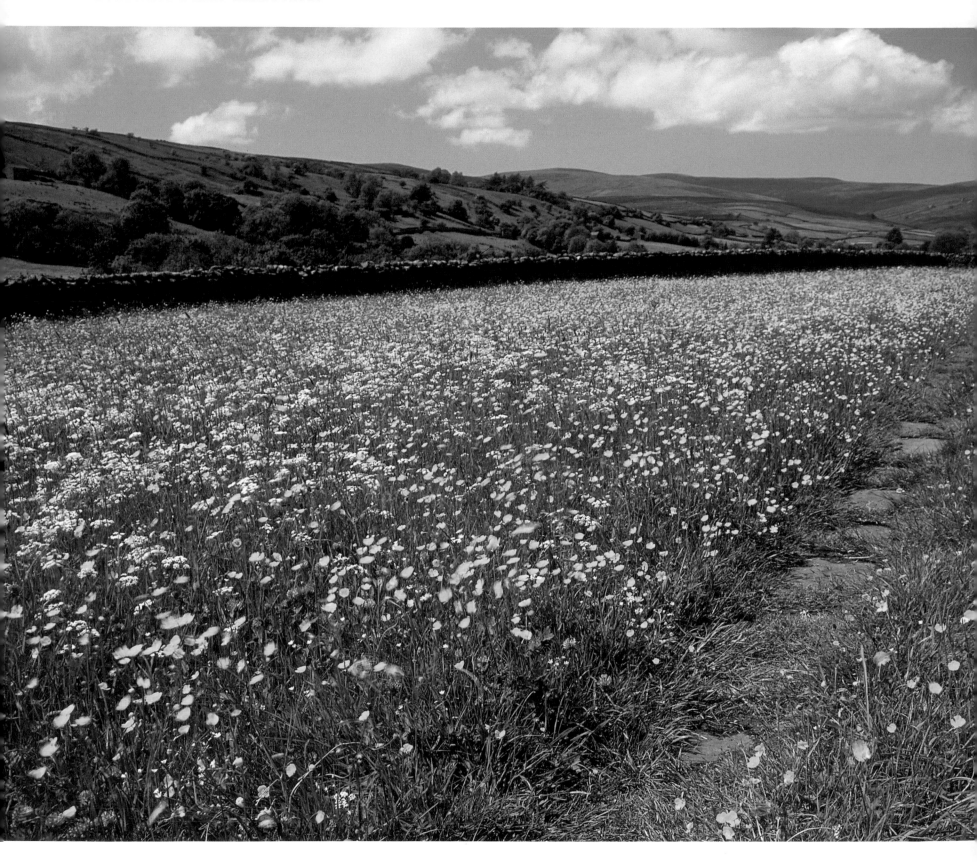

Footpath through the meadows

Take a different footpath out of Muker – this time towards Usha Gap and Thwaite – and on a plateau above the valley floor you find yourself wandering through meadow land. The footpath has been set out with stone setts to encourage walkers to keep to its route. This is a vital factor in ensuring that farm land and wild flowers are not disturbed.

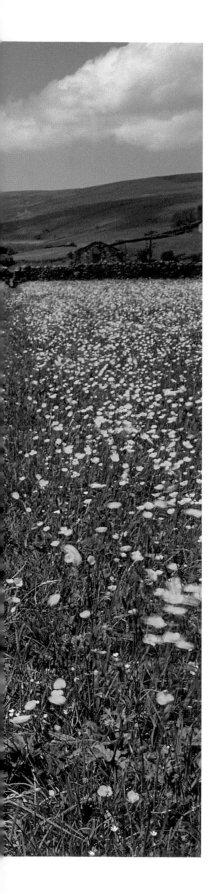

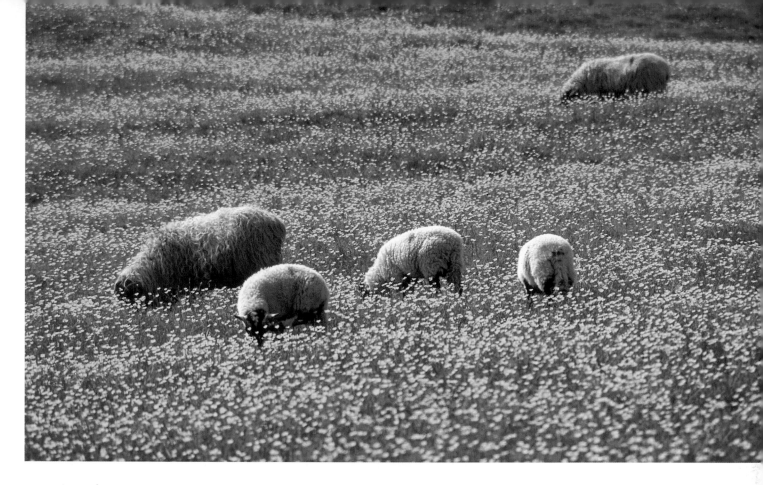

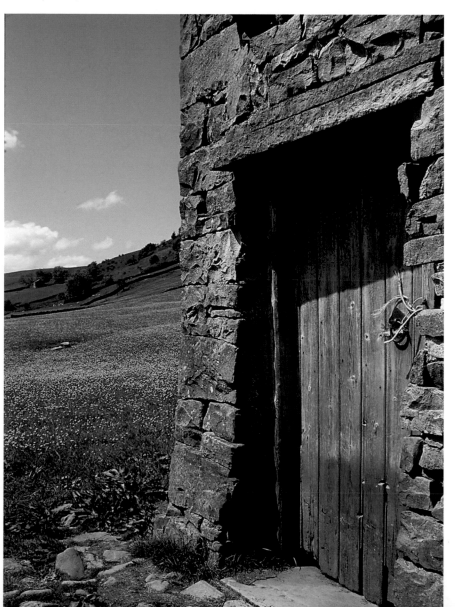

Meadows and sheep

Just occasionally you will find that the farmer has let his sheep into the meadows. The resulting picture is an image of tranquillity as the sheep and their lambs graze peacefully among the spring flowers.

Barn door in spring meadow

The grey stone barns which are to be found in almost every meadow around Muker offer a stark, but interesting contrast to the colourful meadows around them. Here, the texture of the stonework and the woodwork of the door – which is secured by a length of sisal – can be clearly seen in this barn which seems to stand guard over the meadow.

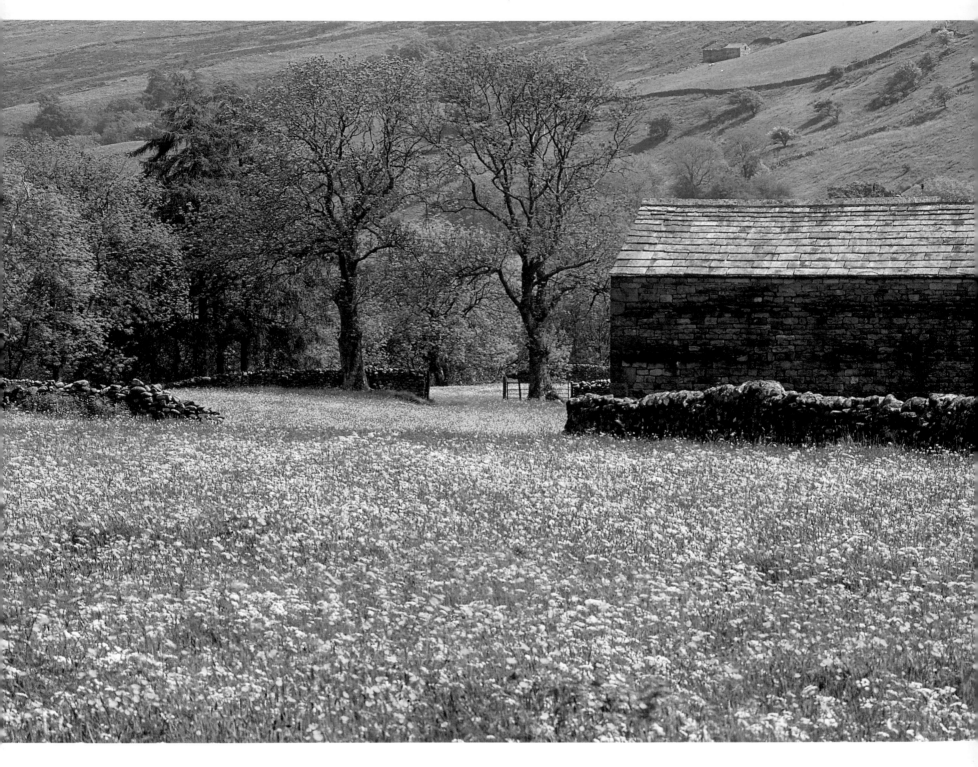

Meadows, barns and woodland

There is something splendid and random about the way the land has been developed over the centuries. In this photograph the meadow and barn run close up to nearby woodland. The reasons for any particular layout of walls and barns have been lost in the mists of time, but what is certain is that we have inherited a landscape which is at one with nature.

Bluebell (Scilla)

Walk in the woods and you may well find yourself in the middle of a carpet of bluebells. I found this little specimen early one morning, when the sun was just squeezing its way between the overhanging branches of the surrounding trees. While the flower itself was caught in the sunlight, the area beyond was in shadow and this enabled me to catch the back lighting, which makes the flower almost incandescent.

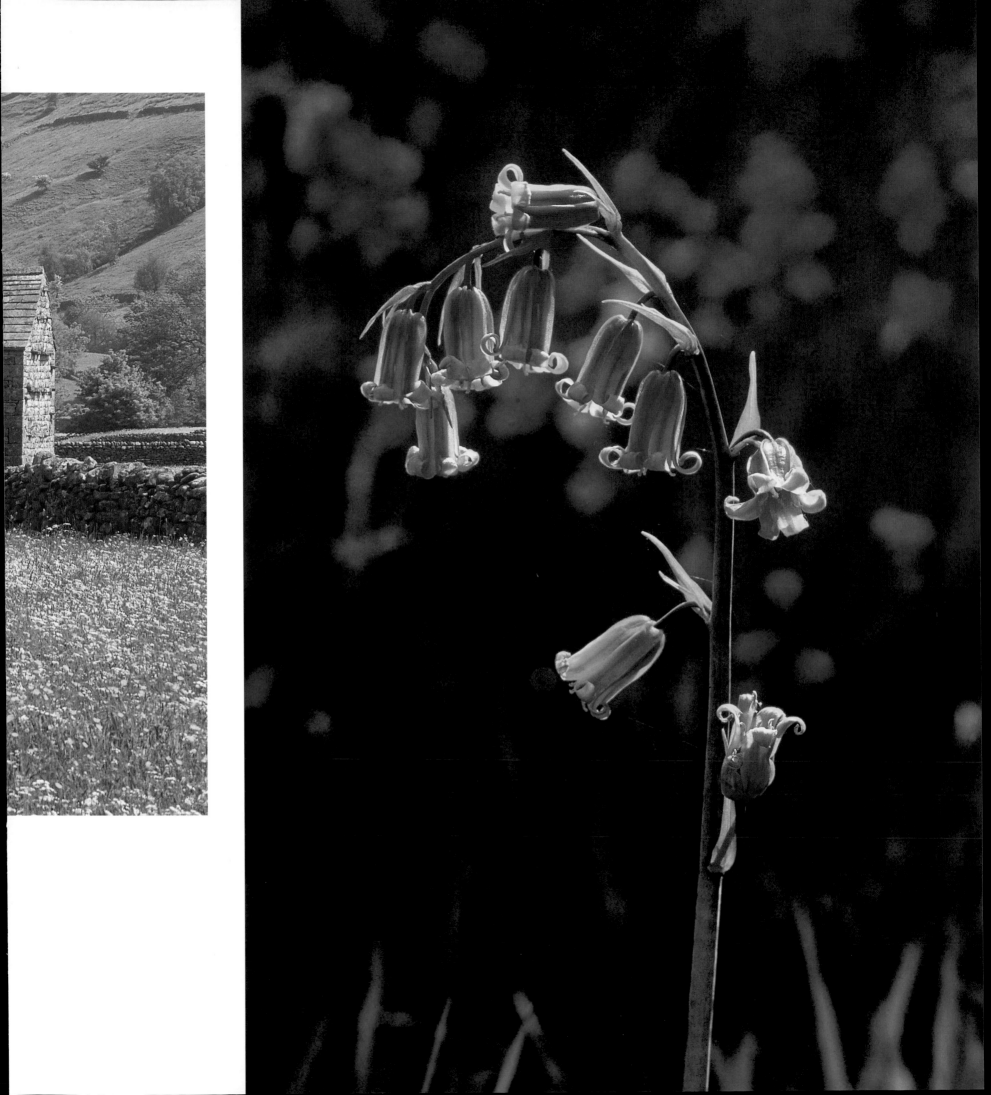

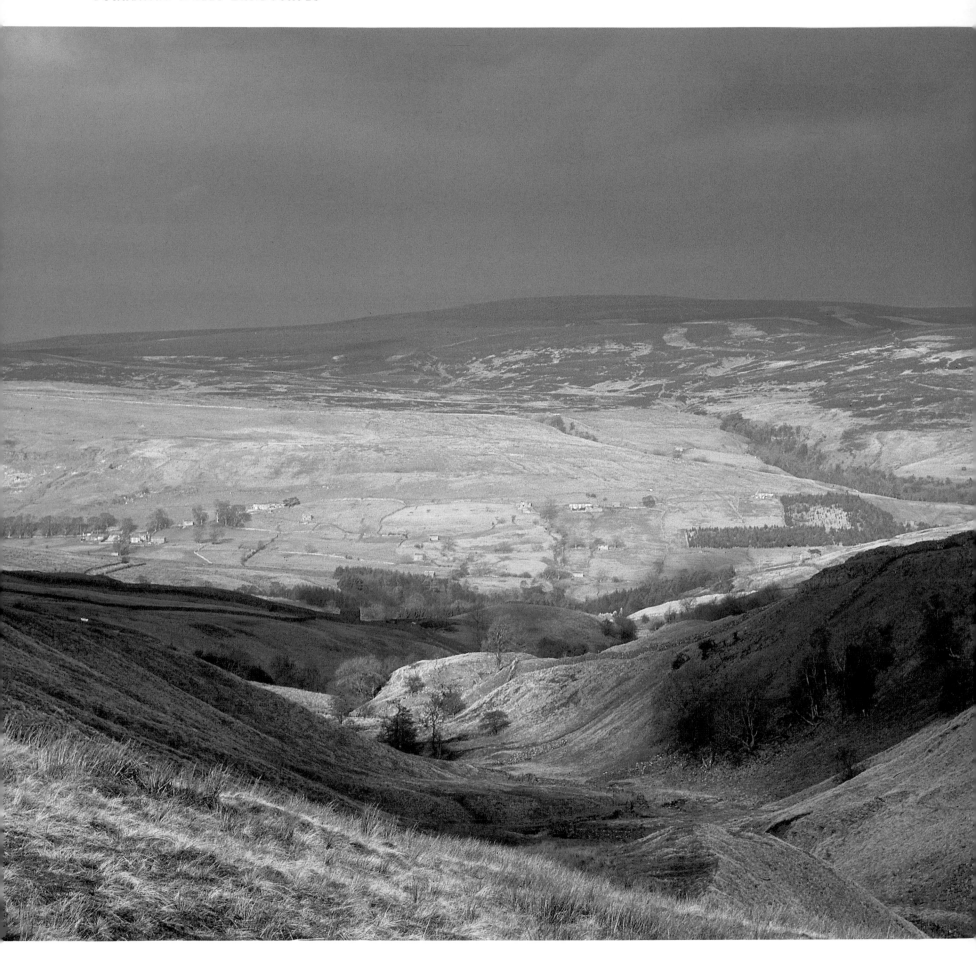

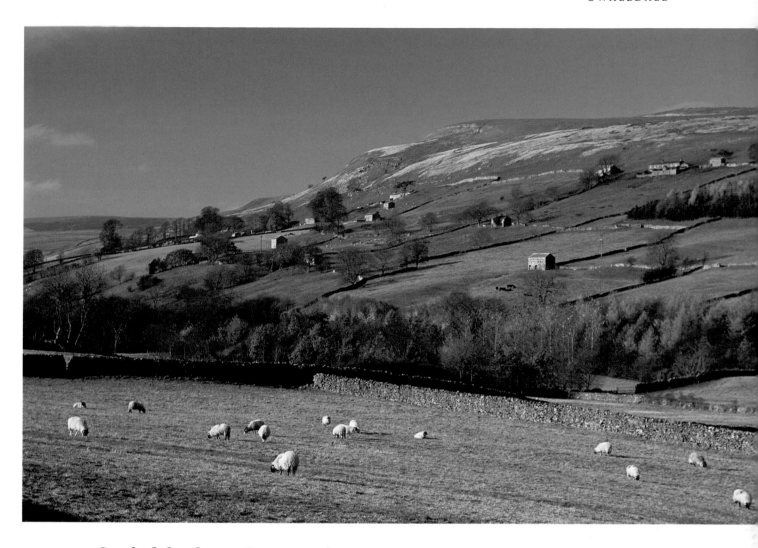

Swaledale above Gunnerside

This photograph of Swaledale just above Gunnerside was taken on a lovely November morning. The full clarity of early light brings out the autumn colours and highlights the barns and farms dotted across the fellside.

Upper Swaledale from Buttertubbs Pass

The dale has many moods and this photograph of the upper dale, taken from the Hawes to Thwaite road in winter, looks down and across a dale overshadowed by lowering skies. But even on the most cloudy of days, small breaks in the cloud allow the sun to light up the surrounding fells like a patchwork quilt.

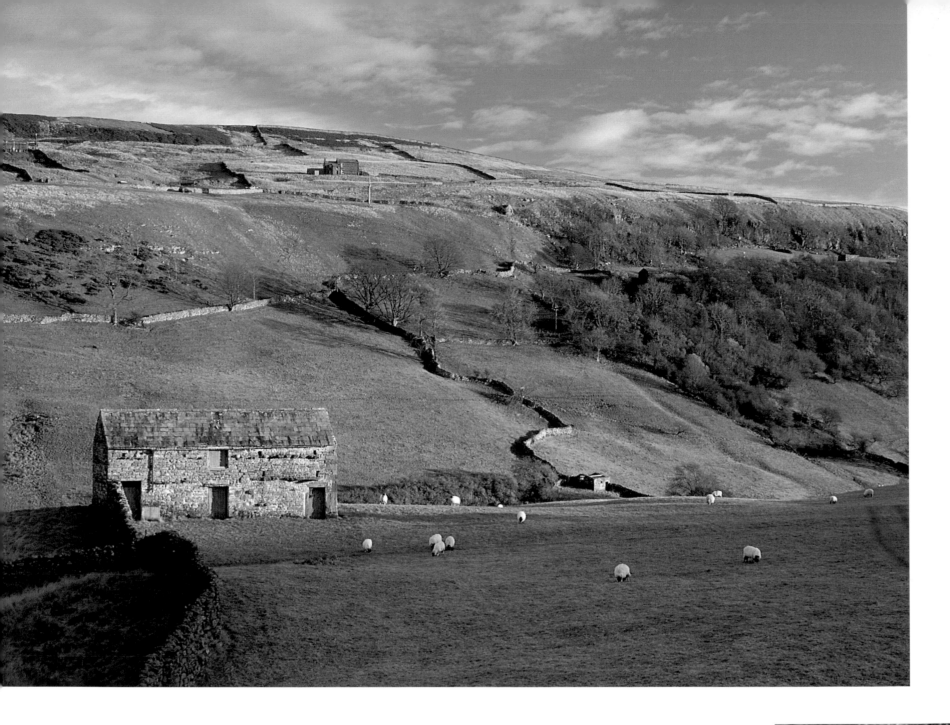

Evening sunlight near Angram

In the hills above Thwaite, close to the little hamlet of Angram, sheep graze in the meadow as the shadow of the evening sun extends across them. The typical stone-built barn, with its faded red paintwork and the fellside beyond, provide a perfect counterpoint. Despite the beauty of the scene more practical thoughts often occur when you look at a scene such as this. How, for example, did the farmstead on the distant fell ever manage to provide anyone with a living?

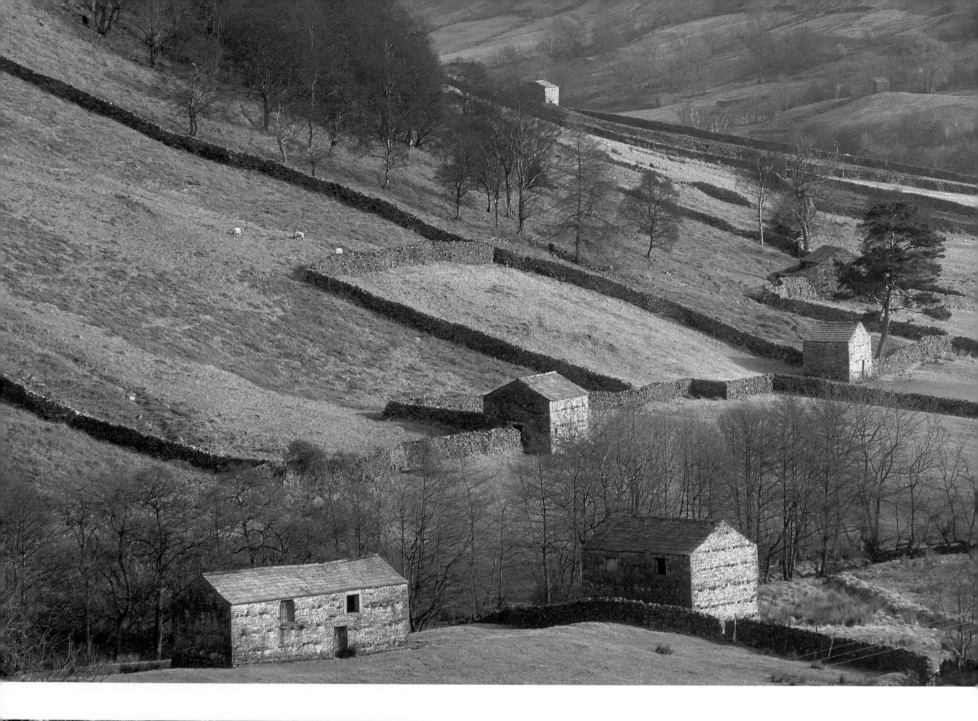

Field barns near Thwaite

These field barns stand in the warm winter sun like sentries at the foot of the fellside. Simply constructed, the barns were very effective for the purpose for which they were built. The lower floor was usually a shelter for animals, normally sheep or cattle; the upper floor was used to store winter fodder.

Ferns and drystone walls

Most stone walls blend rapidly with the landscape and provide a haven for small animals and certain types of vegetation. Here a colony of ferns intermingles with herb robert (*Geranium robertianum*) and grows profusely up the side of this wall which is already partially covered by moss.

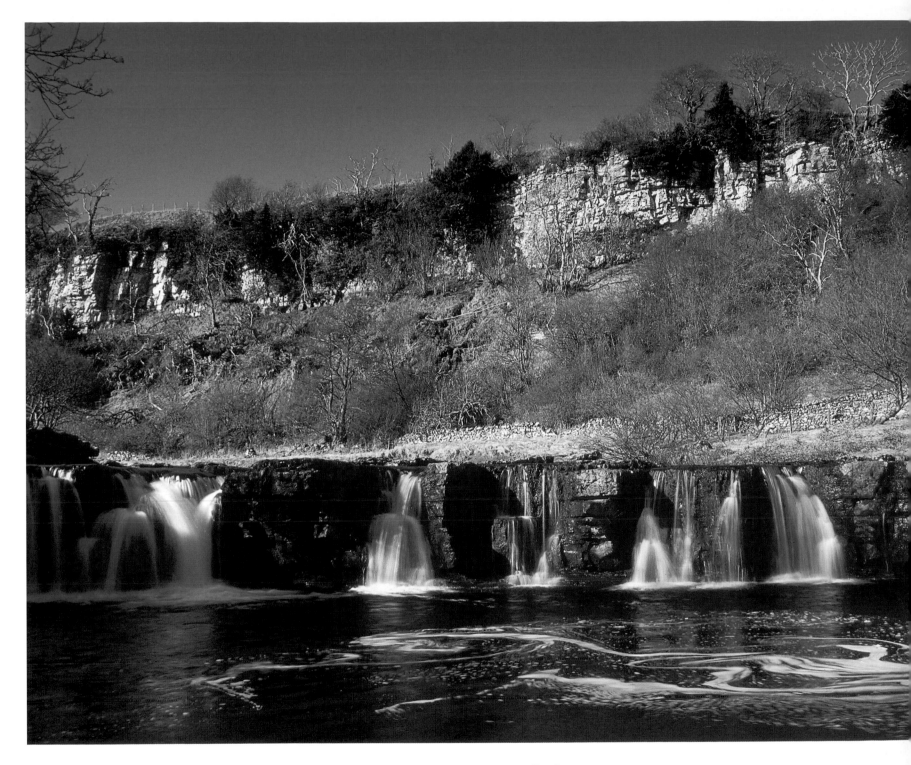

Wain Wath Falls

The area around Keld has a plethora of stunning waterfalls. The Wain Wath Falls are more familiar to most visitors because they are visible from the West Stonesdale road. The falls are made even more attractive by their dramatic setting beneath the rugged limestone crags of Cotterby Scar. In this picture, the patterns of foam that had formed into spectacular swirls after tumbling over the falls are particularly striking.

Morning light

Wain Wath Falls is really a line of several individual smaller falls all lined up along the same outcrop of rock. This picture, taken in the early morning light, takes advantage of this by concentrating on just three sections of the falls. The warm sunlit rocks in the foreground add a touch of contrast and depth to the rest of the scene.

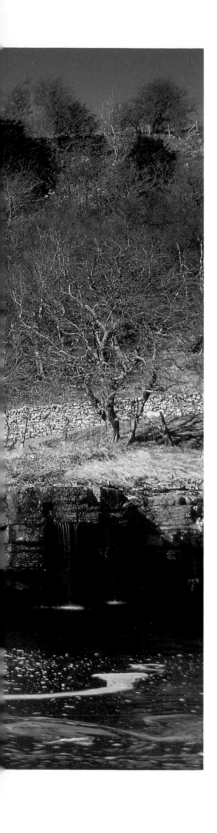
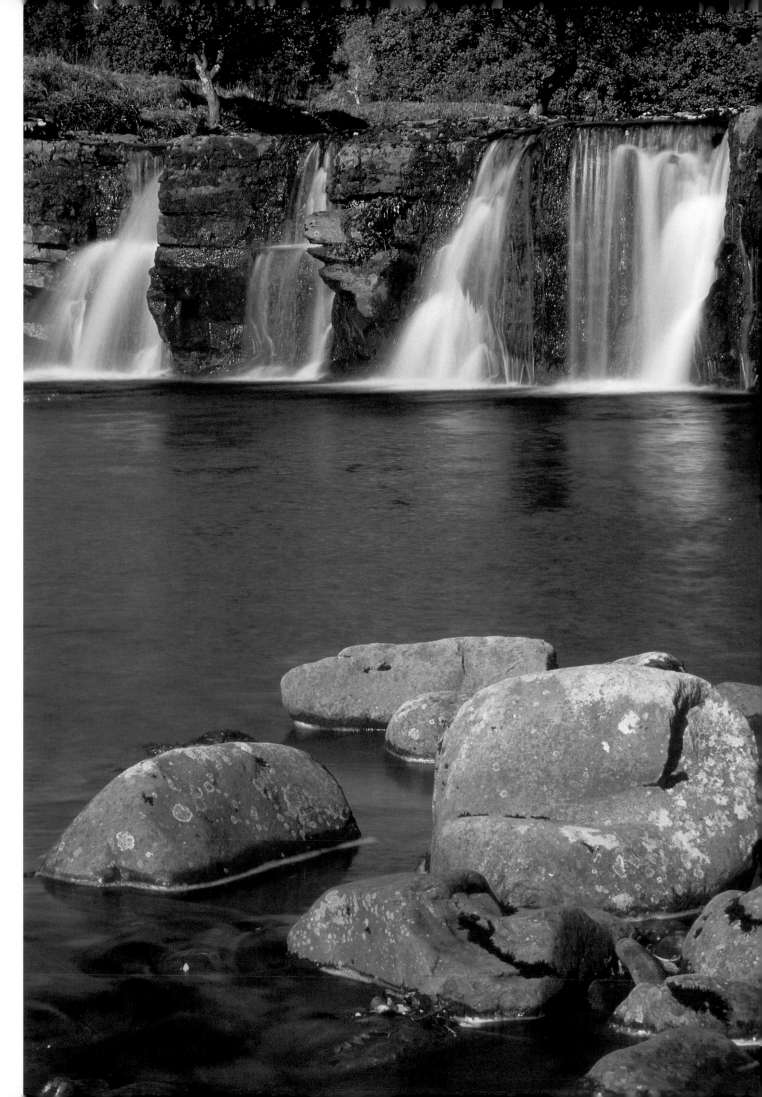

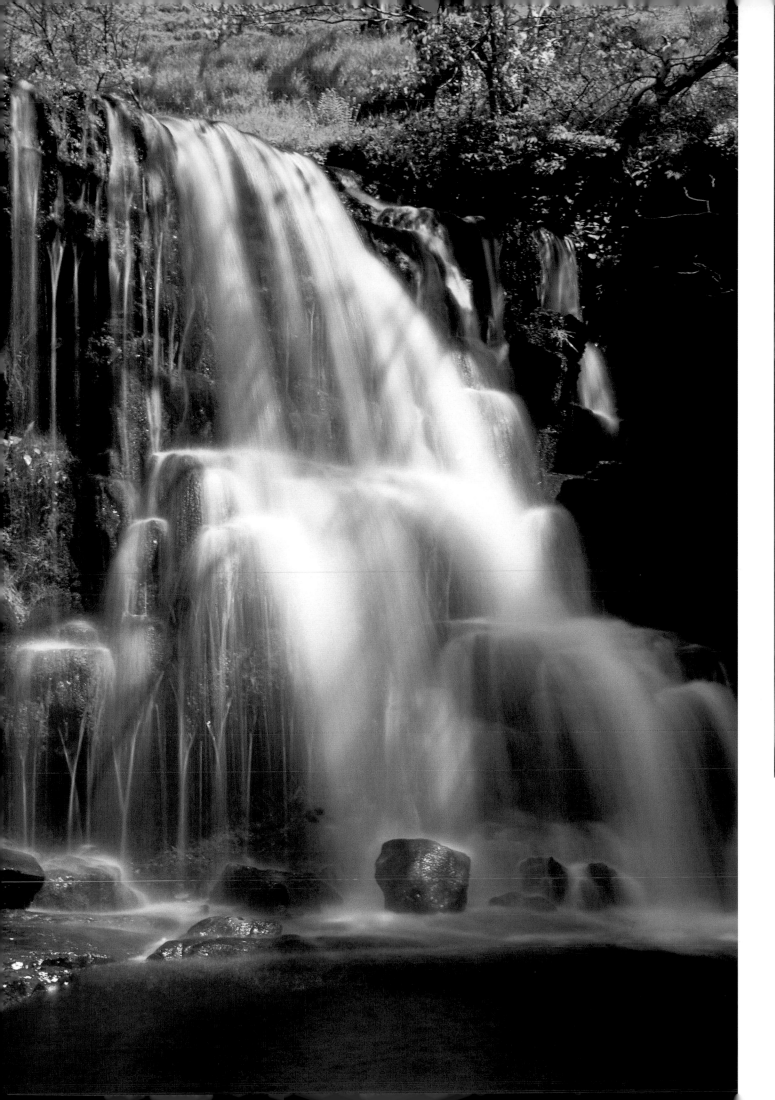
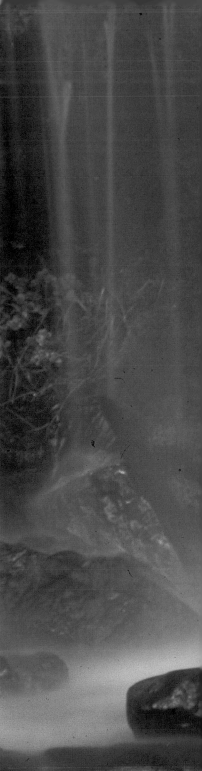

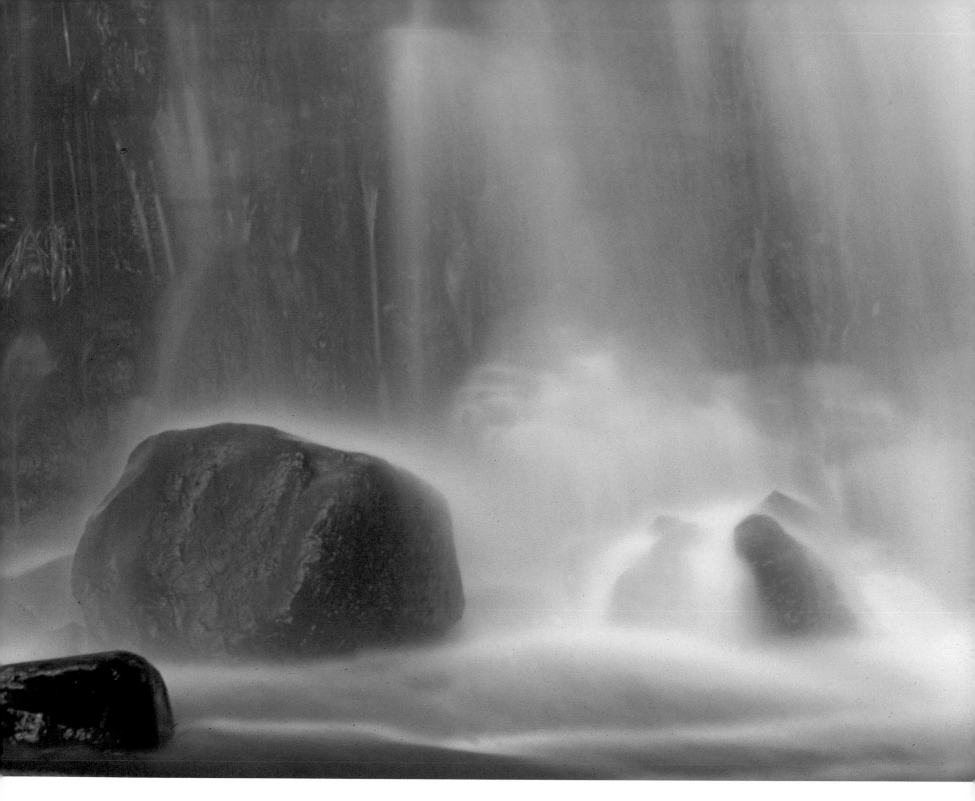

East Gill

East Gill falls are located at the foot of East Stonesdale and close to
the intersection of the two most famous long-distance walks in the
north of England: the Pennine Way and the Coast to Coast Walk. On
its way to join the Swale in less than a couple of hundred yards, they
carry East Gill over this lovely tiered limestone formation, producing
a wonderful tumbling flow of water as it cascades downwards.

Water flow patterns

It is often the case that by moving in a little closer you can find
another and equally evocative image. The use of a tripod and a slow
shutter speed to photograph the base of the falls has brought the
water into focus as it pours down from above. The result is almost
ethereal in the way the rocks glow with the white of the water
spraying over them.

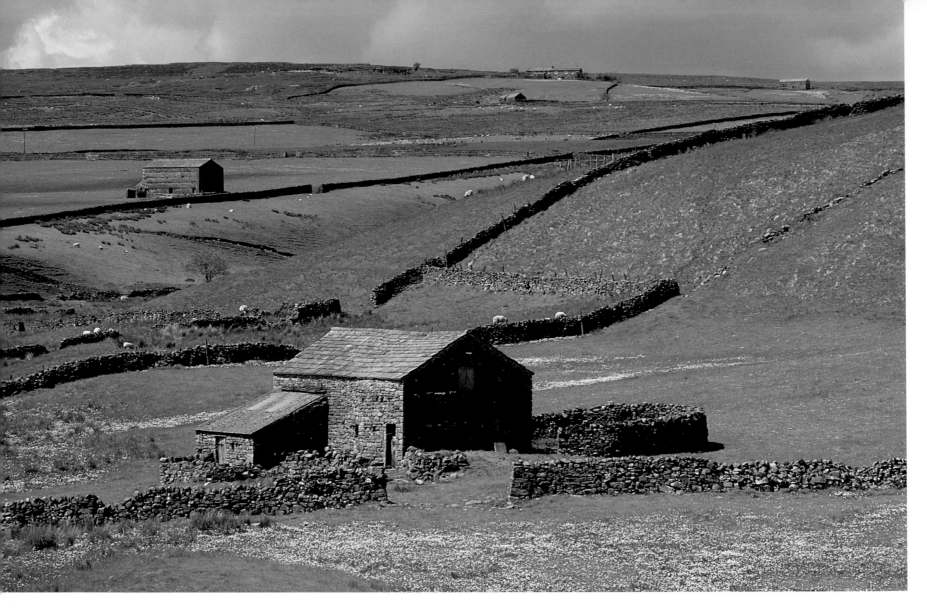

Hill farm overlooking Whitsun Dale

This view of the upper dale shows clearly what is meant by the term "hill farming". The farmstead of Harker's House stands out against a threatening skyline. Below the barns share the bottom land with a carpet of king cups – or marsh marigolds (*Caltha palustris*) as many people call them – while sheep enjoy the rough fell pasture behind.

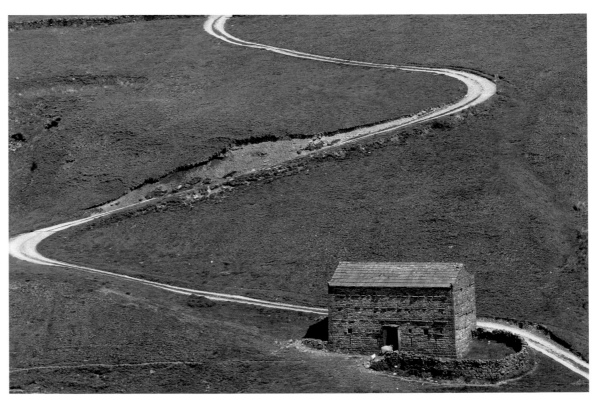

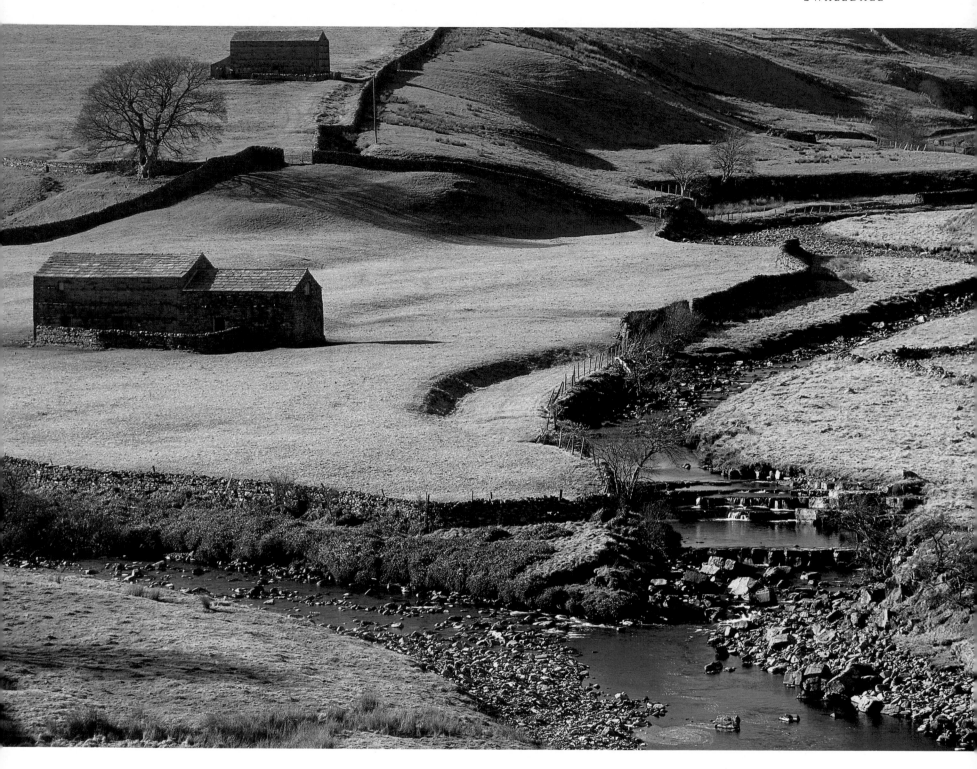

Isolated barn, West Stonesdale

Many a photographer has stopped in West Stonesdale to photograph this simple barn, made picturesque by the winding farm track that passes behind it before climbing the fellside. On this occasion I was fortunate to catch the ewe and her lamb just wandering into the barn's doorway, adding a touch of life to an otherwise almost barren landscape.

Birkdale Beck and Whitsundale Beck

This junction of these two streams could rightly be called the source of the Swale, for it is at this point that Birkdale Beck flowing in from the right of the picture joins Whitsundale Beck and becomes the River Swale itself.

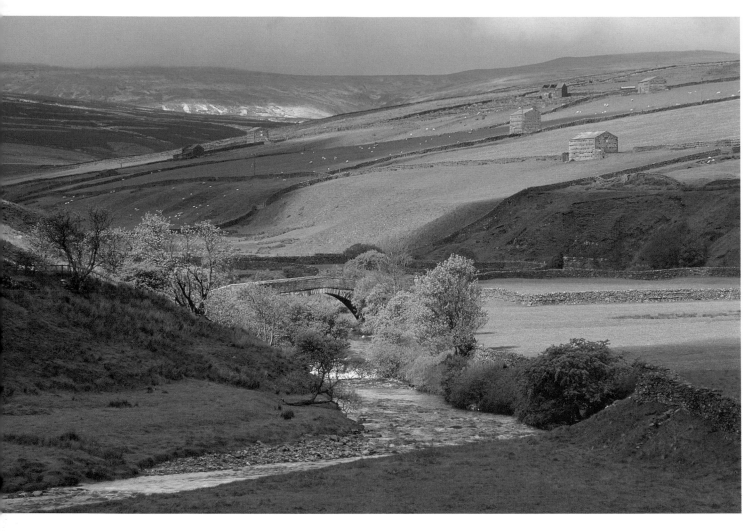

Birkdale and High Bridge

This picture serves as a reminder of how hard the climate in the high dales can be. With High Bridge in the foreground, the view takes you up into the far reaches of Birkdale right at the head of Swaledale. The fact that this picture was taken on a late spring bank holiday Monday, with snow still dusting the far fells, speaks volumes about the Yorkshire Dales.

.

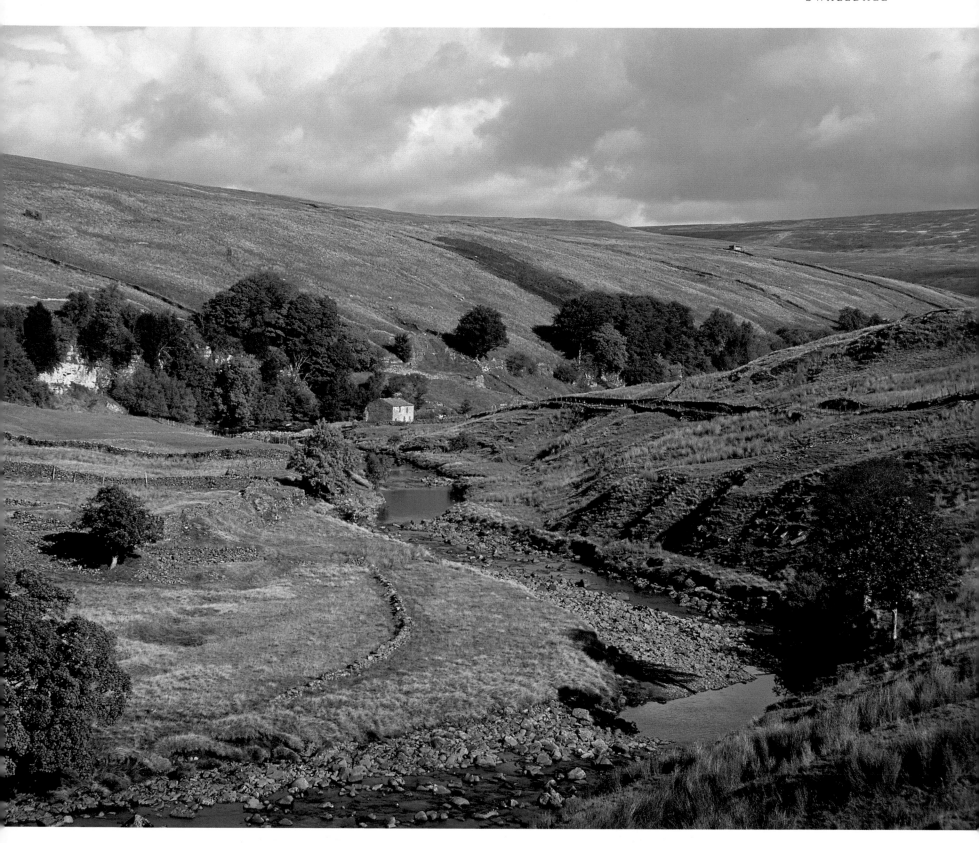

The infant Swale flows toward Keld

The infant River Swale is seen here winding its way down the dale and past Cotterby Scar under an early autumn sky. The grasses have all gone to seed, changing the summer green of the fields to yellow with the odd tree also beginning to turn in colour.

Chapter 2

Wensleydale

Wensleydale runs parallel to Swaledale just over the fell and to the south. But it is a dale of completely different character to its near neighbour since it is on a much larger scale. For most of its length, Wensleydale is the broadest of the Yorkshire Dales and is not as intimate as its partner to the north. Wander about Wensleydale, however, and you will find so much to enjoy, often tucked away in corners and in the tributary dales which are so common. Above all, the dale has a rich vein of waterfalls created by the waters of the River Ure and its tributaries, tumbling down over the limestone steps created by the Yoredale Series limestone. This dale is less remote and has a rich history – its abbeys and castles bear witness to this. But one thing Wensleydale does have in common with all of the Yorkshire Dales is its natural beauty, particularly its attractive meadow land, wild flowers and field barns.

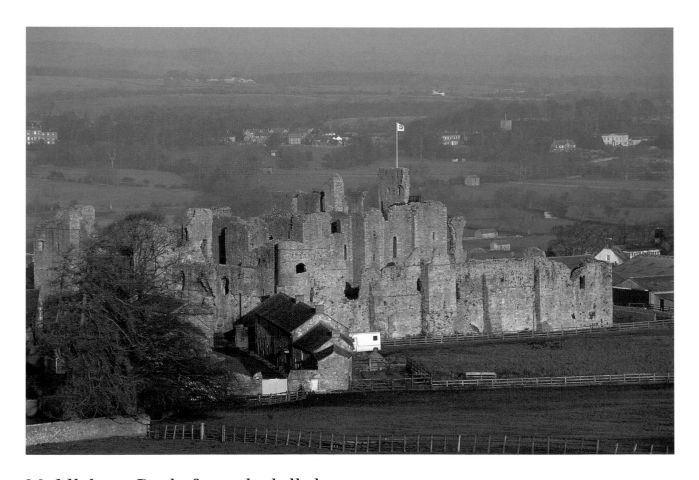

Middleham Castle from the hill above

Middleham Castle, two miles south of Leyburn, was once the stronghold of the Warwick family and King Richard III during the Wars of the Roses. It stands defiantly against the ravages of time overlooking the lower part of Wensleydale. The buildings clustered at its base form part of the famous horse racing stables of Middleham. They remind you of how many local homes would be clustered under the walls of the castle for protection in medieval times.

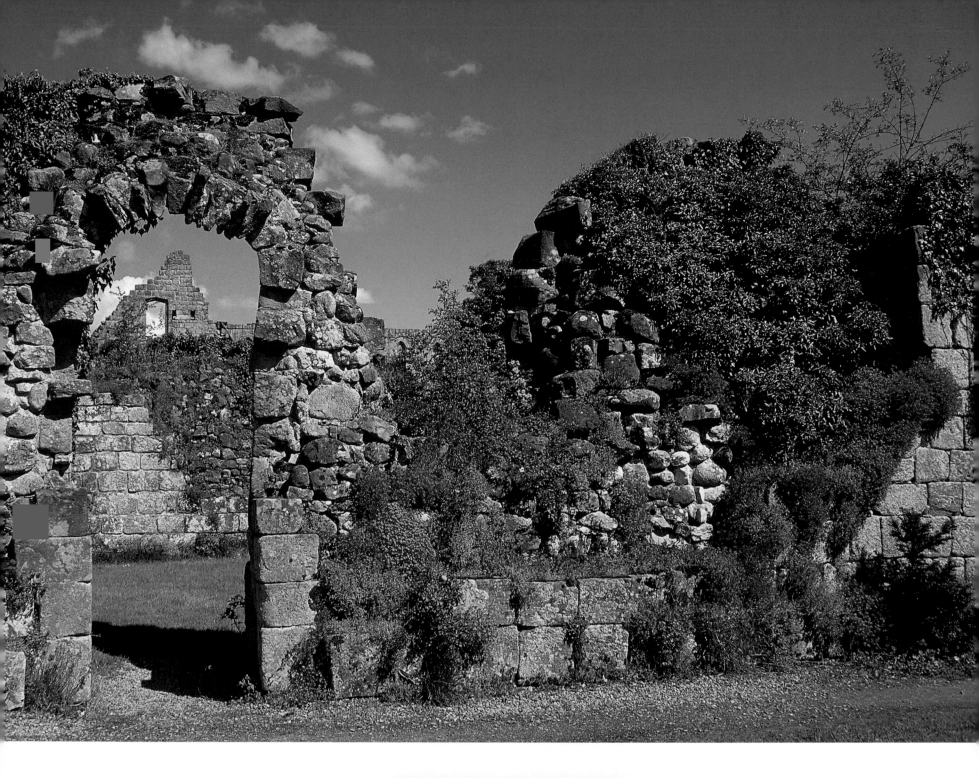

Old archway with aubrieta
(Aubrieta deltoidea)

Jervaulx Abbey, often known as the gateway to Wensleydale, was once one of the most powerful monasteries in the land; it is now a mere shadow of its former glory. Despite this, you will be rewarded by a stroll through its ancient ruins. The Abbey is famous for its wild flowers – if you visit in spring you will find aubrieta, periwinkle and japonica growing almost wild and providing a colourful spread.

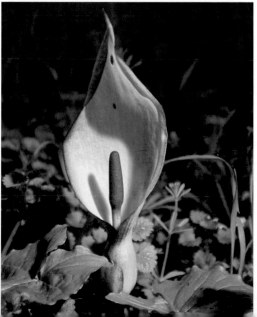

Lords and ladies
(Arum maculatum)

Often found in scrub land, the lovely lords and ladies (or cuckoo pint) is just one of many wild flowers that can be found among the ruins of Jervaulx Abbey. The word *jervaulx* is from the French and can be translated as "Ure Valley" or "Valley of the Ure", the name of the river which flows through Wensleydale.

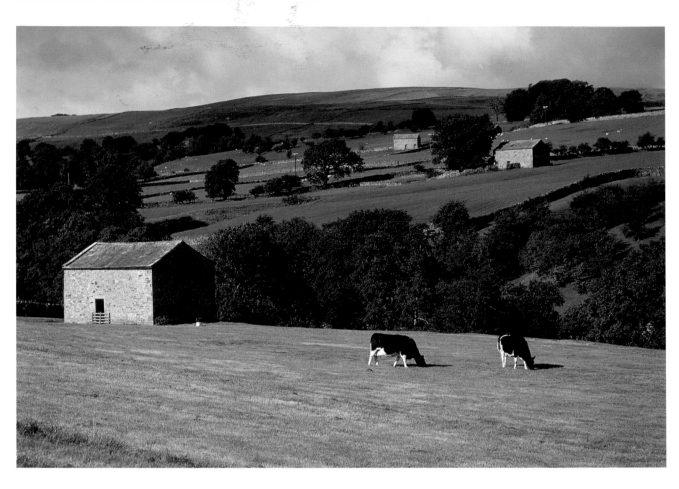

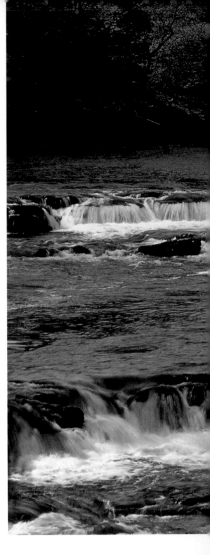

Coverdale valley

Stretching away from the main dale near to Middleham is Coverdale, the first of many of Wensleydale's tributary dales. Coverdale quickly opens up into typical dales farmland with its meadows and barns set against a backdrop of less cultivated moorland. This scene is typical, with the cattle in the near meadow and the odd field ploughed up for cultivation. Beyond that are higher sheep meadows with fields surrounded by drystone walls and dotted with field barns.

River Ure in winter sunshine

Wander along the river bank between the village of Wensley – which gave its name to the dale – and Aysgarth and you are quickly away from the bustle of the dale. Here the River Ure is wider and quieter than higher up the valley. This photograph, taken on a frosty winter's day, shows the nearly still waters with the shimmering reflection of a tree.

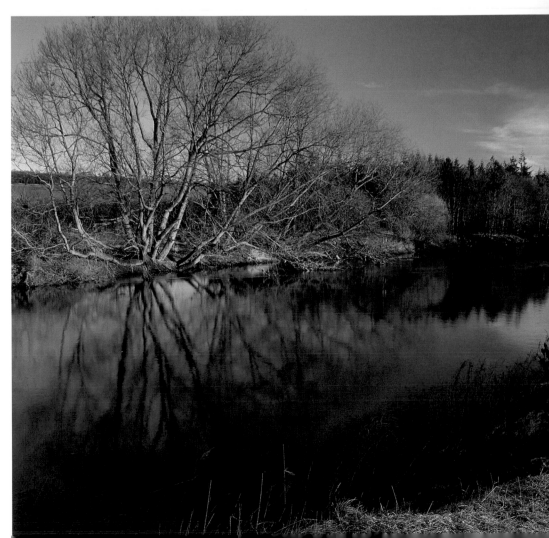

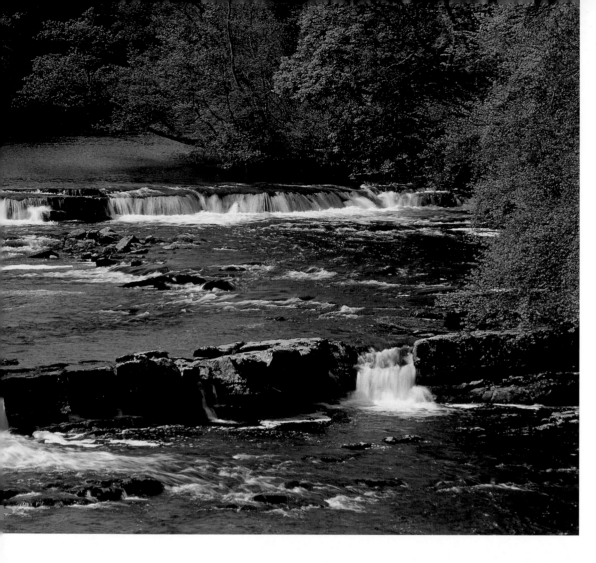

Redmire Falls

Redmire Falls is one of the hidden gems of Wensleydale. Hidden from the invasive motor car, the only way to explore the area is by foot. As a result, the falls and the surrounding woods have been left more or less untouched giving them a natural feel that you can imagine they have had for many centuries. The water flows over a series of small picturesque waterfalls and you could almost imagine Robin Hood and Little John having their legendary tussle in this secluded spot.

Sheep in rolling meadows

Farther along the valley, the land becomes more undulating and in the winter sunshine sheep quietly feed in the rolling countryside. The low angle of the afternoon sun helps to give form and shape to folds in the land.

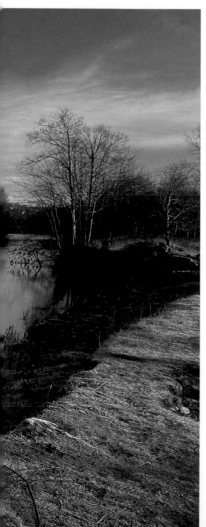

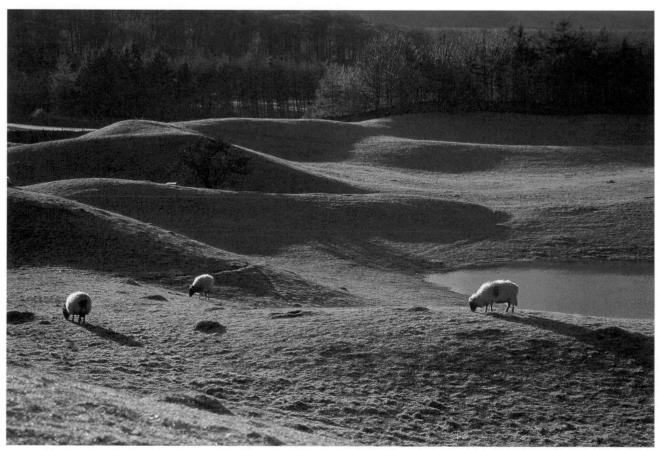

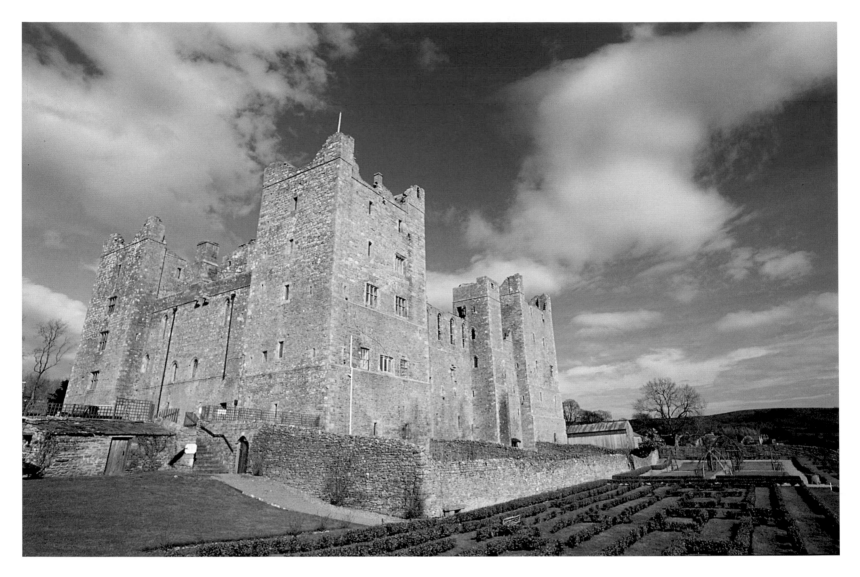

Castle Bolton

Castle Bolton stands proudly overlooking the dale. A loyalist stronghold in the civil war it was rendered almost indefensible by Cromwell after a prolonged siege. The building has been lovingly restored over recent years and is well worth a visit. Many rooms are still as they were when Mary Queen of Scots was imprisoned here. The re-planting of a medieval herb garden and maze add to the atmosphere of the castle.

Ewe and lambs in a spring meadow

Castle Bolton is set in the heart of the country, so you will not have to wander far to see some of the more traditional sights associated with the dales. This photograph of a ewe protecting her two young lambs standing together among the dandelions in the meadow could be a miniature portrait of the dales itself.

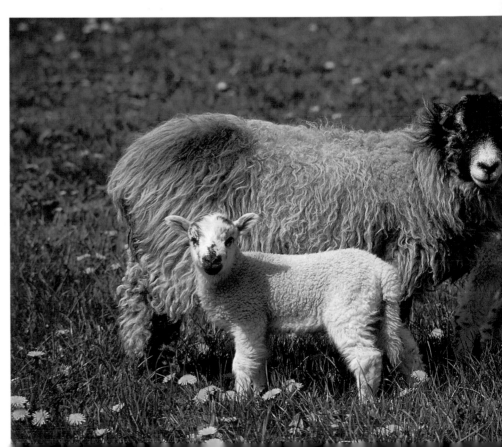

Purple orchid

(Orchis mascula)
The lovely purple orchid is the earliest flowering orchid in Britain and it can often be found as early as mid-April. Its colouring can vary from deep purple to palest pink.

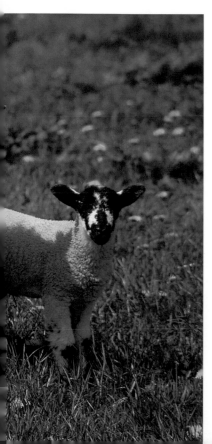

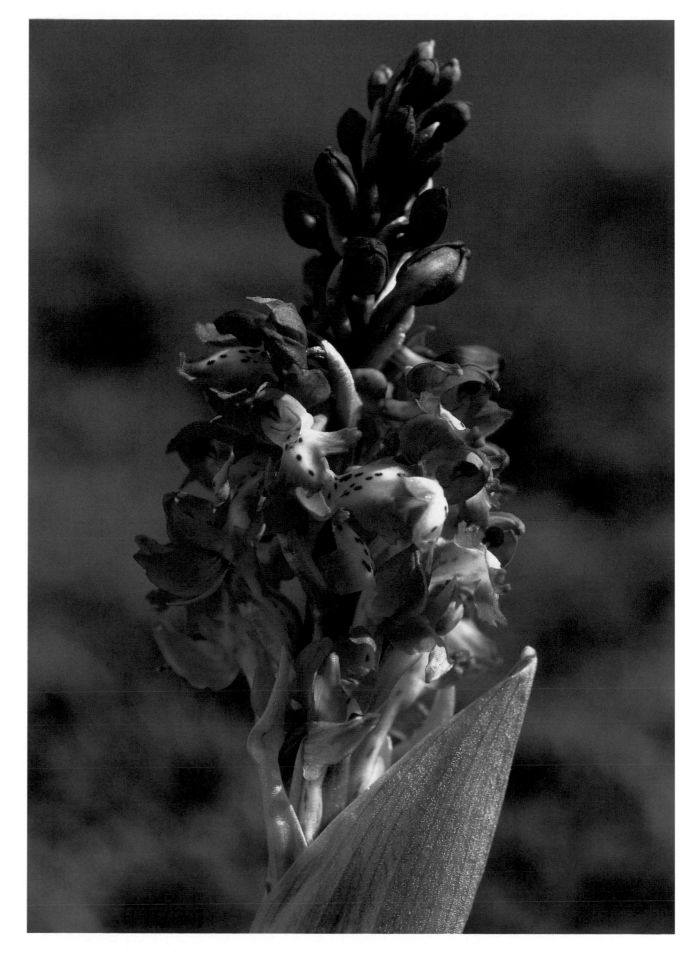

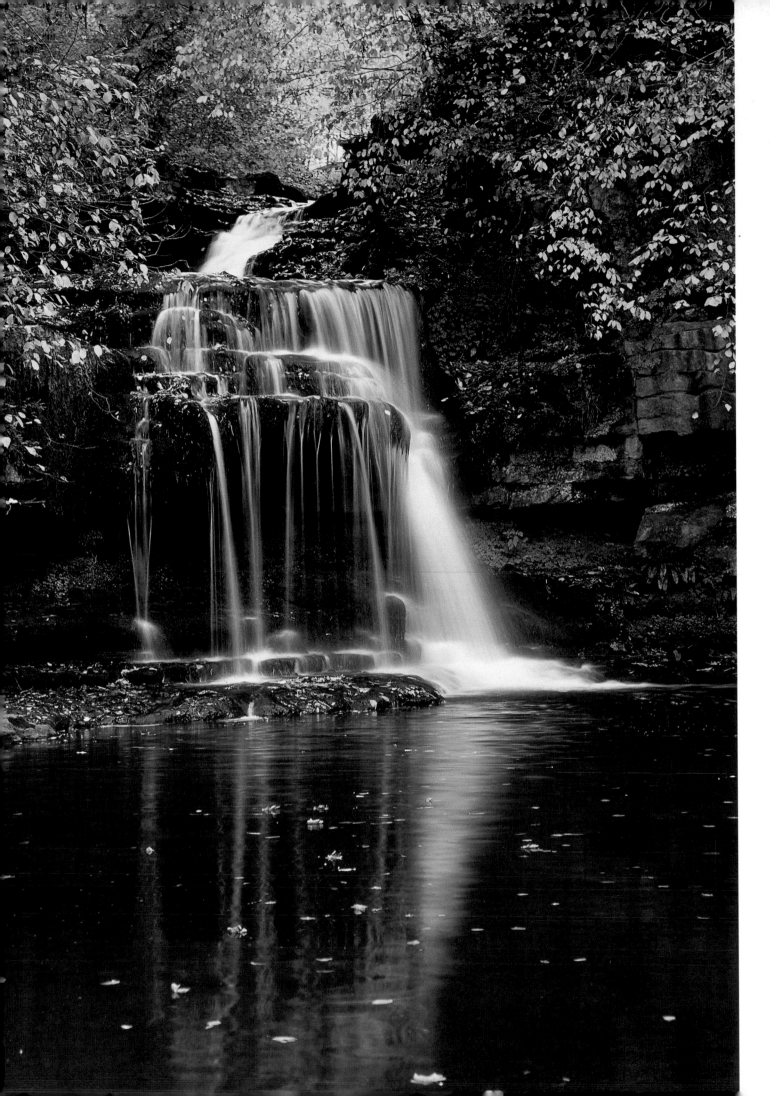

West Burton Falls

Wensleydale is a place of hidden nooks and crannies and Bishopdale is no exception. West Burton Falls are tucked away in a quiet little corner of the village of West Burton. Seen here on an October afternoon, Walden Beck appears almost graceful as it tumbles down out of the autumn woodland and into the little gladed pool. The dark still waters of the pool with the shimmering reflection of the trees only adds to the feeling of peace and beauty.

Sheep and dales barn, early spring

In very early spring, the bracken on the fells still glows gold in the sunlight. This flock of expectant ewes is confined to the lower meadows for protection against the worst of the dales' weather and to be near to the shepherd as lambing time approaches. The scene must have remained essentially unchanged for centuries. The barn adds to this timeless quality, as the building would have been used for storing winter fodder before tractors were the norm in farming circles.

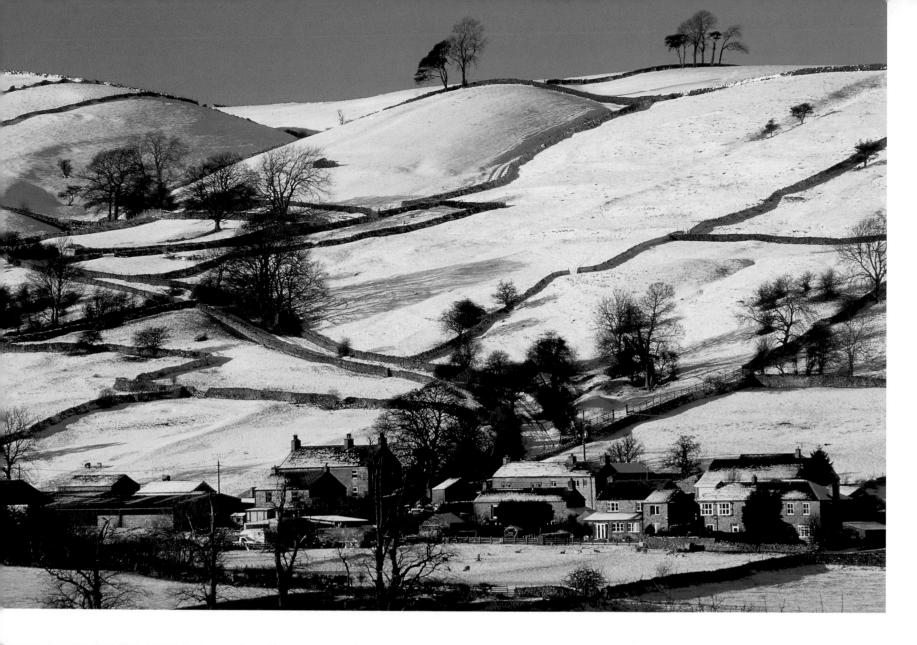

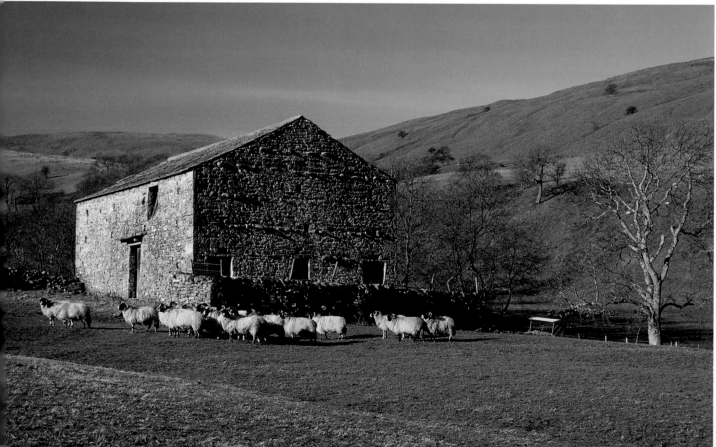

Thoralby village in winter

Bishopdale is a tributary valley more or less opposite Castle Bolton. Here, in the depths of winter, the landscape is covered with snow, revealing all the more graphically the drystone walls that border the fields of the dales. The scattering of trees stripped of their leaves stand even more starkly against the landscape with the little village of Thoralby nestling at the foot of the fell.

45

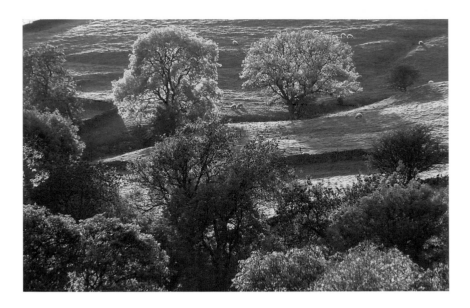

Late afternoon in Waldendale

In this little dale, the meadows are often surrounded by trees. As the sheep graze peacefully the trees are caught in the late afternoon sunlight, taking on an incandescent glow as the light streams through their yellowing leaves.

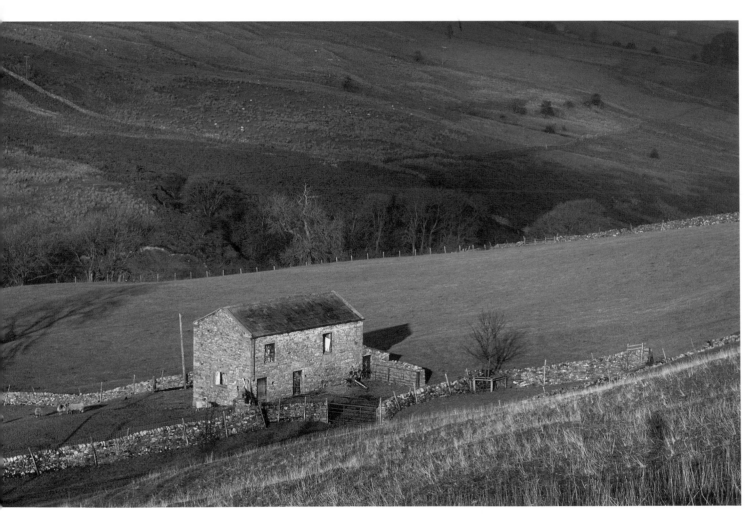

Waldendale barn

Drive up the "no through road" out of West Burton and you will find yourself in another hidden tributary dale, this time Waldendale. Here the fellsides reach right down to the bottom of the dale and any farmland has had to be carved out of the rough ground. This beautiful, well-cared for barn sits in one of the adjoining fields that runs down to the beck. On the far side of the barn, the rough fell forms a steep side to the beck.

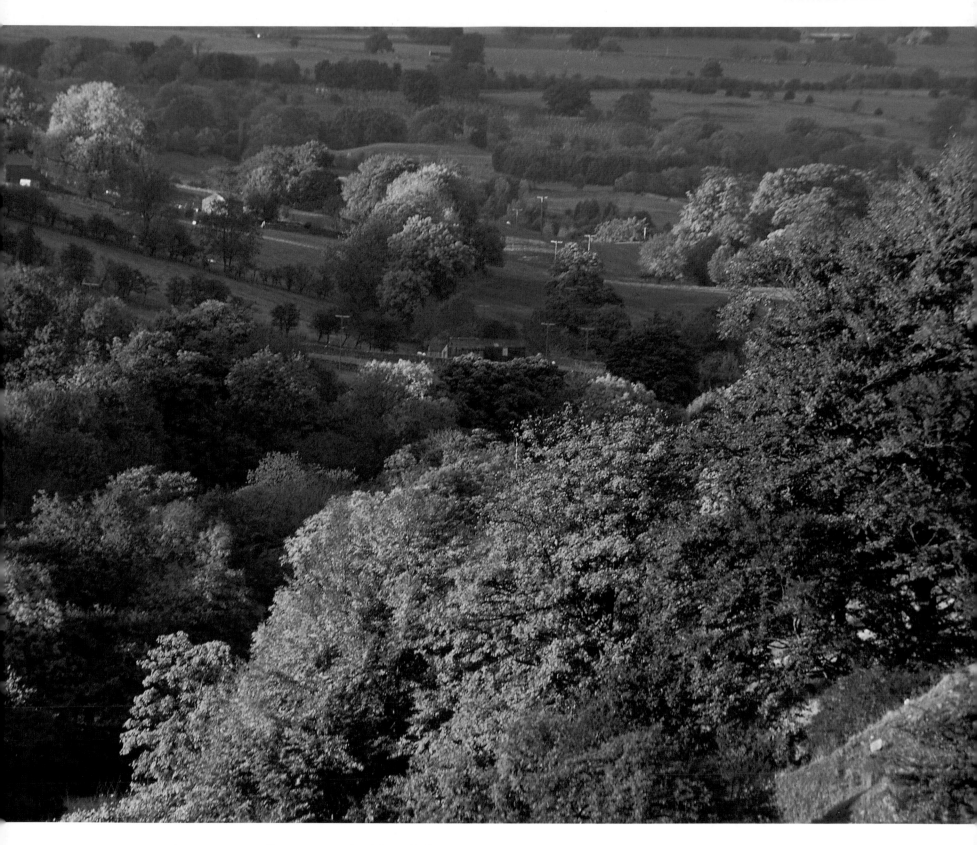

Autumn colours in Waldendale

Looking down the little dale of Waldendale and back into Bishopdale you can see that, in many places, its steep sides are wooded. In the late afternoon, just before the sun dips down behind the fell, the autumn colours of the trees are seen in all their glory. It is as if nature is trying to put on a last defiant show before the onset of winter.

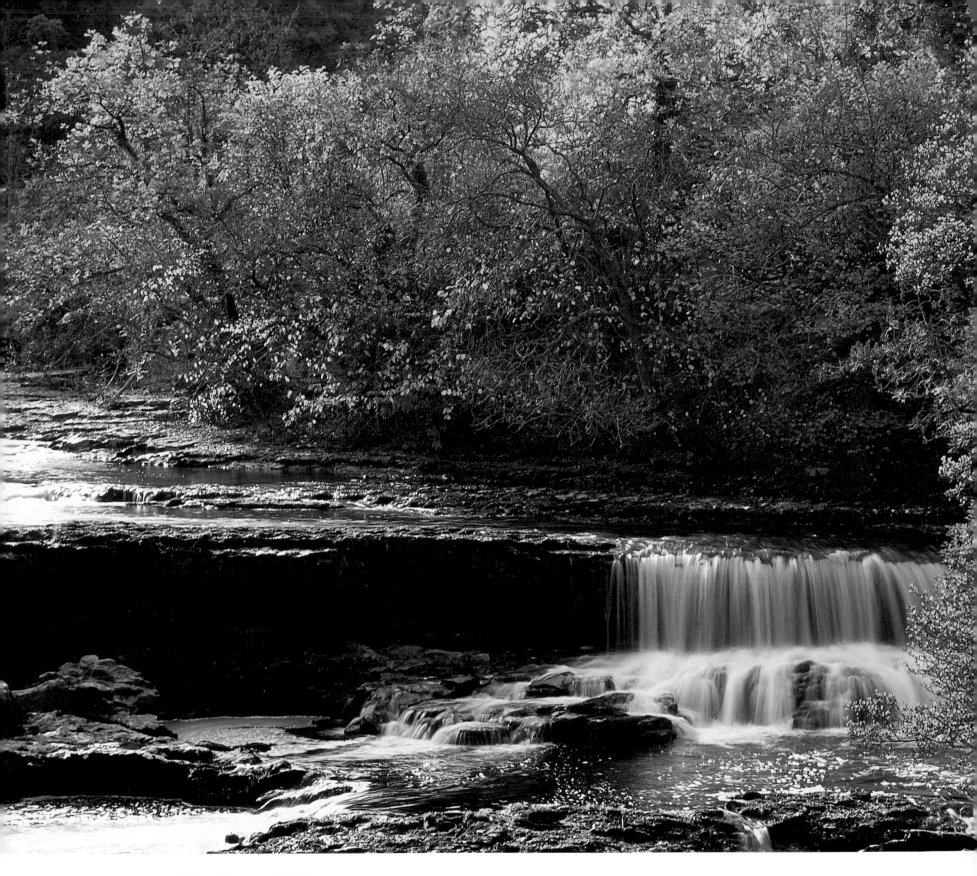

The Upper Falls in autumn

Aysgarth Falls is, without doubt, one of the "hot spots" of tourism in Wensleydale – and it is easy to see why. In the space of a couple of miles, the River Ure passes over a series of three major waterfalls created by the limestone landscape of the dale. The Upper Falls, pictured here in the autumn sunshine, provides a peaceful setting following a long dry summer. The autumn colours of the trees add to the apparent peace and beauty of the location.

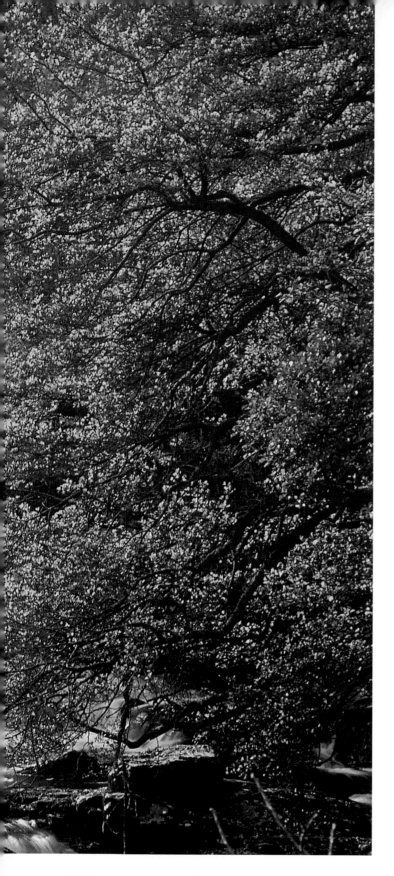

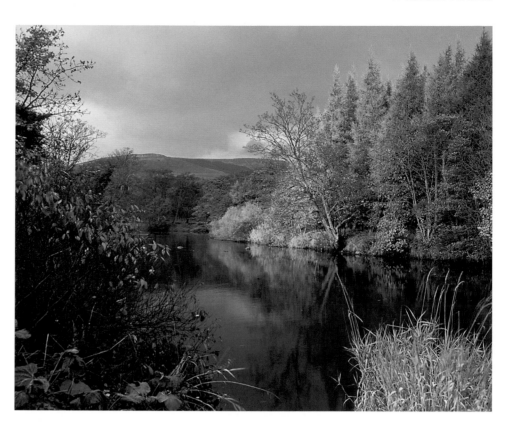

Still waters of the Ure near Aysgarth

The river Ure flows peacefully less than a mile from the point at which it crashes over the famous Aysgarth Falls.

Mill race overflow

It is worth looking at all the facets of the Aysgarth Falls. Here the water spills over from the old mill race in a graceful little fall that is not as spectacular as the main falls themselves but nevertheless provides an interesting sideshow.

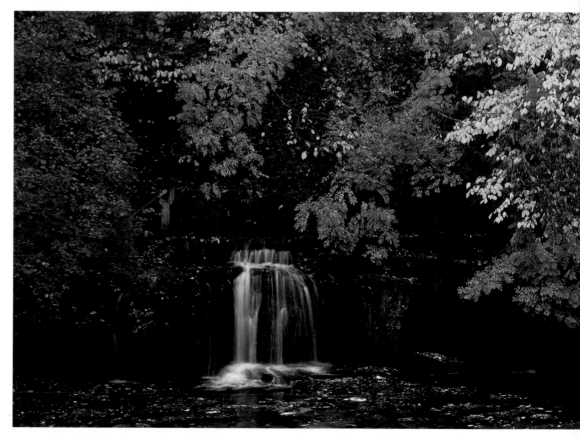

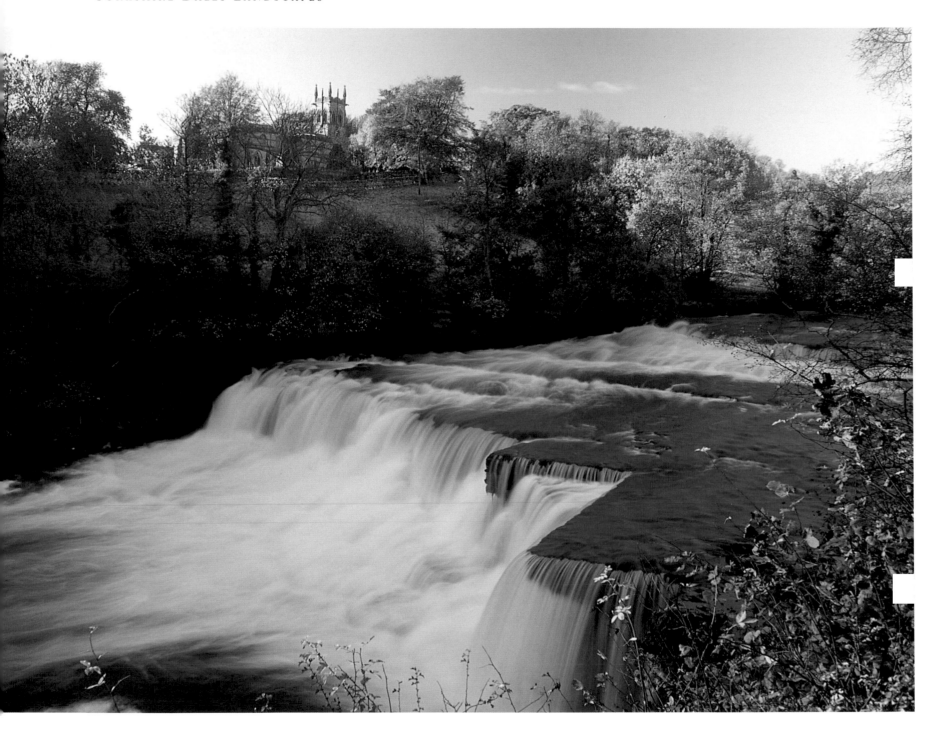

Middle Falls in autumn

Walk a little further downstream and you come to the Middle Falls, a dramatic cascade of water over a limestone outcrop. The falls are seen here just after sunrise as the light catches the church and the autumn colours of the tree tops. The angular nature of the rock structure is quite remarkable and contributes to the character of these falls. It is just a shame that the visitors are almost imprisoned by safety fences that prevent anyone from having an uninterrupted view of this lovely scene.

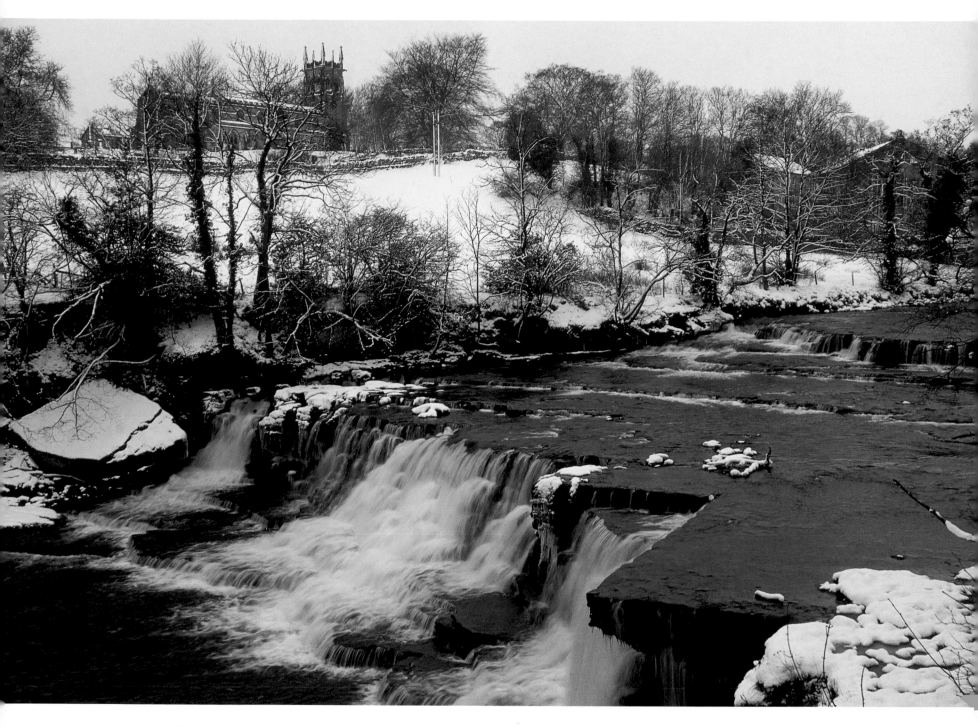

Middle falls in winter

Come back to Aysgarth Falls in a different season and the mood changes completely. In its winter colours, the landscape now takes on monochromatic tones with only the stone of the church and the slight peat staining in the water revealing that this is, in fact, a colour photograph.

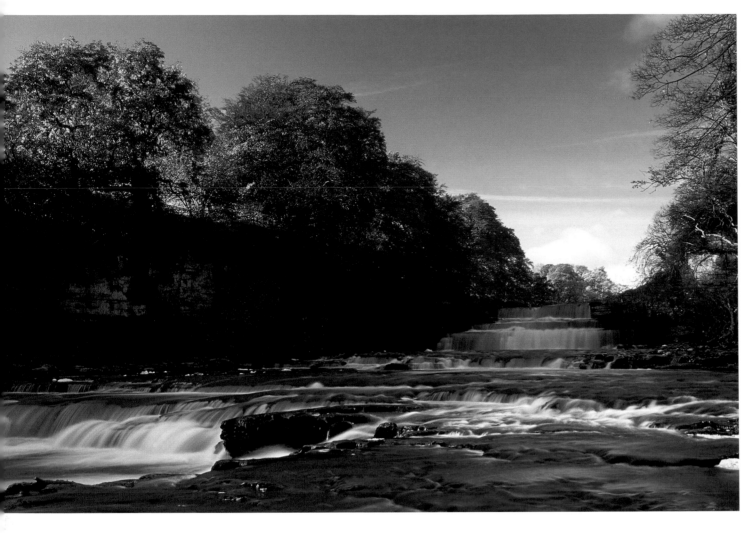

Lower Falls in autumn

The Lower Falls are a closely-placed series of limestone ledges that combine to create
the step-like nature of this waterfall. Like the neighbouring falls, the banks of the river
are surrounded by trees. Here, in the autumn sunlight, the foliage helps to make a near
perfect scene with the water making its way over each limestone ledge in graceful steps.
Spreading away from the base of the falls is a whole series of smaller ridges over which
the water then passes.

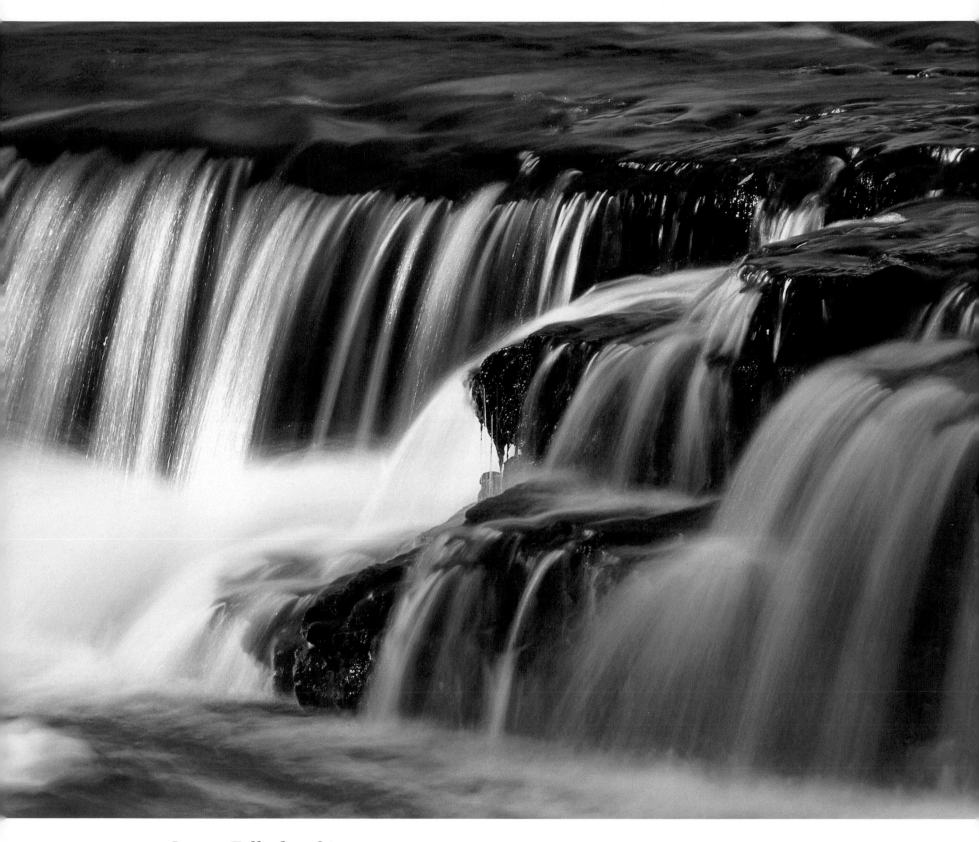

Lower Falls detail

The lack of fences here means that you can explore the river as it makes its way over the bedrock. As well as the main falls there are other smaller but no less beautiful waterfalls, barely more than rapids but still worth a second look. Here in this little corner the water flows and sprays out in pleasing patterns. There is a luminous quality to the water, stained by the peat from the fells, making it glow almost golden in colour as it plunges over the rocky ledge.

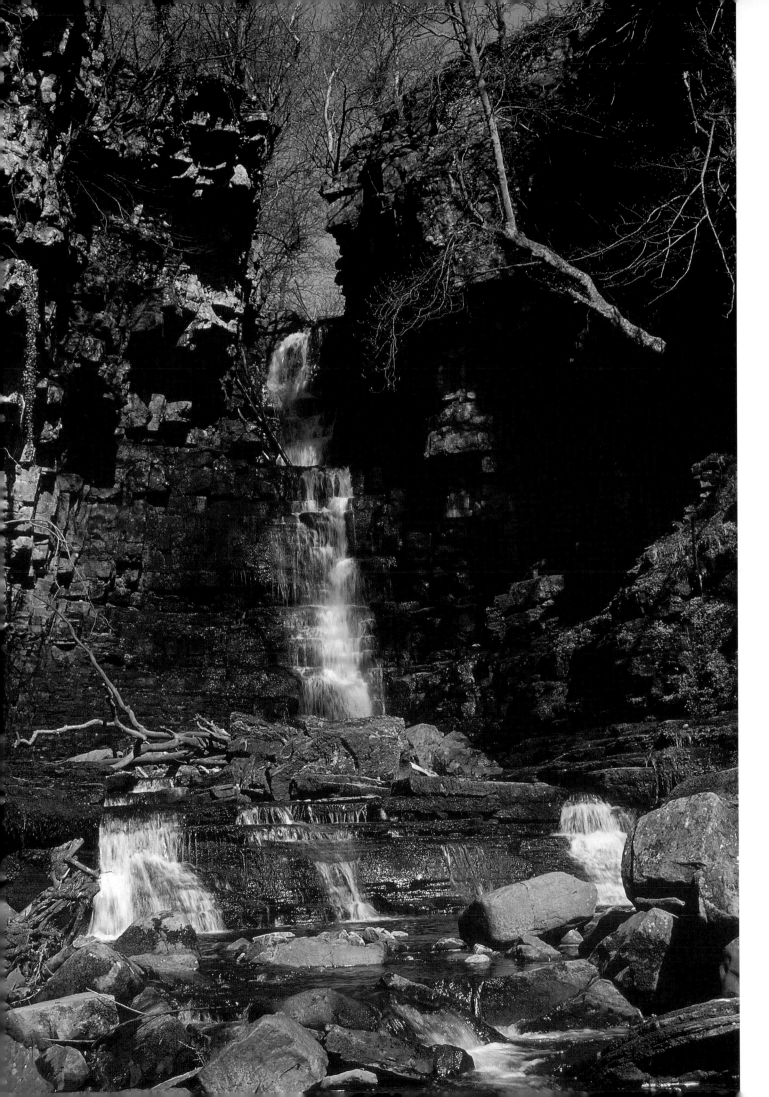

Askrigg

Askrigg nestles into the northern flank of the dale. The town was once the main centre of the upper dale, since it lies close to the old Roman roads that lead either over Stake Pass to Ilkley or further west over Cam Fell. When the turnpike roads opened, trade and commerce went to Hawes instead. Askrigg achieved fame when it became the location for filming the television series *All Creatures Great and Small*, inspired by the Yorkshire vet James Herriot. Here the rooftops of the houses that line the narrow winding main street glisten in the winter light as the residents stoke up their fires against the cold.

Mill Gill Force

A short walk across the fields, past some old mill buildings and into the hills behind Askrigg, brings you to a wonderful little gorge. Here a couple of spectacular small waterfalls carry Whitfield Beck down into the dale below. The first fall is Mill Gill Force created by the water tumbling over the Yoredale series of limestone steps. Hidden at the back of a short but steep-sided gorge the water tumbles over the limestone into the rocks below.

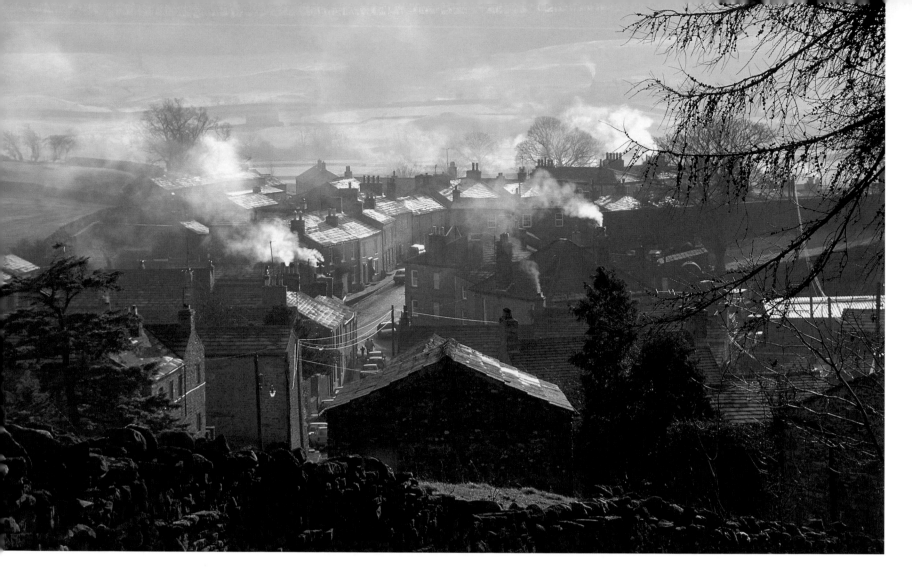

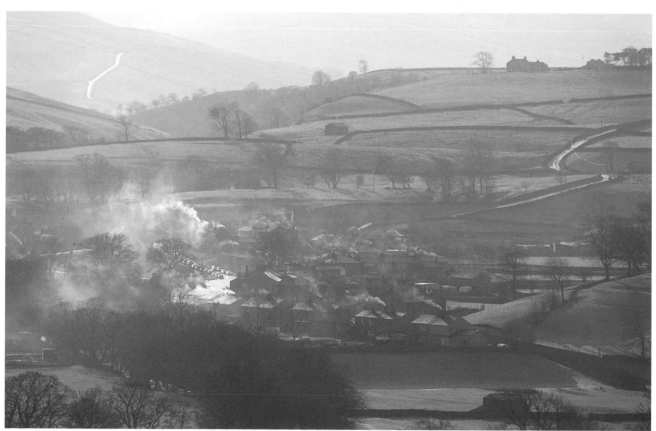

Bainbridge on a misty winter's morning

Step out of the gorge and on to the slopes of the main dale and you find yourself overlooking the old forestry village of Bainbridge. Again there is an ethereal mood to this scene as the winter sun backlights the haze created by the smoke from the many domestic fires. The sunlight glints on the houses and parked cars, but also on the roads that snake their way up the fellside towards Semerwater and Raydale.

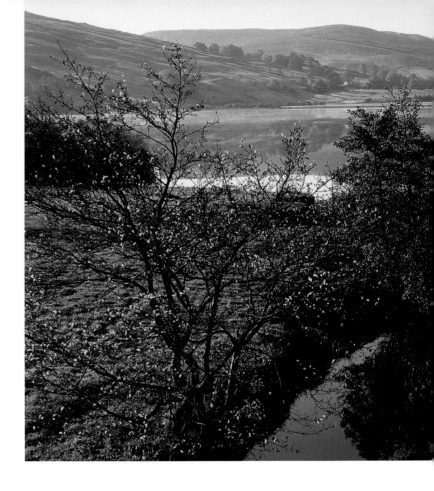

Semer Water from the overlooking fells

Semer Water, a glacial lake, lies in a hanging valley left over by the ice age and surrounded by limestone fells. Seen here from one of the limestone crags, the skyline is dominated by the dramatic form of Addlebrough standing like a sentinel on the far side of the valley. In the distance beyond, the repetitive shape of Penhill is visible. The foreground fellside glows gold in the late spring with the dead grasses left over from the previous year.

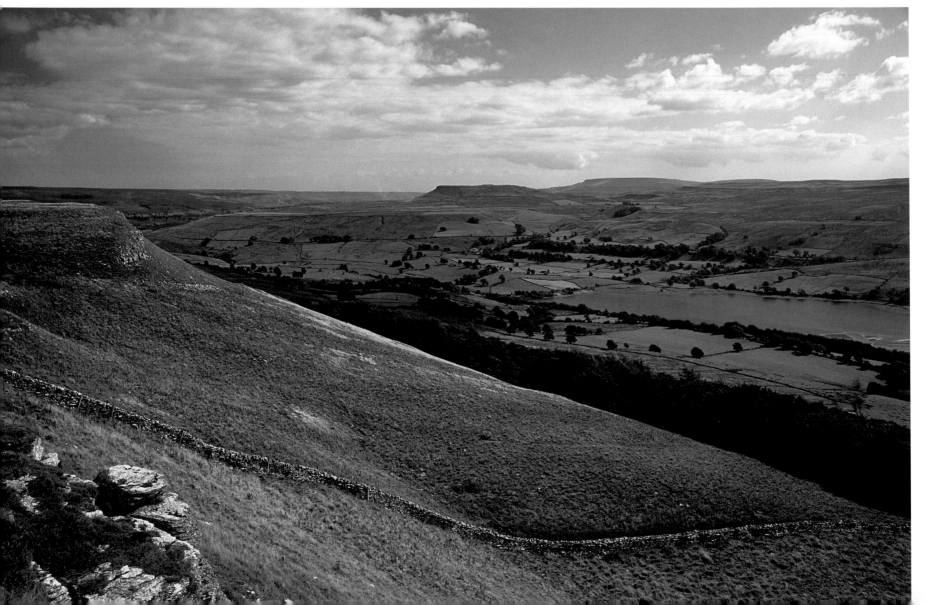

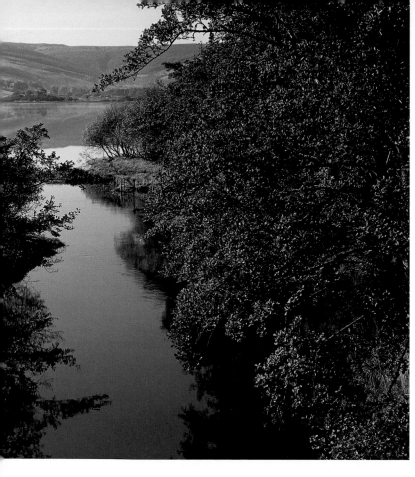

Semer Water on an early autumn morning

The outflow of the River Bain provides the foreground for this shot of the lake, still with a touch of mist in the autumn morning. Looking at this scene, you cannot fail to remember the legend of the sunken town. A beggar, refused food and shelter by all but one old couple, laid a curse on the community, causing the lake to flood it completely except for the single house of those who took him in. True or not, there are remains of an old village built on stilts which dates back to prehistoric times.

Semer Water in winter

It is always fascinating to return to locations in differing seasons and on this occasion the contrast between autumn and winter is stark but beautiful. The lake is frozen and the low sun shines off its surface creating patterns of its own. Clouds are racing over the fells, with the threat of more snow to come. Even the infant River Bain – at three miles in length, the shortest river in England – is still partly frozen over.

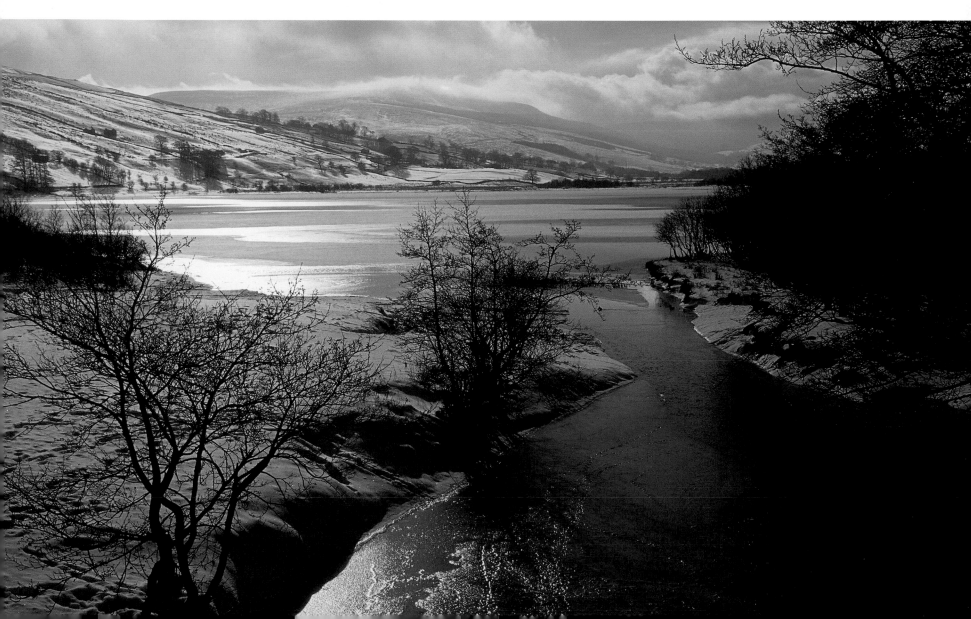

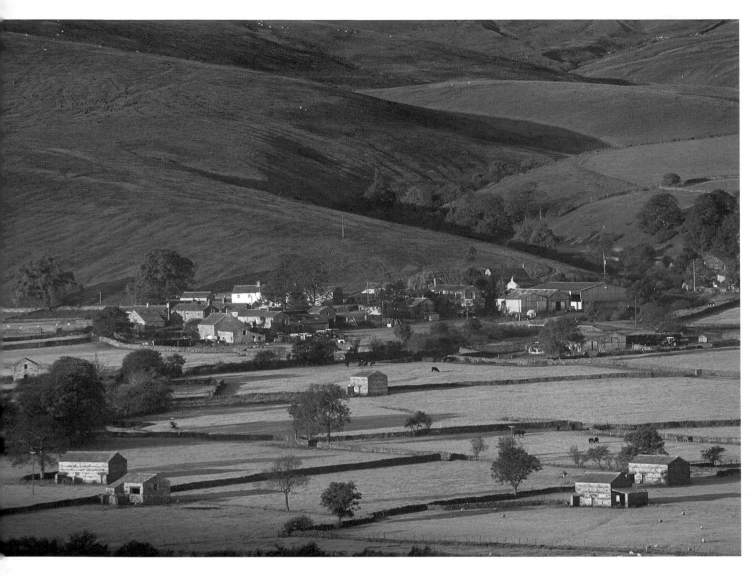

Marsett at first light

Beyond Semer Water and close under the fells lies Raydale and the little settlement of Marsett. This photograph was taken from the hillside overlooking the village early one September morning just as the sun began to rise over the fells behind. It cast its light over the village and the old flood plain, now peppered with field barns and divided up by drystone walls. It was the first light of day on this dale.

Milkmaid *(Viola cornuta)*

The land to the south-east of the lake is now a nature reserve and is a great place to find wild flowers in profusion. With the light shining through its delicate petals, this milkmaid flower displays the soft, delicate tracery of its veins.

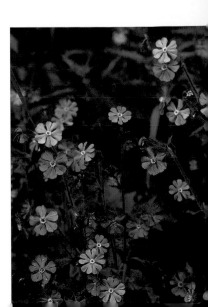

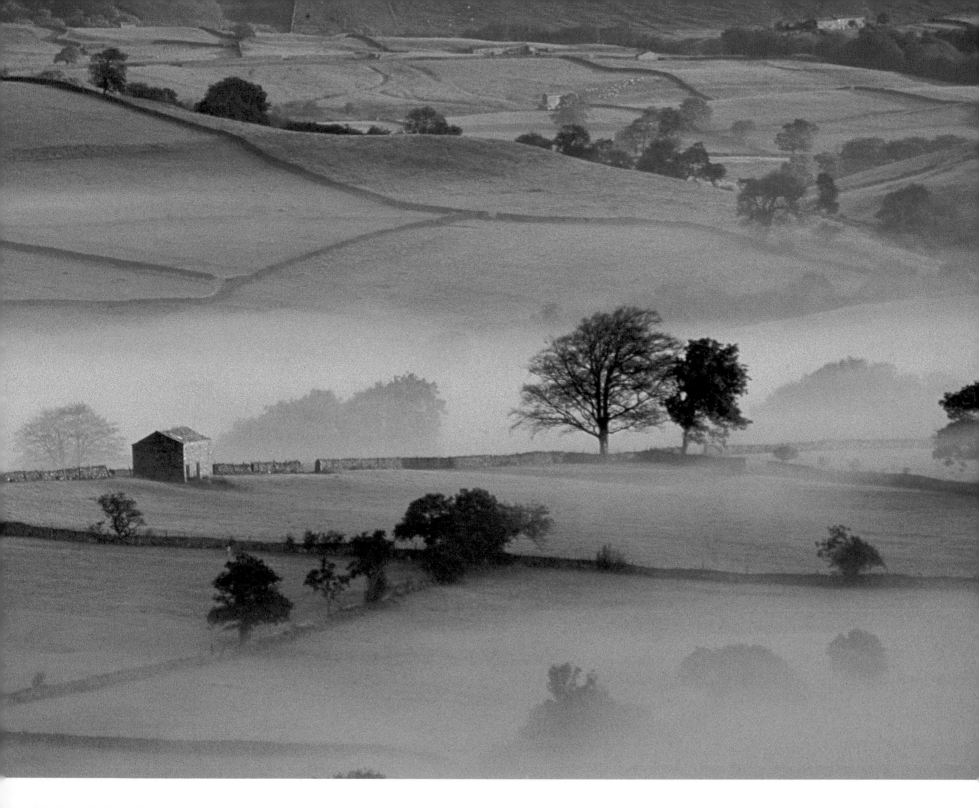

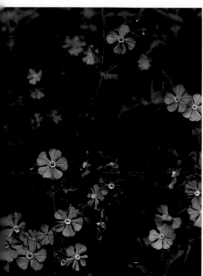

Red campion *(Silene dioica)*
The red campion – seen here with a spectacular clump of deep pink flowers – can often be found along the verge of a dales road. It has a long flowering period, from May to July.

Morning mists
Looking away from Marsett you can see Wensleydale in the distance on the far side of the lake. The morning mists ebb and flow with the sun just catching this solitary barn set on a rise in the land. The mystical feel of the landscape is enhanced by the darker shapes of the little groups of trees standing clear of the mists.

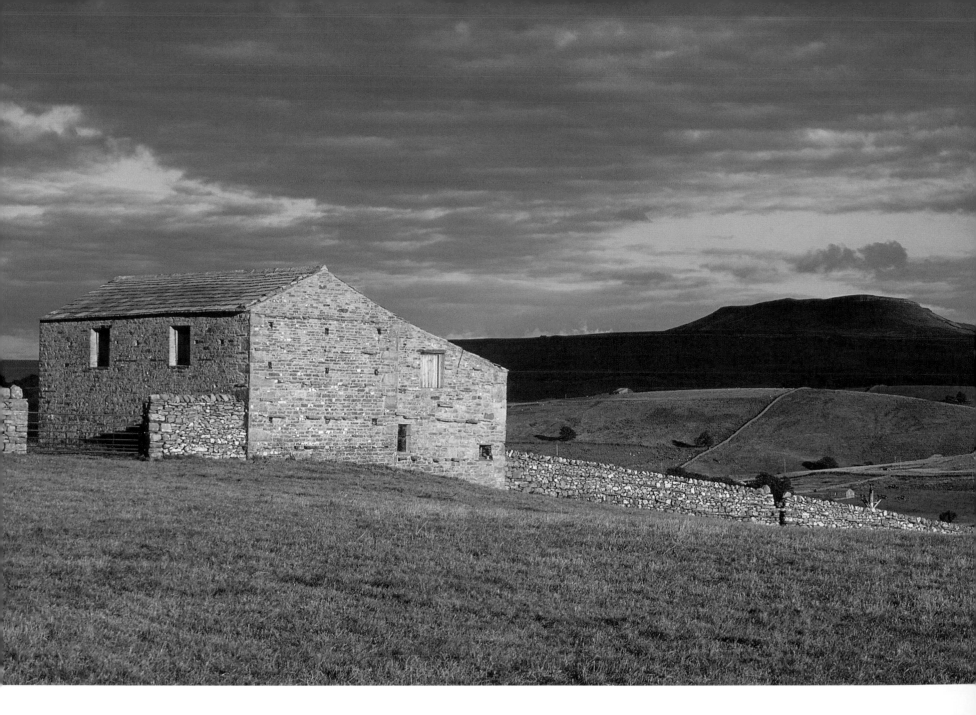

Sunlit barn with Addlebrough

The contrast between this sunlit barn and meadow in the foreground and the distant sight of Addlebrough in shadow makes for a strikingly simple picture which catches the mood of a glorious dales evening. The blue-grey of the high clouds above only seems to add to this mood.

Dales farmsteads

The traditional long – or laithe – houses which reflect the designs of the original Norse setters of the Dales were often built in folds in the land. The addition of strategically placed trees gave shelter to the little settlements. Catriggs Farm between Bainbridge and Hawes, seen here in the glow of evening light, is a classic example of this type of structure. Even more recent buildings and electricity poles seem to blend in with the barns and their surroundings.

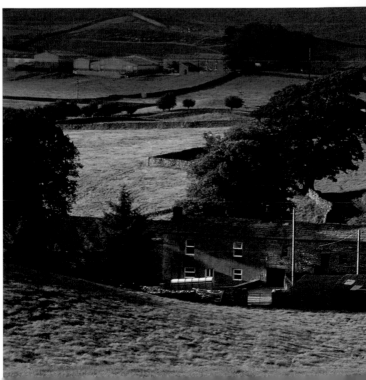

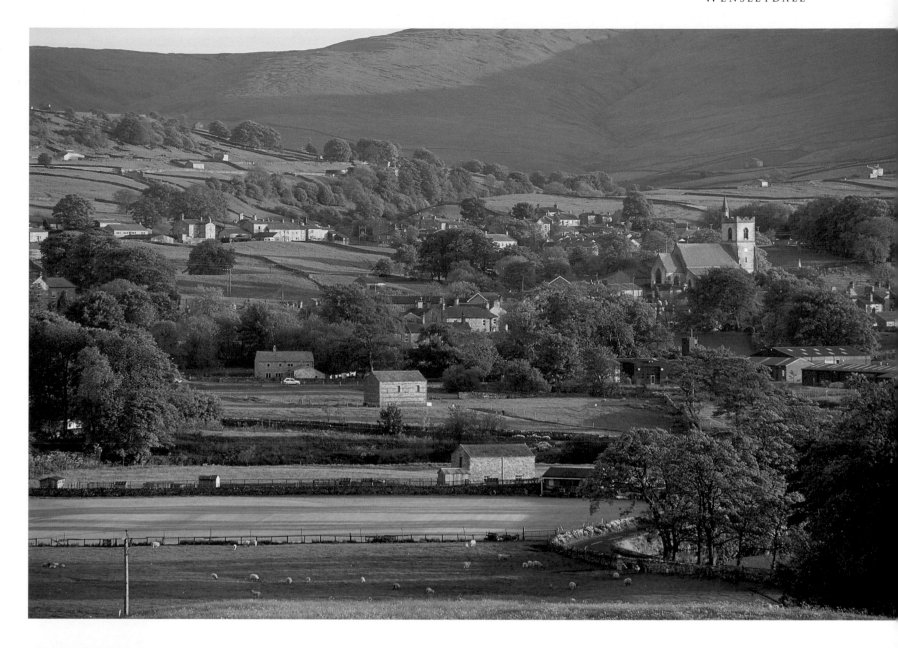

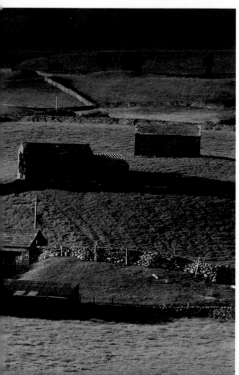

Hawes

The dale between Aysgarth and Hawes is a patchwork quilt of small communities, farmsteads, barns and drystone walls interspersed with trees scattered along the river bank or field margins. This view, in the evening light, across the dale to Hawes, is typical of the landscape of Wensleydale. The low side-lighting makes the York stone of the buildings stand out from their surroundings.

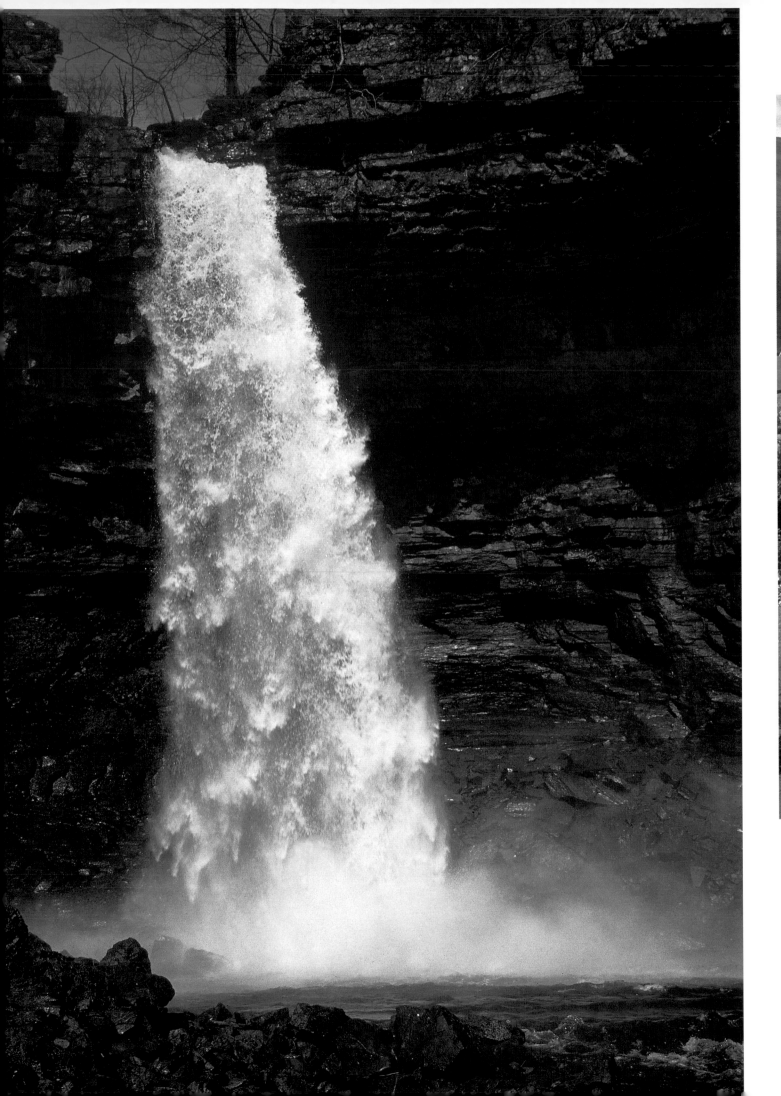
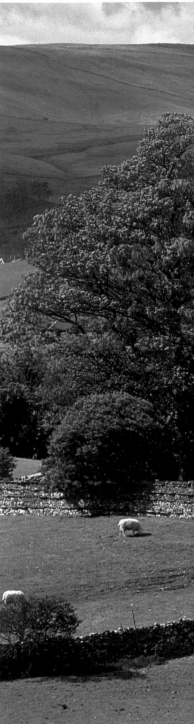

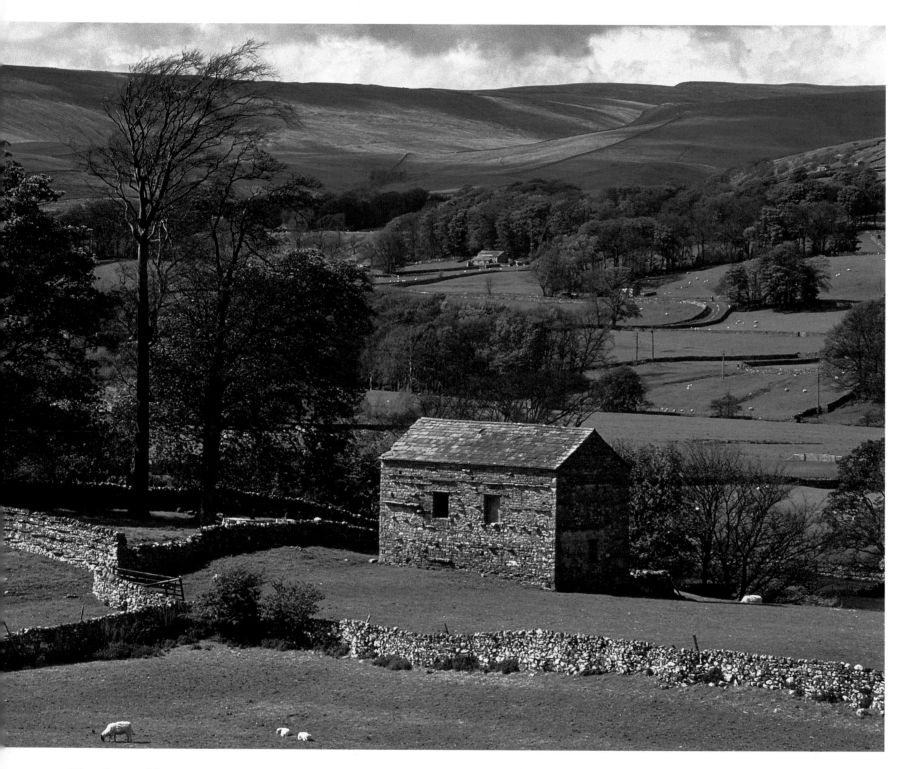

Hardraw Force

Hardaw Force, on the far side of the dale, is tucked away on the fringe of the still-brown fells. This is one of those "must visit" locations. The fall, which at 100ft (30m) is the highest free-falling waterfall in England, is at the head of a small gorge behind the village of Hardraw and is reached through the local Green Dragon Inn. If there is any sunlight, the spray from the crashing waters invariably creates a rainbow, especially around the middle of the day when the sun is at the correct angle.

View across the dale

The sight of the dales in early spring is always a pleasure to the eye. Here sheep with their young lambs occupy the fields across the whole of the dale. Some trees have burst into leaf, while others wait to do so. The far fells still retain their winter covering of dead grasses. It is a time of regeneration in the dale as the days draw out and summer approaches.

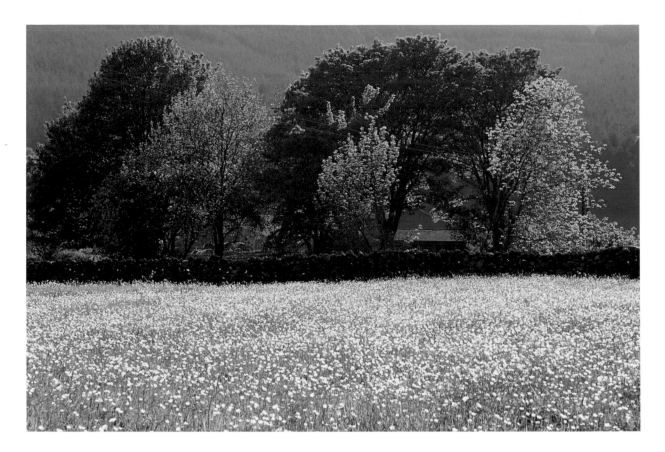

Spring meadow in Cotterdale

Travel west from Hawes and you will come to the lovely "hanging valley" of Cotterdale. In spring the meadows of Cotterdale are as beautiful as any elsewhere in the dales. Here the meadow is a riot of colour and the trees behind have that luminous quality that only occurs when the leaves are freshly opened.

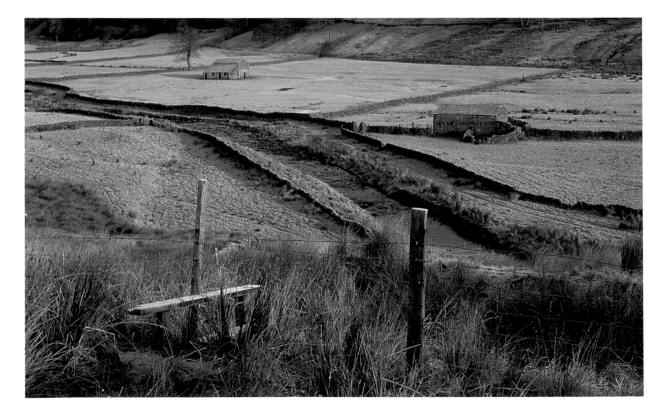

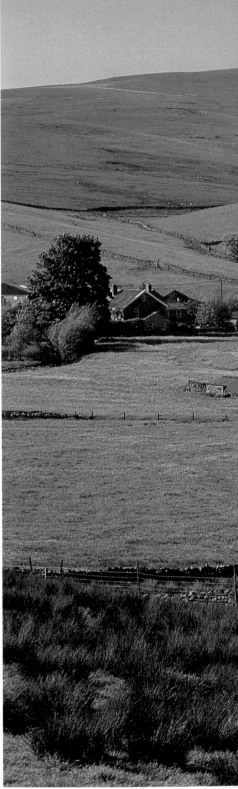

Winter frosts

The landscape changes in colour and mood with the seasons and this photograph of the path leading into Cotterdale shows this. Now, instead of greens and yellows dominating, it is the browns of the dead vegetation that create the mood.

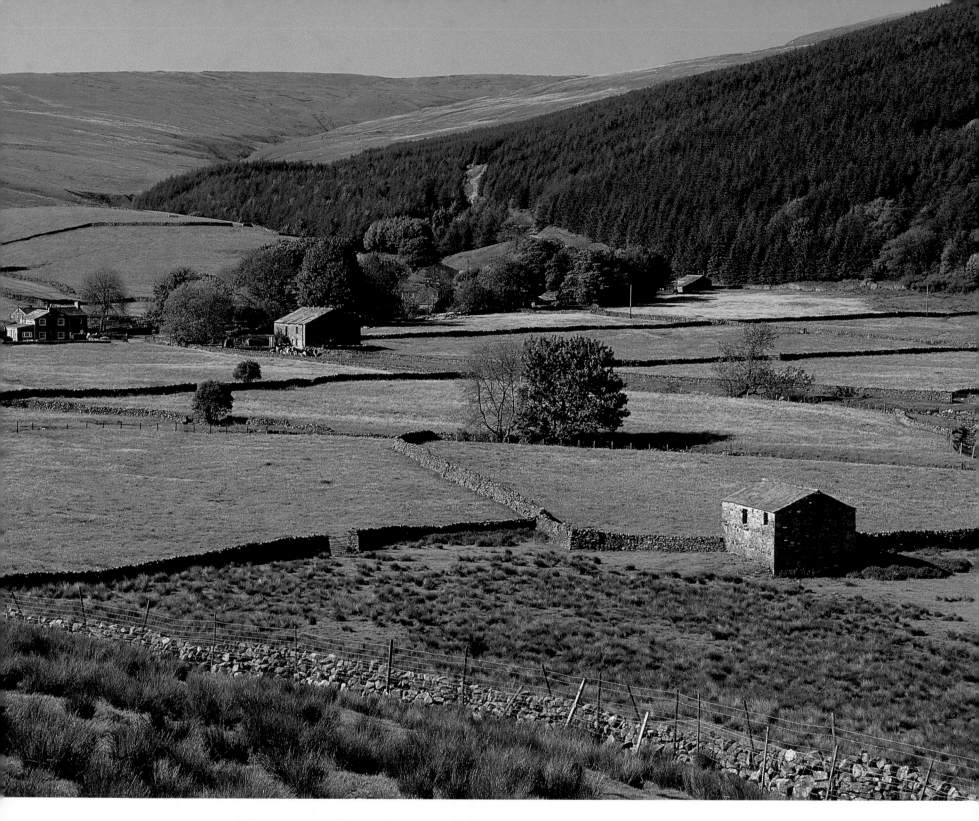

Hanging valley of Cotterdale

The moraine land left by the ice age means you actually climb up out of the main dale before entering the valley. Beyond the moraine is a small flood plain of good bottom land that supports the small farming community of the dale. Hidden away from casual view it remains a small, but very real, cameo of life in the dales.

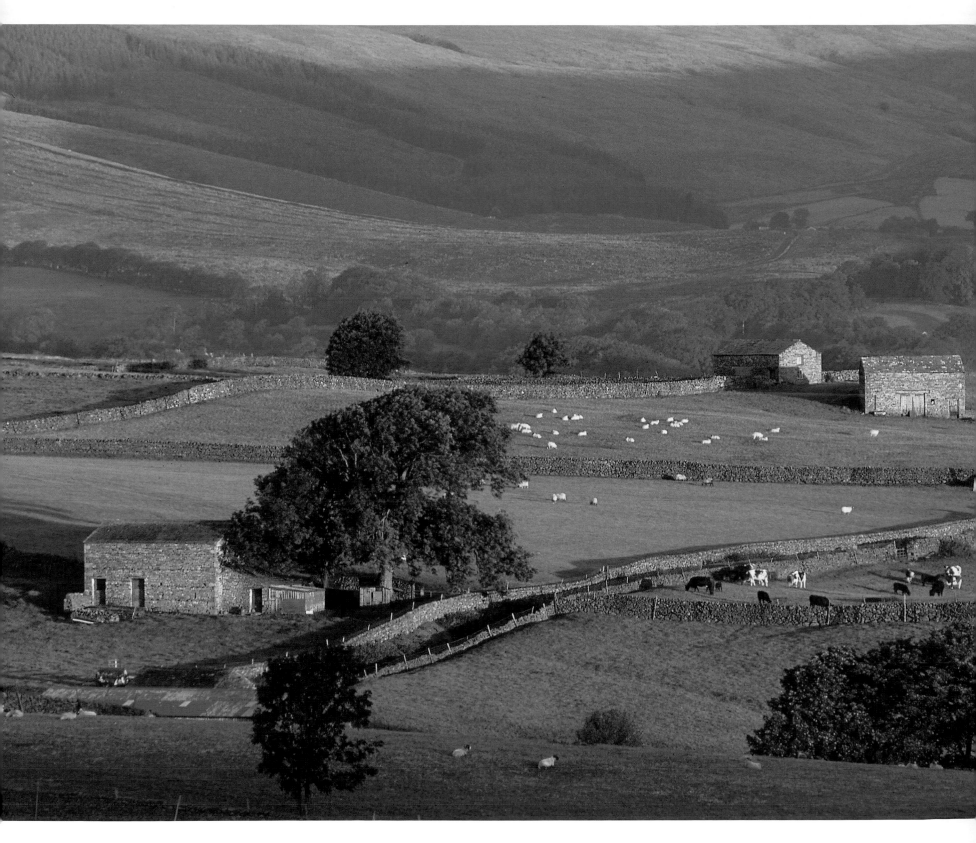

View across the dale from Widdale

This view from Widdale looking out towards the main dale is typical of the dales at their best. The scene, catching the first light of day, is randomly made up of winding roads and fields filled with cattle and sheep, all bordered by drystone walls and set against the backdrop of the high fells. The warm light of sunrise makes the rich colour of the dales' barns stand out prominently. An archetypical Wensleydale scene!

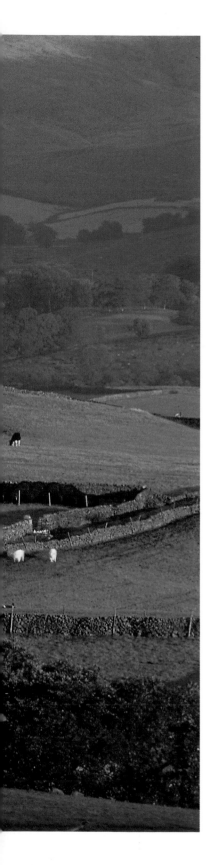

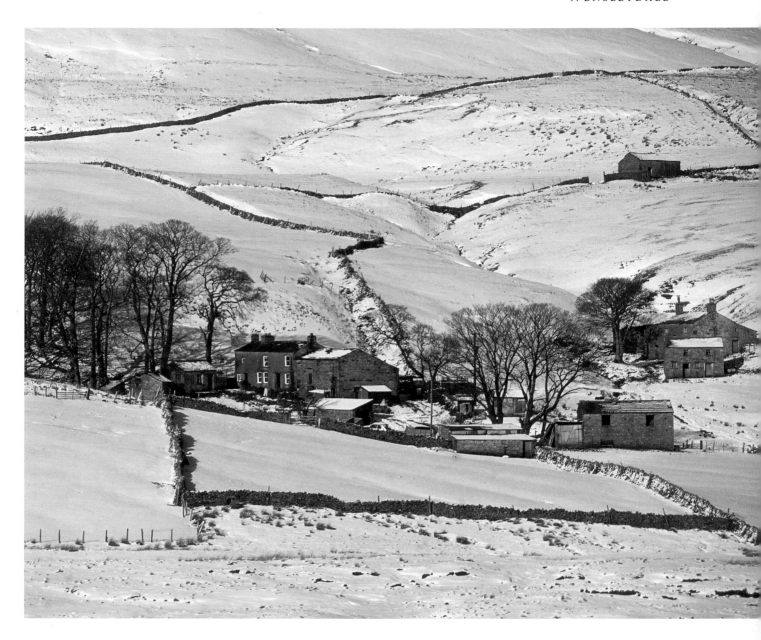

Isolated farm in Widdale

This shot of Widdale, which lies almost opposite Cotterdale and carries the old turnpike road from Hawes over to Ingleton, reminds us that the high dales can be a bleak place to make a living, especially in winter. The little farmstead of Swinely House, with a winter covering of fresh snow, speaks volumes about the isolated nature of hill farming in the high dales.

Chapter 3
Wharfedale

Wharfedale starts in the high fells and flows eastwards, as if to run parallel to and south of Wensleydale. However, the glacier that formed the dale came up against the huge mass of the fells of Buckden Pike and Great Whernside. This forced it to make a right turn and flow southwards so that Wharfedale now emerges to the south of the national park. Like Swaledale it is a narrow dale and has an intimate quality with the fells close by at all times. Wharfedale's landscape has been greatly affected by the Craven Fault, which thrust huge sections of great slab limestone to the surface and this is at its most spectacular at Kilnsey Crag. The wild flowers that abound in Wharfedale are one of the most abiding memories and sources of pleasure visitors will get from the dale. Those, together with its limestone fells and pavements, are the great attraction for the visitor. And, of course, like elsewhere in the dales, there are always waterfalls, often tucked way up little gills and valleys.

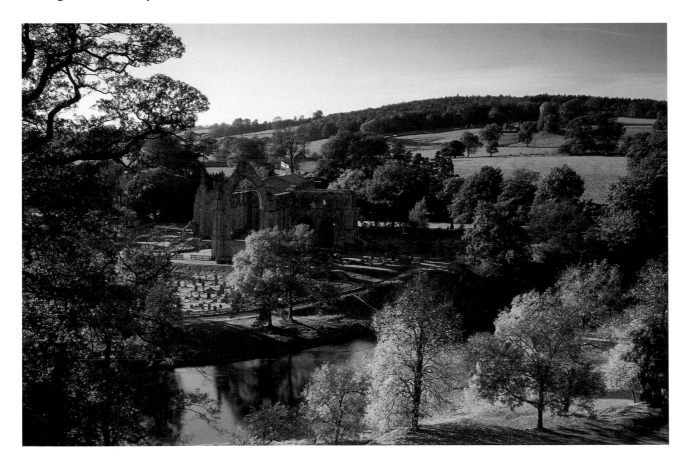

Bolton Priory in autumn light

We start our journey at Bolton Abbey – or Bolton Priory as it is more properly known. Viewed from the shelf of wooded hillside over the river, the autumn colours of the trees add a touch of magic to an already beautiful landscape. Located on a bend in the river the old abbey buildings occupy a prime position beside the River Wharfe. The abbey and its grounds, which extend for 30,000 acres across both sides of the dale, are owned and maintained by the Duke of Devonshire.

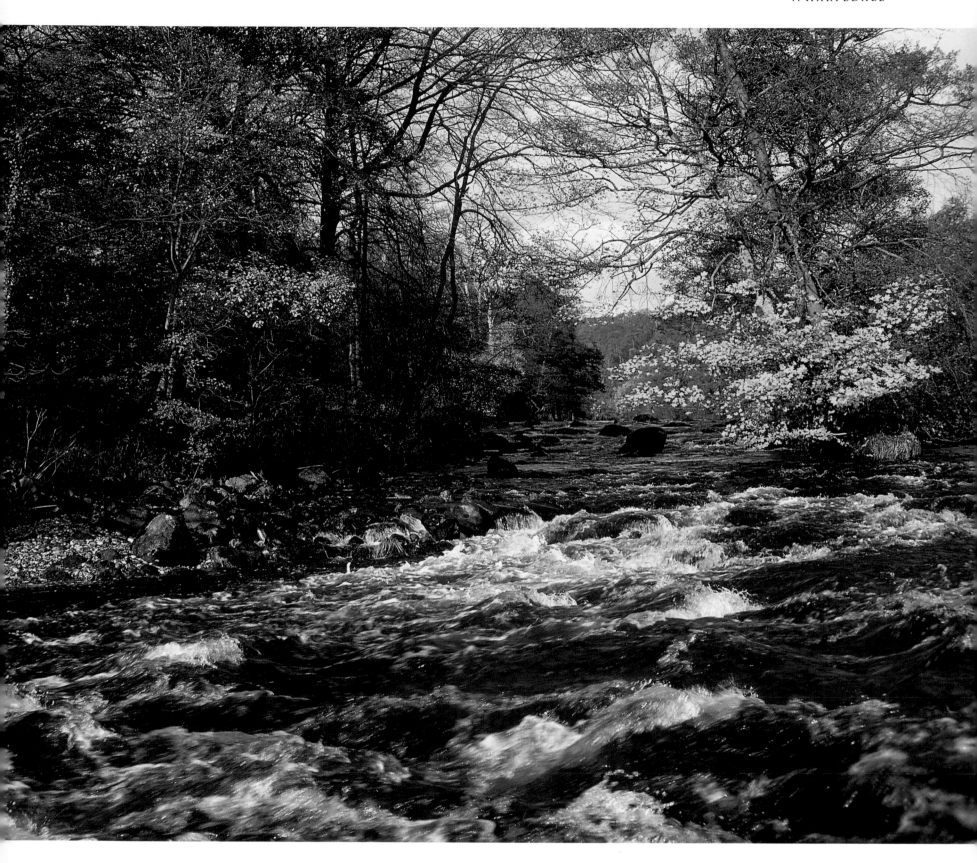

River Wharfe and Strid Wood

As you make your way up river, you will find yourself approaching the wooded gorge that is known as Strid Wood.
In this picture the river is emerging from the gorge, with the trees all around at their very best in autumn colour.
The rapid-like waters of the Wharfe tumble in a mix of white and deep blue as they pass over the rock-strewn river bed.

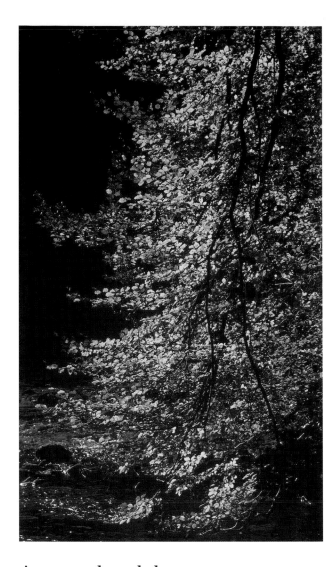

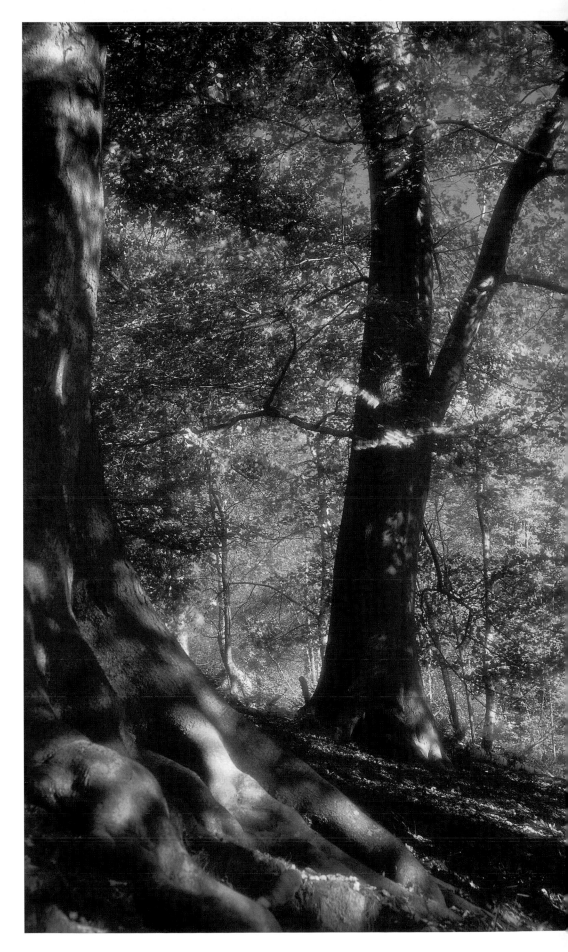

Autumn beech leaves

There is something about a beech tree in its autumn
colours that is very special. Seen here with the light
streaming down through the leaves from above the
gorge, the colours of the leaves are breathtaking.
The dark backdrop of the gorge behind brings out
the colours of the leaves even more.

Autumn tints in Strid Wood

I photographed this view one September day, as the
colours were beginning to change and as I wandered
in the woods overlooking the Strid Gorge. The
dappled light as it came down through the branches
and leaves, some changing colour and some still
green, captured the mood of the season as summer
was drawing to a close.

The Strid

Deep in the gorge is the feature that gives this area its name. The Strid – or stride – is little more than a crack in the rock bed of the gorge through which all the waters of the River Wharfe have to squeeze. It is a place where nature has produced dramatic beauty. But it is also a place that can lead the unwary to tragedy – the sides of the gorge are slippery and the force of the water while exhilarating is unforgiving.

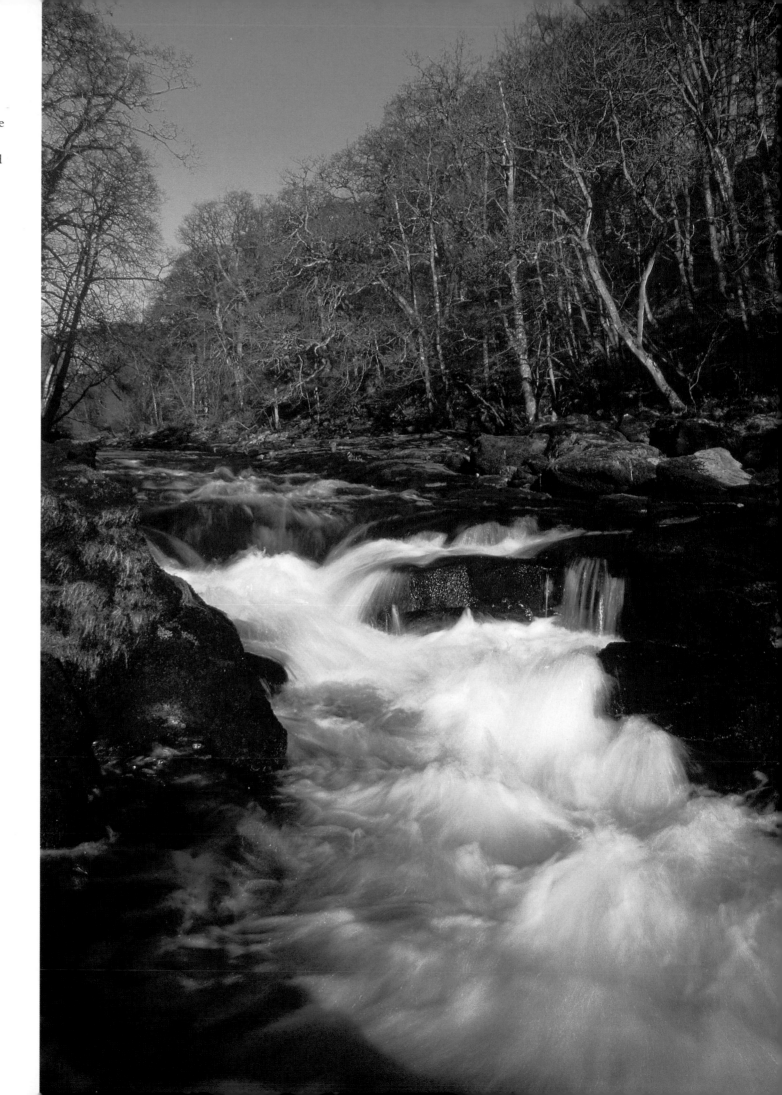

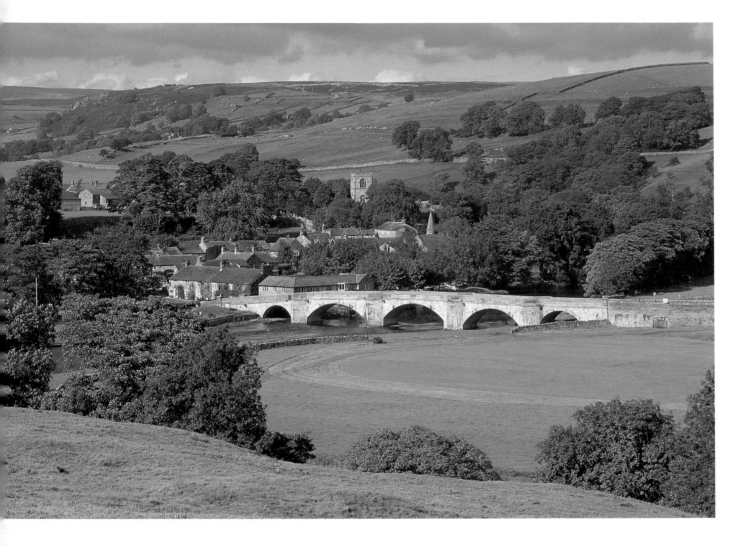

Burnsall village

The well-loved village of Burnsall with its five-arched bridge is situated a few miles upstream of the Strid. In the middle of the dale, it is almost at a crossroads between the gritstone that lies downstream and the limestone country above.

Cupola smelting works

The tributary valley of Hebden Gill winds away from the main valley and up into the hills behind Grasssington. The industrial past comes to life here in the form of the Cupola Smelting Works. A network of tunnels leads across the moors to chimneys like this one which has been carefully preserved. The idea was to let the gasses from the smelting process pass up the tunnels to cool and deposit the lead in them on the tunnel walls. Children were then sent along the tunnels to recover the precious metal.

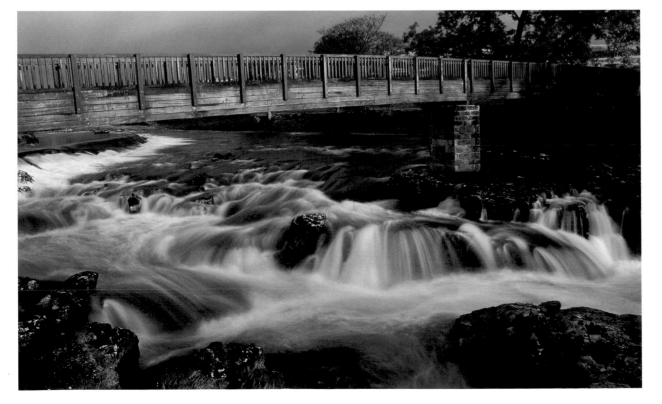

Linton Falls

The first real sign of limestone in the dale is where the river tumbles over Linton Falls just below Grassington. The footbridge brings visitors to the falls from the national park information centre and car park on the outskirts of Grassington. Upstream, and still in view, is the old weir built to help service the nearby mills.

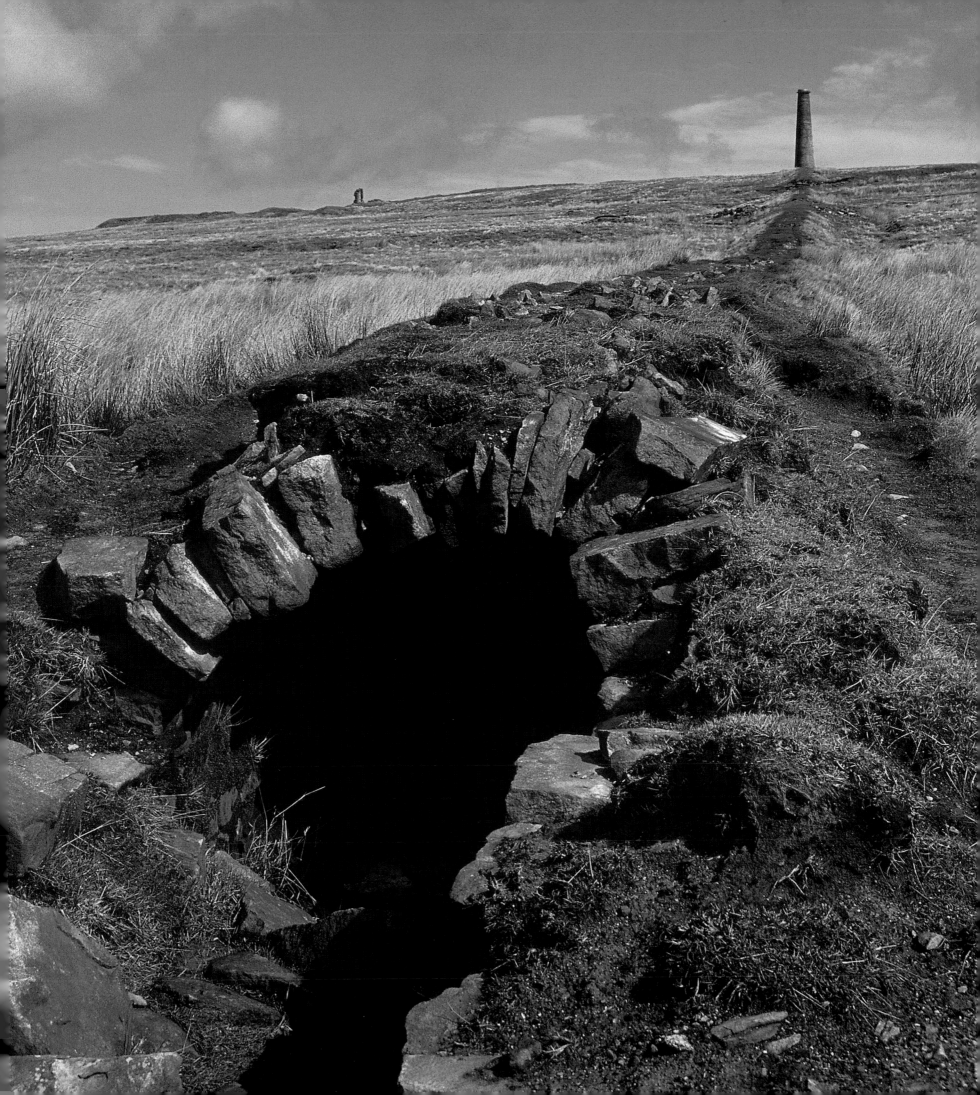

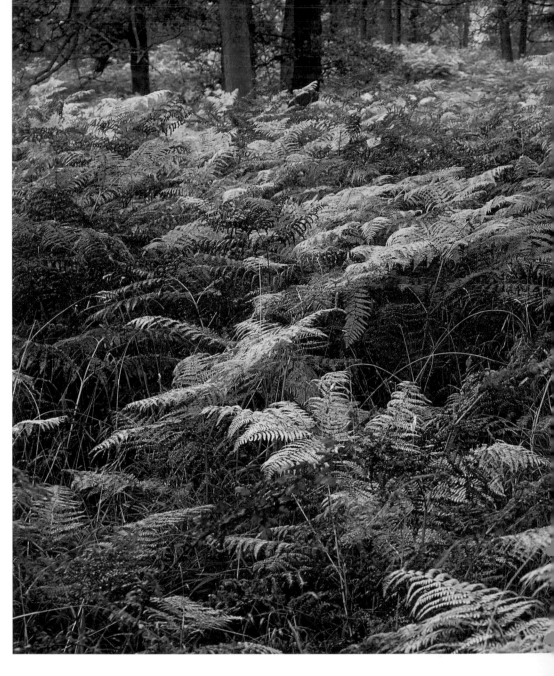

Autumn in Grass Wood

Grass Wood is one of the oldest woodlands in the dales. Laid out over thousands of years, it spreads from the river up the slopes of a huge cliff of slab limestone that was thrust through the surface of the earth by the Craven Fault. It is now a protected site. Many of the conifers stand surrounded by bracken – in this case it has turned into the rich golden colours of autumn. Conifers were planted during the Second World War and they are now being cleared to allow natural woodland to develop.

Primrose *(Primula vulgaris)* below

It is the spring and summer flowers that give Grass Wood its real beauty. In the spring primroses especially grow in abundance while in the autumn there is a wide variety of fungi.

Violet (*Viola cornuta*) below

The primroses of Grass Wood are invariably accompanied by wild violets. Like so many flowers we really don't notice them – and rarely look at them in detail. The beauty of nature is in the detail of the flower which can only really be seen in a close-up such as this photograph, taken with a macro lens.

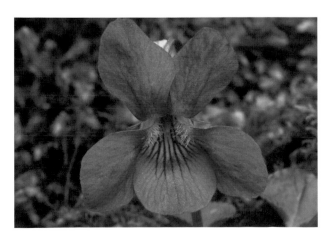

Common puffball *(Lycoperdon perlatum)*

With the end of summer, the flowers may have gone but the fungi soon begin to appear. The undisturbed woodland encourages their growth and this photograph of a group of common puffballs is typical of what can be found on the slopes of Grass Wood. One expert in fungi has claimed to have found over 40 different specimens of fungi in these woods on the same day. Here are a few I've discovered.

Yellow staghorn

(Calocera viscosa)
Growing out of some moss-covered old dead wood near Fort Gregory (the old fortress that was on the top of the cliff) I found these little yellow staghorns. Their colour is almost incandescent in the dim light under the woodland cover.

Aniseed toadstool

(Clitocybe odora) below I was near the top of the cliff one day, wandering through the scrub, when I found a fairy circle about 25ft (8m) in diameter of aniseed toadstools. This little group was the only one that I could get close to, either because of scrub blocking my path or because I was keen to avoid damage to some other habitat. I was particularly taken with the soft greenish-blue colour on top and the perfect gill formations underneath.

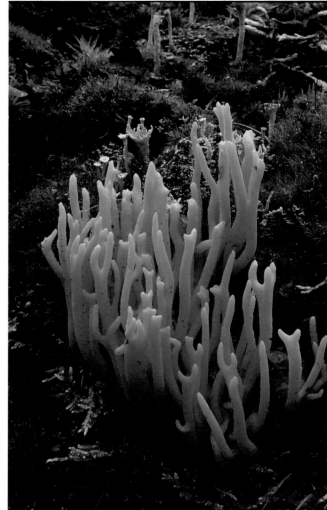

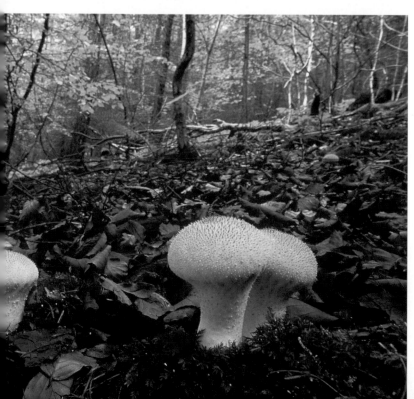

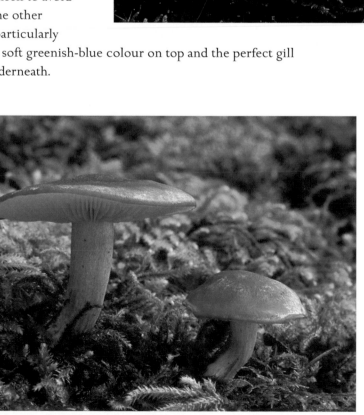

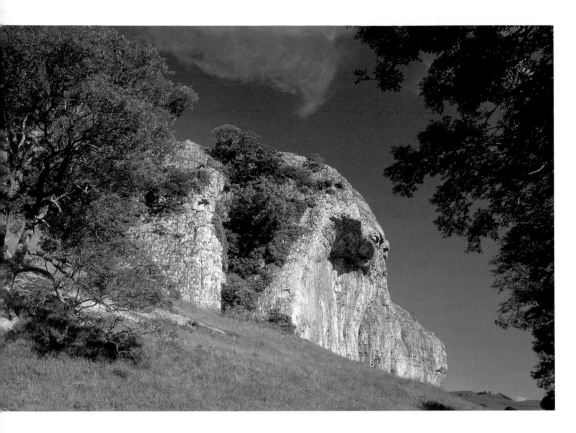

Kilnsey Crag

Kilnsey Crag is perhaps the most famous feature of Wharfedale – a sheer wall of limestone rising out of the ground at the junction where Upper Wharfedale and Littondale merge into one. The crag is certainly one of the more dramatic manifestations of the Craven Fault. Photographed here in the light of a July morning against a nearly perfect blue sky the massive overhang, that is such a challenge to rock climbers, is clearly visible.

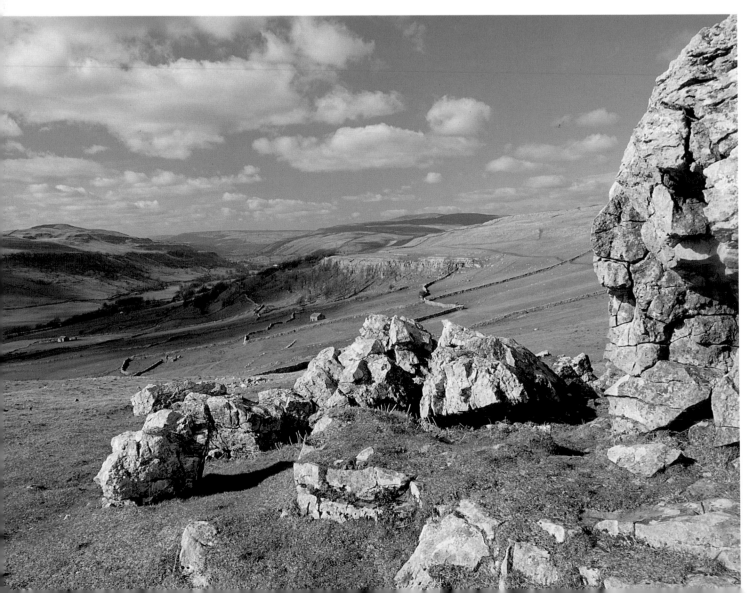

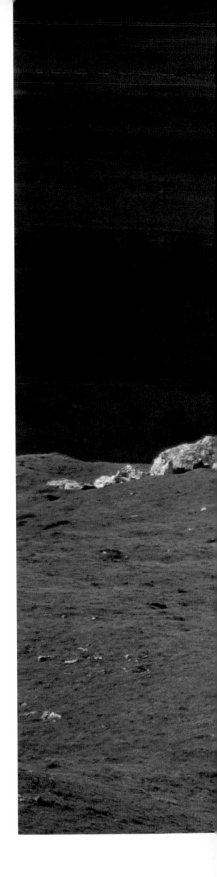

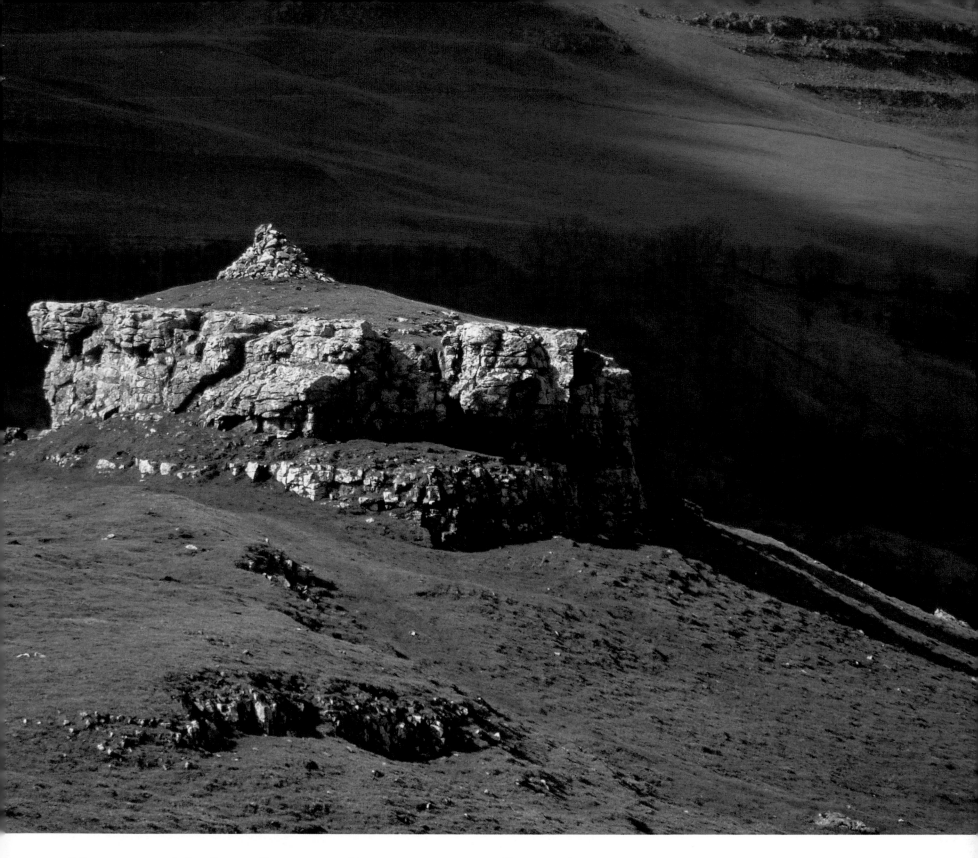

The upper dale from Conistone Pie

Across the dale from Kilnsey is one of the places that I love best in the dales. Under the lea of Conistone Pie is a glorious picnic spot, located close to the Dales Way, from which there is a wonderful view of Upper Wharfedale. Old Cote Moor, on the left, gives way to Upper Wharfedale itself and, on the right, the mass of Buckden Pike rises above the eastern side of the dale.

Conistone Pie

Conistone Pie is a picturesque feature, an isolated circular plinth of limestone which stands like a sentinel overlooking Wharfedale. The cairn on the top helps to enhance the name by which it is popularly known. That this solitary piece of limestone got left behind by the power of the glacier is almost unbelievable. Thankfully, like many other unusual features of the limestone dales, it is there for us to enjoy.

Limestone crags rising above the Dales Way

Walkers along the Dales Way – the long-distance route from Ilkley to Bowness in the Lakes – can enjoy an excellent view of Conistone Pie and the limestone crags above them. As this photograph shows, the unusual shapes of the crags mark them out as distinctive features well worth a second look.

Bird's eye primrose

(Primula farinosa)

The leached limestone soil of these fells supports a rich variety of flora but two plants in particular stand out – the bird's eye primrose and the mountain pansy. The bird's eye primrose, seen here, is relatively rare – in England it can only be found in the dales of Yorkshire, Durham and east Cumbria. Walk these slopes in May or early June and you will be sure to find them dotted in little groups about the fellside.

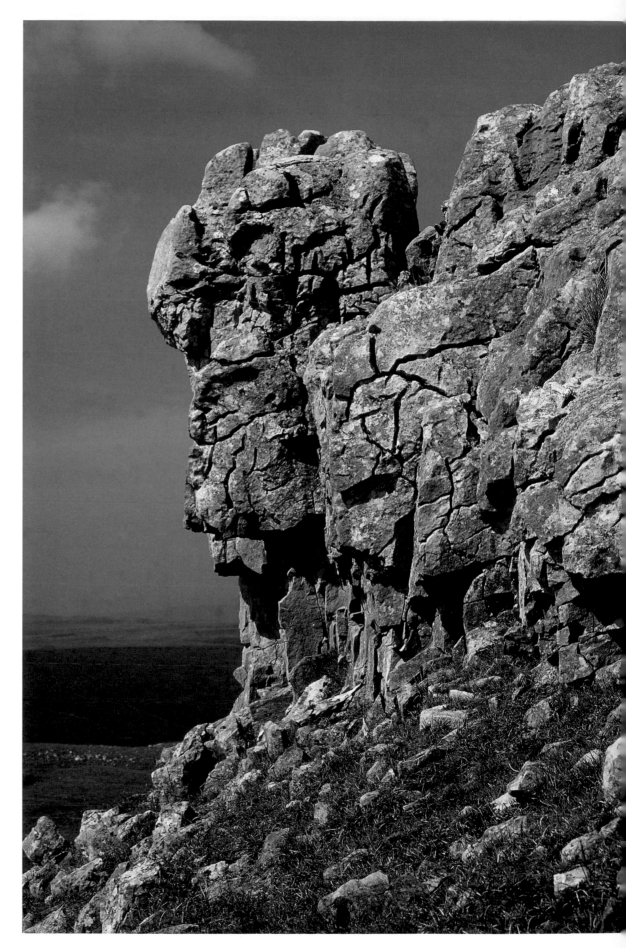

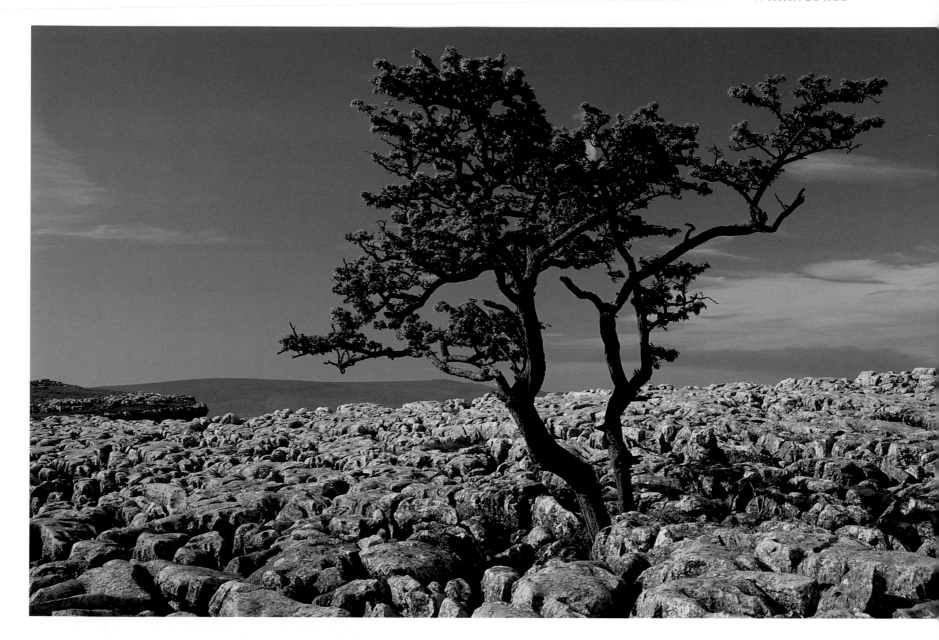

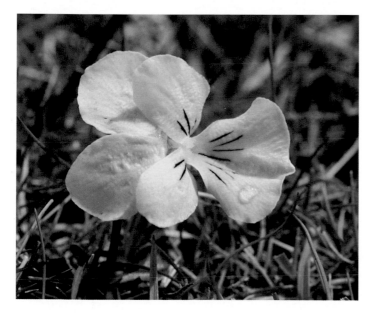

Conistone limestone pavement

Make the effort to climb the crag above the Dales Way and you will discover this wonderful limestone pavement laid out before you with the occasional isolated tree dotted around. Limestone pavements were created during the Ice Age, when glaciers scraped the earth from the underlying limestone. Over the millennia, since the glaciers receded, the chemicals in snow and rainwater have worked away at the limestone to produce the wonderful pattern of "grikes" – gaps or fissures – in the surface of the pavement.

Mountain pansy *(Viola lutea)*

Mountain pansies can be found in many upland parts of Britain, their colours of purple and yellow tending to vary depending on the exact location. However, I have never seen this pure yellow variety anywhere else but in the dales and especially Wharfedale, where they seem to thrive.

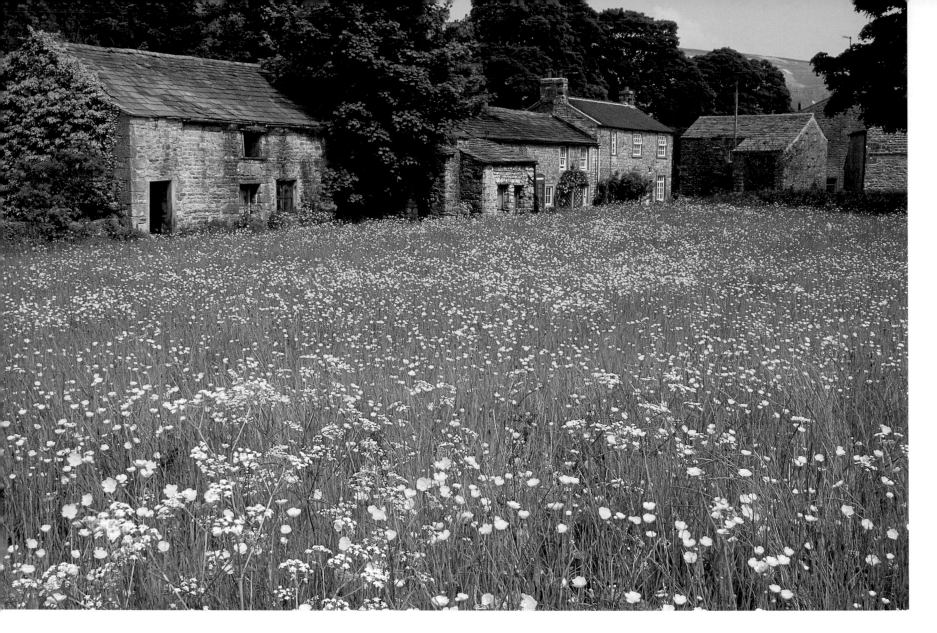

Arncliffe village green

Arncliffe, the main village of Littondale, is a typical
stone-built village with a traditional village green
surrounded by unspoiled cottages and barns. The grass
on the green is not mown down and manicured as in so
many other places but allowed to grow and show off the
wonderful carpet of spring flowers seen here.

Littondale from Arncliffe Cote

Littondale reaches into the high fells of the dales and the
River Skirfare flows down it eventually joining the River
Wharfe between Conistone Pie and Kilnsey Crag. The
dale has its own distinct style of small villages separated
by the usual patchwork quilt of fields bounded by
drystone walls and scattered with field barns. Seen here
from the side of Arncliffe Cote, on the old monk's road,
the dale stretches out before you with the limestone
crags and heather of Old Cote Moor.

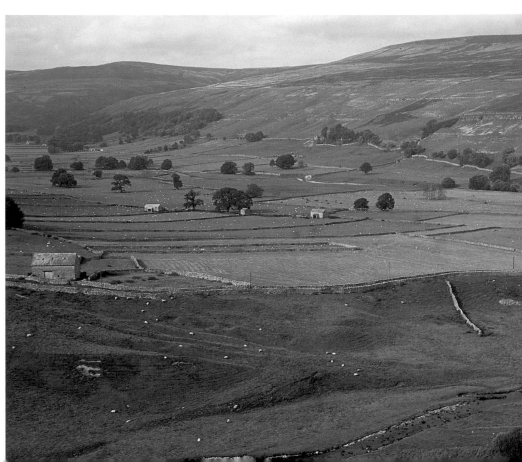

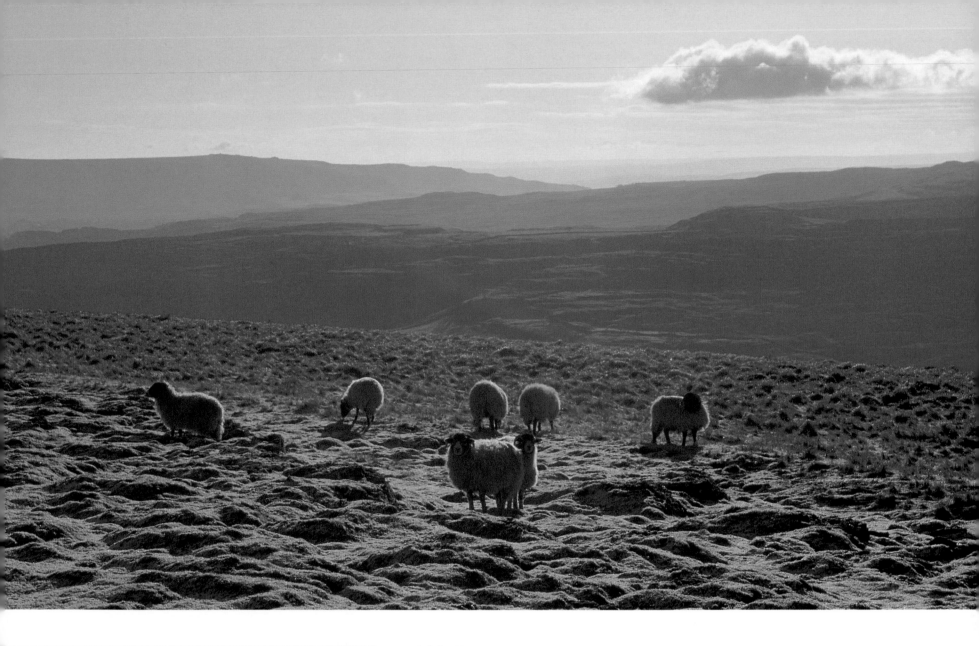

Old Cote Moor in winter

As elsewhere in the dales, winter is in sharp contrast to the rest of the seasons. Here, high on Old Cote Moor overlooking Littondale, the sheep struggle to find fodder in the frozen landscape and so the farmers will supply them with winter feed.

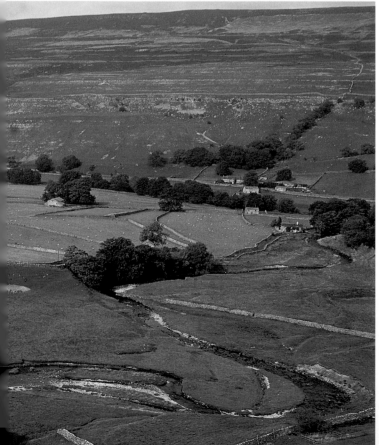

81

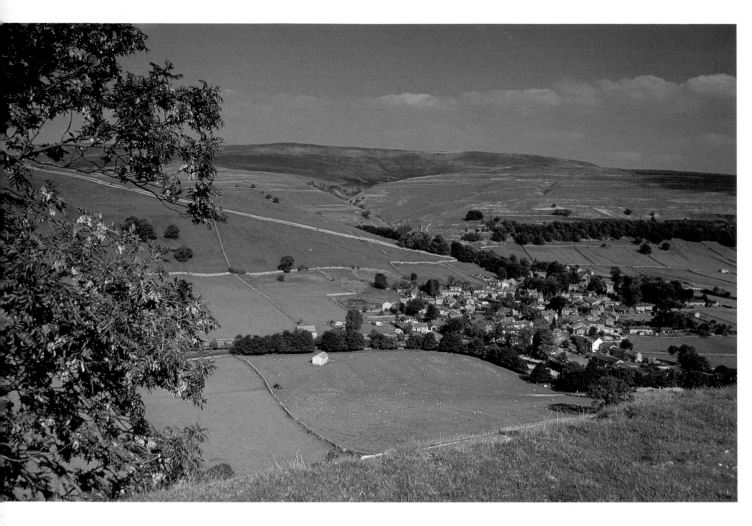

Kettlewell from Goat Scar Crag

Kettlewell sits at the foot of Great Whernside, the highest fell around Wharfedale (not to be confused with the Whernside of the Three Peaks). Seen here from Goat Scar Crag you can understand perfectly why the village was located in this spot. The gill that has its origins high on the flanks of Whernside would have provided (and still does) a natural supply of fresh water. Additionally, the lead deposits found in this and other surrounding gills provided work for local residents.

Spring sandwort

(Minuartia verna)

Wander up Dowber Gill behind Kettlewell and you will find colonies of spring sandwort among the many flowers. This plant is also known as leadwort because it is the one plant that thrives on land with lead in it. No doubt in times past the existence of leadwort was considered a sign of where to prospect for this precious metal.

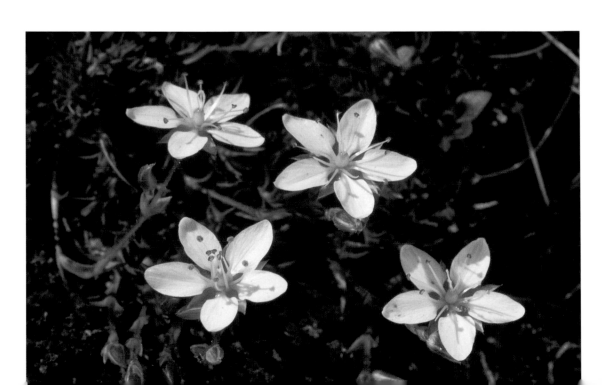

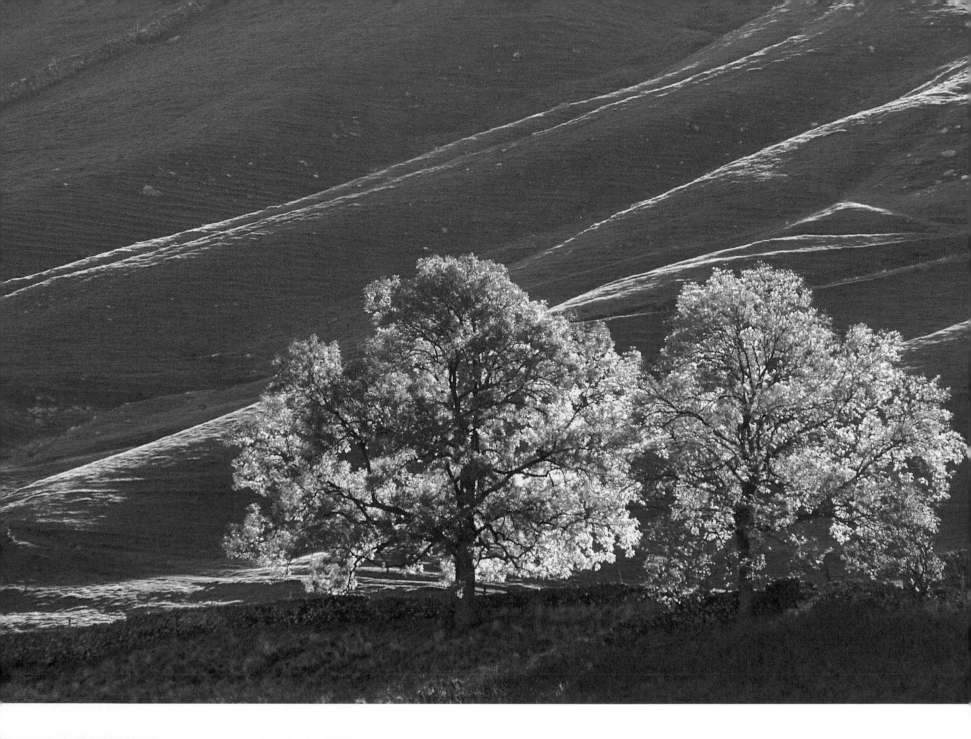

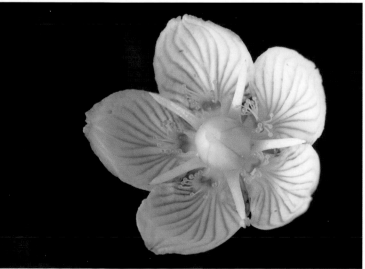

Afternoon light in the valley

This pair of trees located on the fells above Kettlewell has been caught in the afternoon light just before the sun dips below the fell tops. The trees appear to be floodlit from below, almost as if they were in a public park. In truth the effect is caused by the rays of the sun streaming down the fells highlighting the ridges in the land and lighting up the trees from behind.

Grass of Parnassus *(Parnassia palustris)*

Coming into flower in August and September, the configuration of this beautiful flower is almost unique. The flower smells faintly of honey and was used in bygone days to treat liver complaints. It was said that an infusion of its leaves could help with digestion.

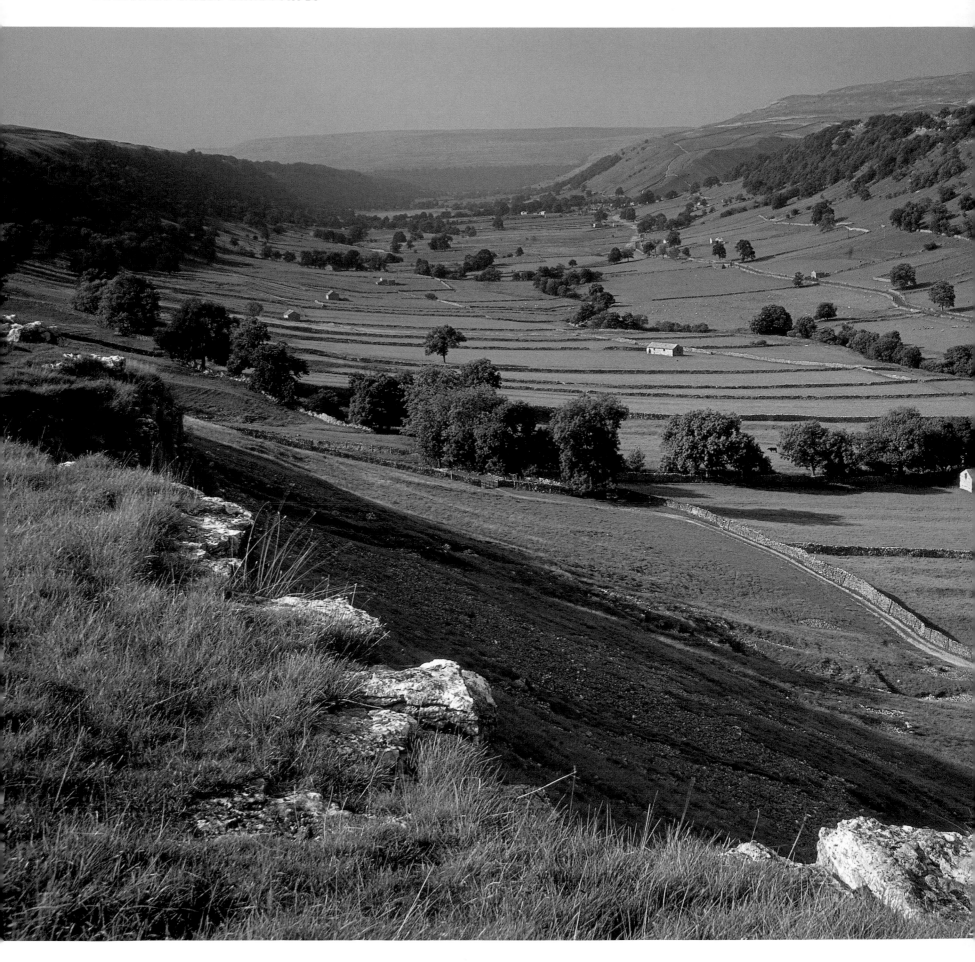

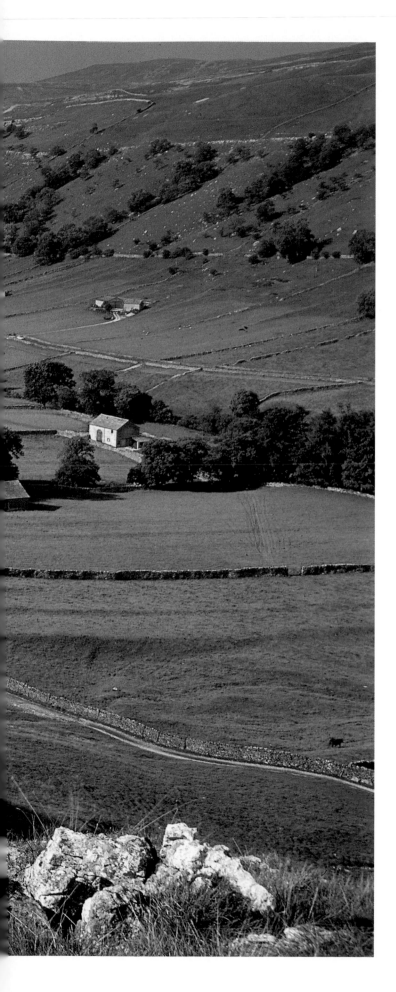

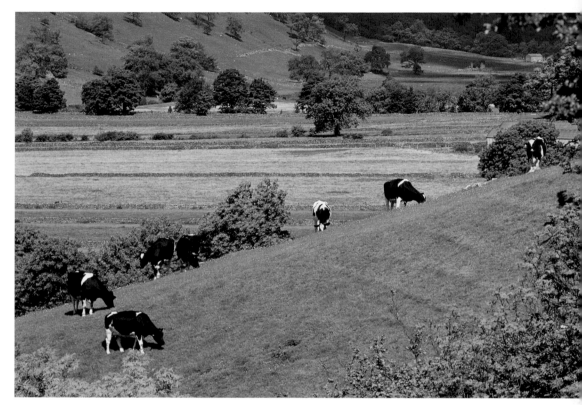

Cattle grazing in meadows

This little cameo tells you a great deal about this part of the dale. The cattle graze peacefully on the lower slopes of the fells, while the meadows of the fertile bottom land are used to grow fodder for winter feed. The harmony created by those golden meadows makes for a scene of rural tranquillity.

Towards Starbotton from Goat Scar Crag

The view from Goat Scar Crag is not confined to Kettlewell alone. To the left a panorama of the upper dale opens up before taking you all the way up to Buckden and beyond to Langstrothdale Chase. From this perspective, the whole of the glacial valley is laid out before you. Field barns, originally built to store fodder and give shelter to livestock, are dotted across the valley bottom with fields bounded by drystone walls.

Buckden Gill

Buckden Gill lies behind the
village of Buckden and
reaches deep into the side of
Buckden Pike. The limestone
of the Yoredale Series is laid
bare as the waters of Buckden
Gill pass over a whole series
of waterfalls created by these
great limestone steps. The
water cascades down among a
wonderful jumble of trees,
limestone crags and soft shale.
The contrast between the
limestone crags and the
fragility of the shale is
apparent here.

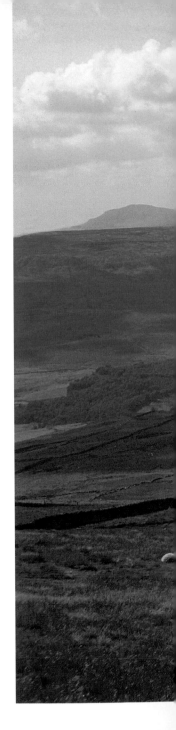

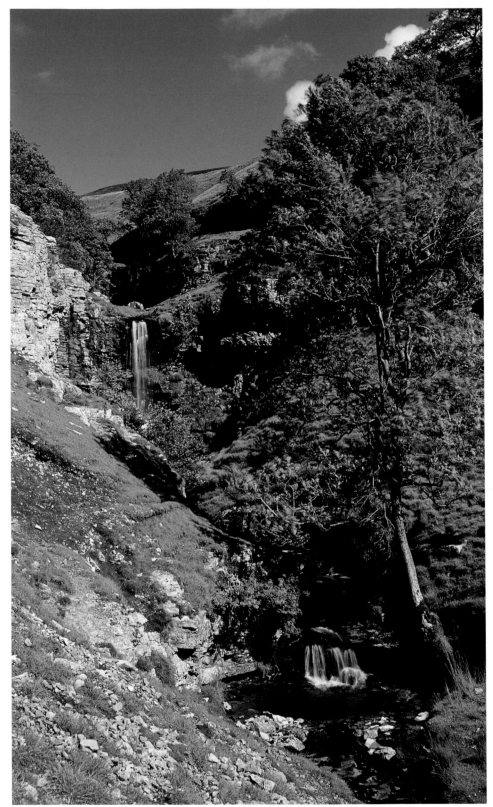

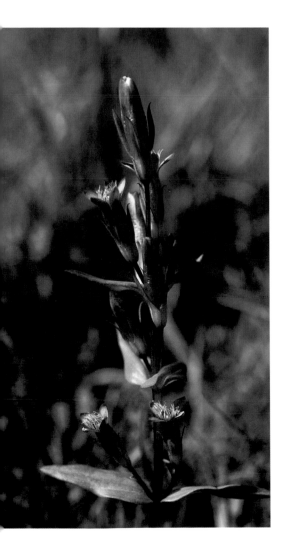

Autumn gentian *(Gentiana amarella)*
Visit in August or September and as you walk up the gill you may well find
examples of the lovely autumn gentian. Growing in sizeable colonies, this gem
pokes it way through the fellside grass to display its little purple flowers.

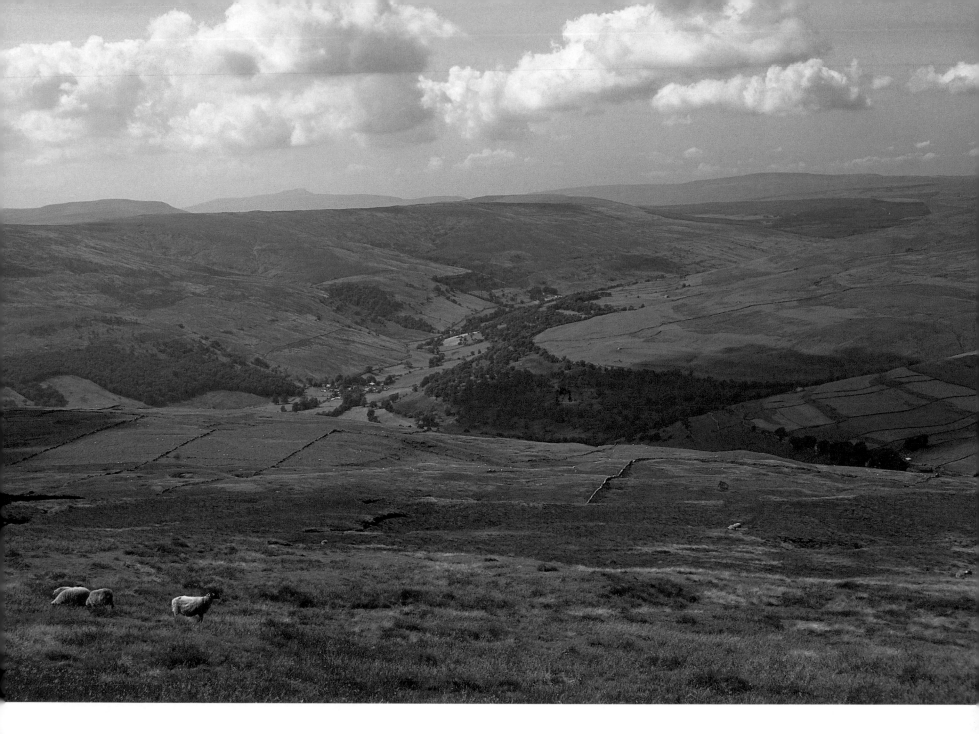

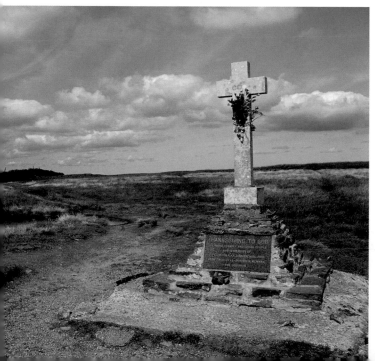

Three Peaks from Buckden Pike

Once on the summit of Buckden Pike the views are spectacular. On a clear day you can see the fells of the Lake District. This photograph is however a little special because as you look out over Langstrothdale the skyline is composed of each of the Three Peaks of the Yorkshire Dales. From left to right you have Pen-y-ghent, followed closely by Ingleborough and then further over the highest of the three, the great whale-shaped mass of Whernside.

The Polish war memorial

Near to the summit sits a memorial to the Polish crew of a Second World War RAF bomber that crashed here. One crew member survived by following some fox tracks down off the fell. He returned after the war and built this memorial to his colleagues, fashioning the fox's head at its foot from the brass fittings of the aircraft. The jet trails overhead seemed to me a poignant salute to those brave men.

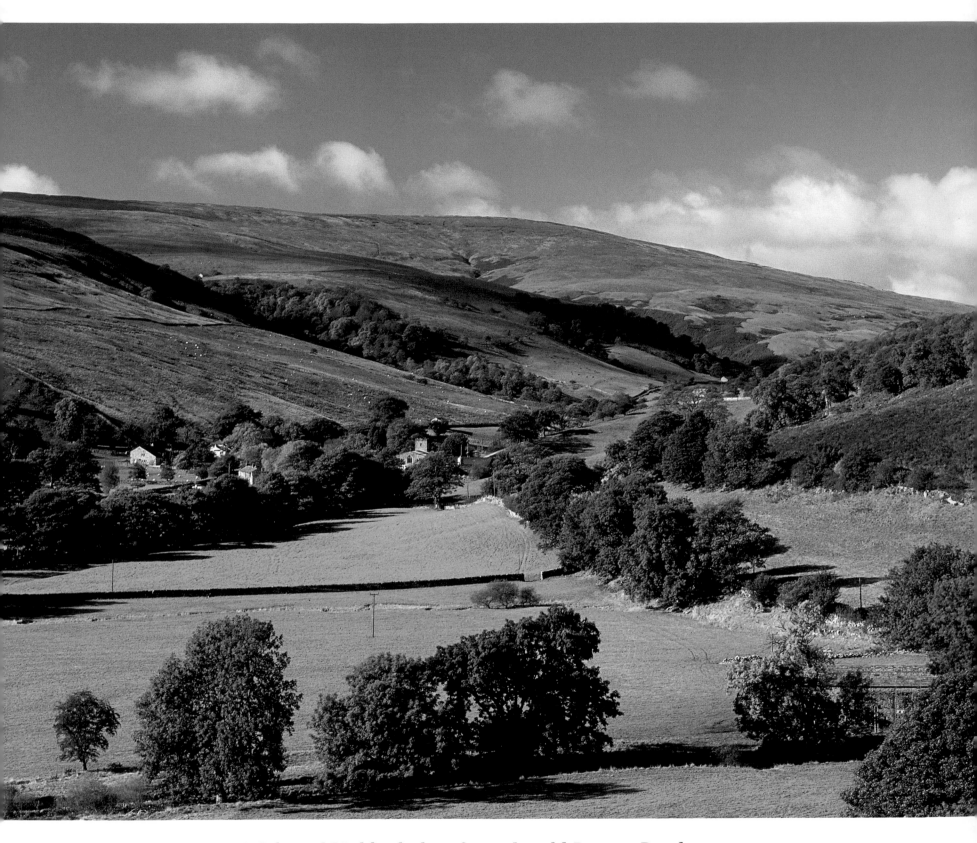

Langstrothdale and Hubberholme from the old Roman Road

The old Roman road linking the settlements of Ilkley and Bainbridge climbs north out of Wharfedale from Buckden village. Seen from the Roman road above Buckden, in the early autumn sunshine, one can clearly see the parish church of Hubberholme nestling among the trees at the foot of Langstrothdale Chase. The chase and its principal village of Buckden both got their names during the period after the Norman invasion of Britain when this part of the dale was a deer-hunting estate. Nowadays, the chase and the village are a centre for tourism in the dale.

Rock rose

(Helianthemum ovatum)
Walk the lower fells around
Buckden and Hubberholme
in spring or summer and you
will be sure to find many
different flowers. Here, in the
grikes of a limestone
pavement overlooking the
dale, is a group of wild rock
roses, a lovely little yellow
flower that thrives in the dale,
sometimes growing in great
swathes across the fells.

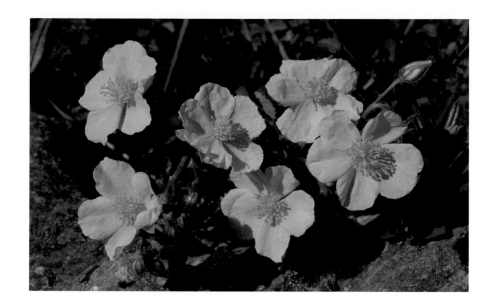

Eye bright *(Euphrasia officinalis)*

Look down at your feet as you walk along and you may well spot what at first seems like drifts of a very
insignificant little white flower. Inspect the individual flowers more closely and you are likely to recognise the
colourful little eye bright, barely the size of a small fingernail. The eye bright is another flower that in centuries
past had medicinal uses; as its name suggests, it was thought to help cure a number of eye ailments.

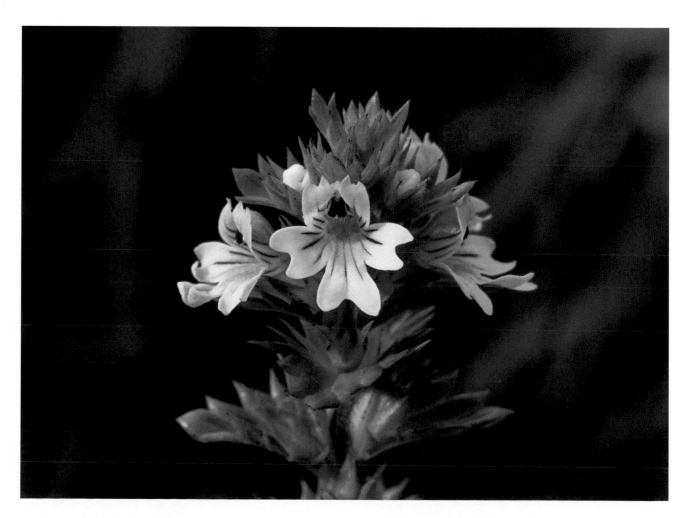

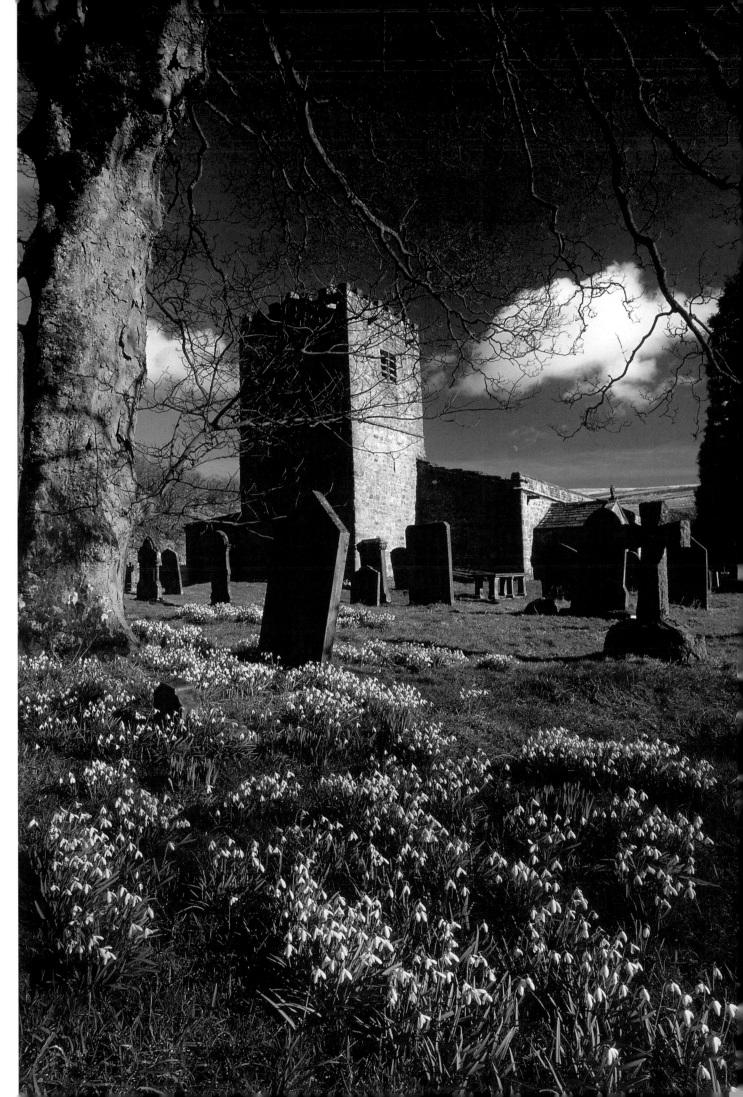

Hubberholme church

The little church at
Hubberholme has to be
high on any list of places
to visit in Wharfedale.
This early English place
of worship is seen here in
late winter with its
graveyard a carpet of
snowdrops. Wander
inside to appreciate the
original architecture and
one of the few minstrel's
roods that remain in an
English church. In
complete contrast, but
blending in with the
building, are the modern
oak pews each with a
little carved mouse on
them depicting their
maker: the famous
furniture-maker,
"Mousey" Thompson of
Kilburn.

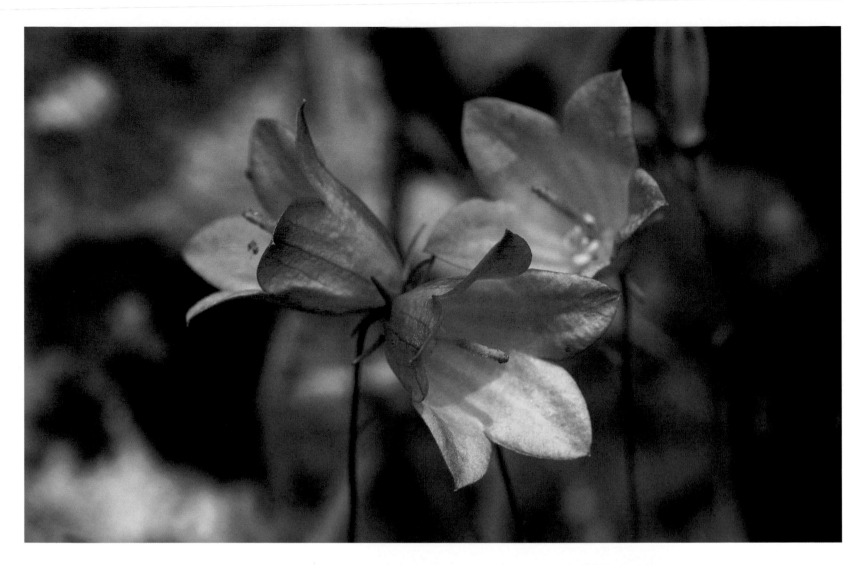

Harebells *(Campanula lasiocarpa)*

The area is home to the little mountain harebell. I found this bunch growing out of a tiny patch of earth among some limestone rocks. The colour of the petals tends to vary with the nature of the soil in which they are growing; in this case they are fairly pale due to the influence of the limestone.

Common spotted orchid *(Dactylorhiza fuchsia)*

The meadows and river bank between Hubberholme and Yockenthwaite are a paradise for anyone interested in flowers. Among the many varieties you may discover are colonies of common spotted orchids, like the specimen shown here. They are usually found along a wide stretch of the river bank in August.

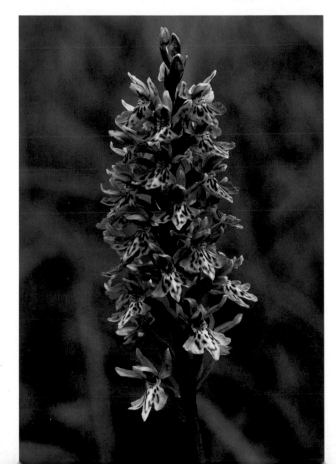

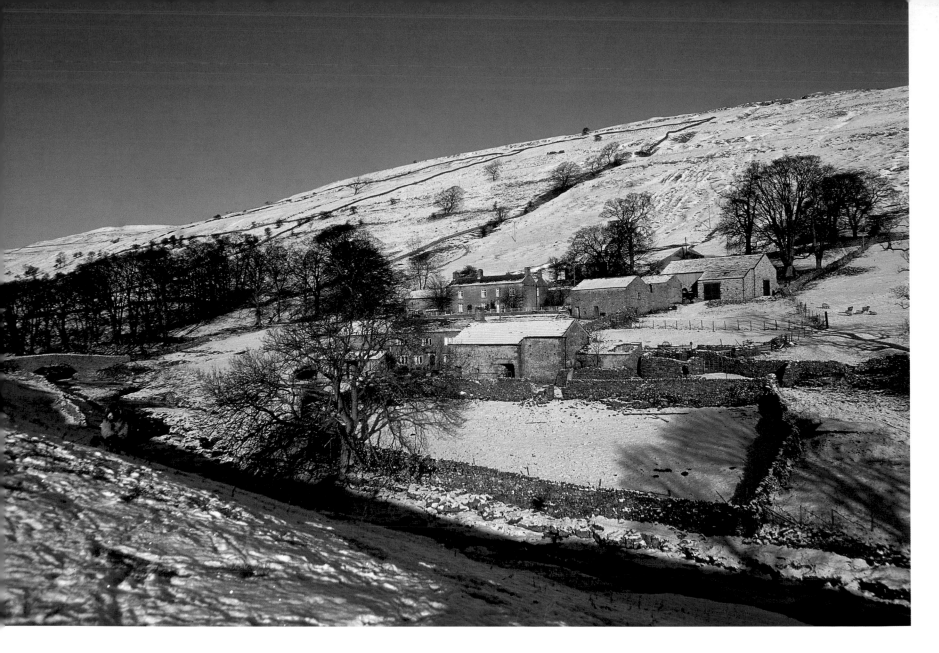

Yockenthwaite

Winter in Upper Wharfedale can be a season of beauty for the visitor but a period of hardship for the farmer or shepherd. The little community of Yockenthwaite, on the Dales Way, is now owned by the National Trust. It was originally settled by the Norse whose route from Scandinavia took them across the north of Scotland and into the Irish Sea before they made their way inland from the west. The little bridge to the left is the only access to the village.

Waterfall near Kidstones Pass

The depth of winter can produce beauty as well as hardship. In this scene of a near frozen waterfall along the flanks of Kidstones Pass near Cray two sparse trees which survive in the limestone rocks are highlighted in the winter sunshine while icicles hang in cascades around and across the falls.

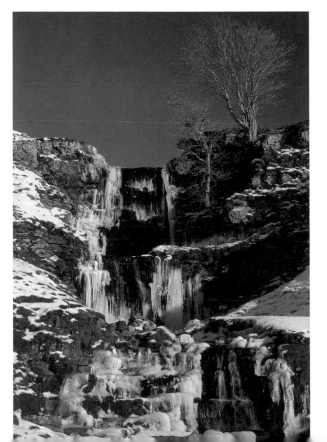

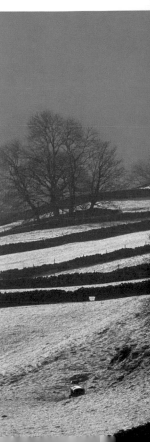

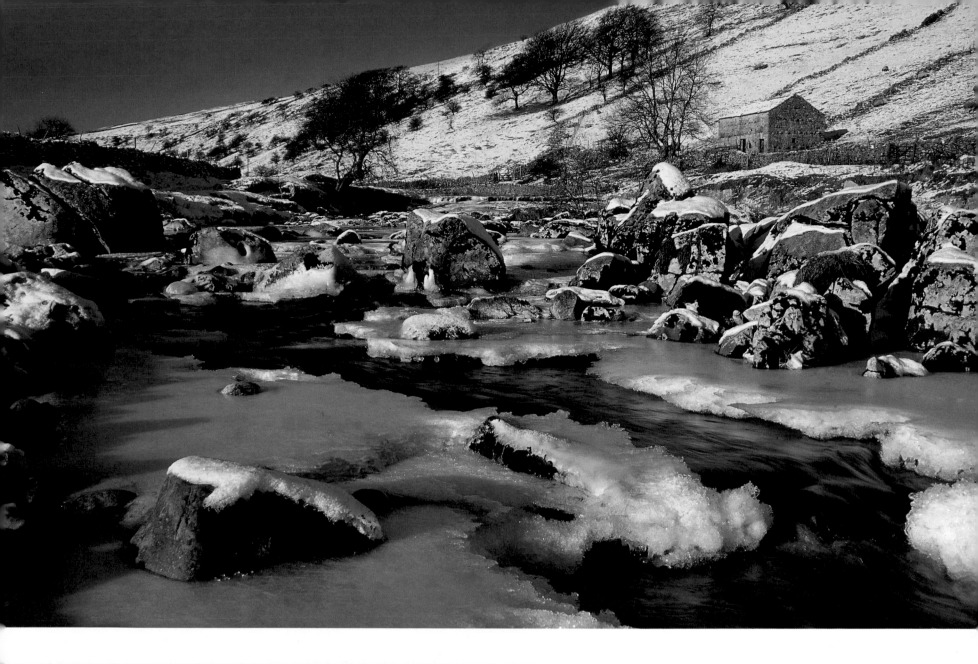

River Wharfe in Langstrothdale

The infant River Wharfe near to Deepdale is nearly frozen over as it forces its way between the snow and ice that has encroached from the river banks.

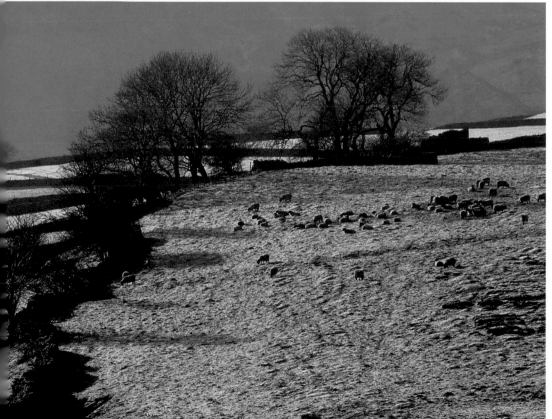

Winter pasture near Cray

You can almost feel the cold in this photograph of a meadow overlooking the main dale near the little hamlet of Cray, north of Buckden on the B6160. In the depths of January the sheep need their thick white coats. The ground is frozen so hard that it cannot provide for their needs. The flock have gathered round one of the feeding troughs which is kept supplied by the farmer during the bitter winter weather.

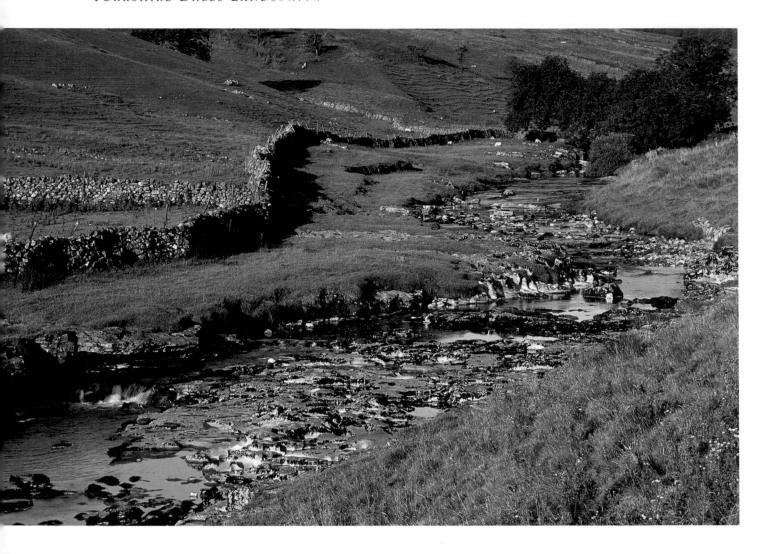

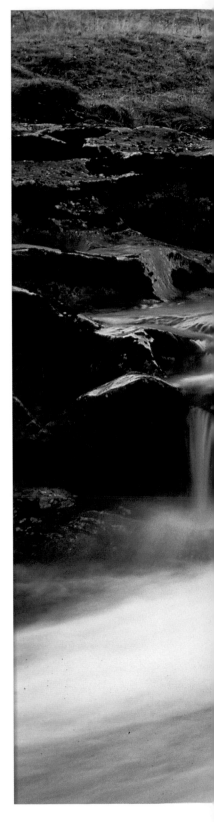

Upper Wharefdale

The River Wharfe in Langstrothdale is barely more than a small stream as it wends its way down the dale over a bed of limestone. The drystone walls on the far side are sufficiently set back to allow the route of the Dales Way to pass along the riverbank itself.

Limestone rock pools

Take time to study the river bed and you will become fascinated by the shapes and patterns that have been created in the limestone over the years. This is like a landscape in miniature, in which the action of the water and loose pebbles or stones has scoured out similarly-shaped little pools from the limestone. Stepped as they are, there is just a suggestion in the mind that one might be looking at something much larger in scale – even magical.

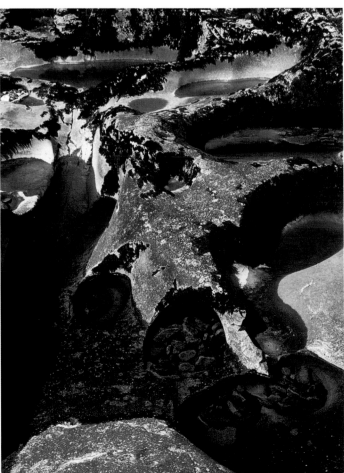

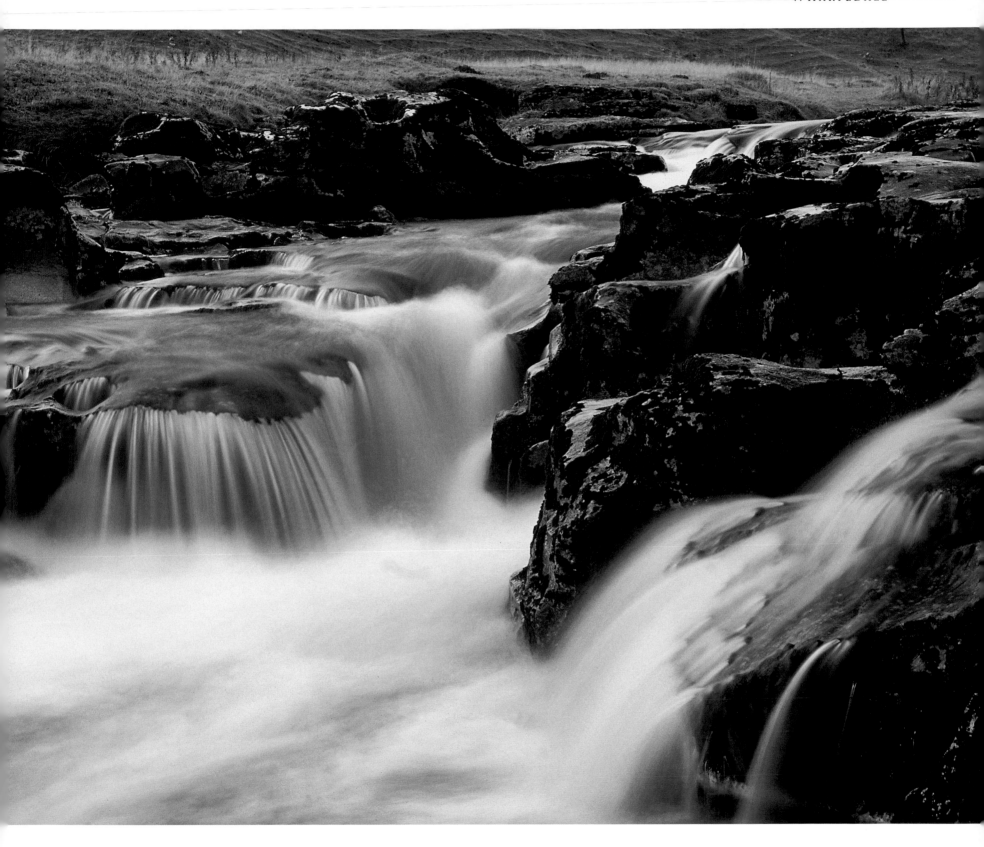

Limestone falls

Every so often as you walk along you will come to places where the limestone has shelved and created small waterfalls. The way in which the water flows over the irregular limestone formations is intriguing. The patterns created by the varying directions that the water takes are both energising and peaceful. I could sit and soak up the atmosphere of this scene for a long time.

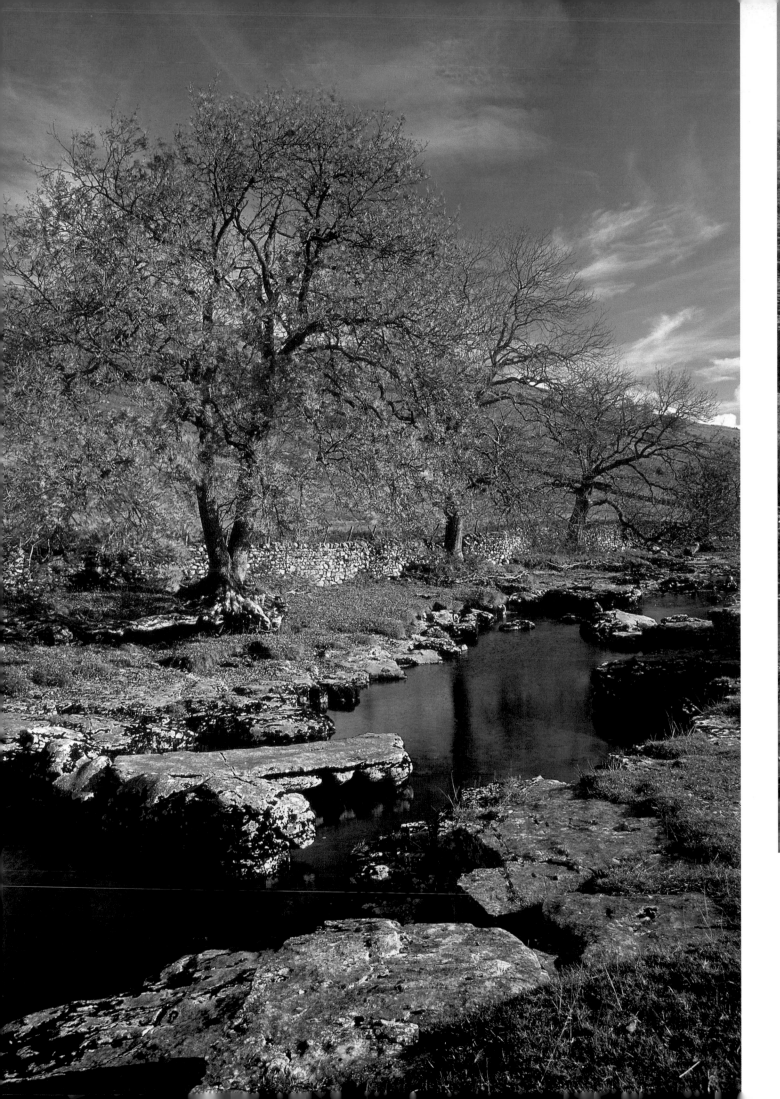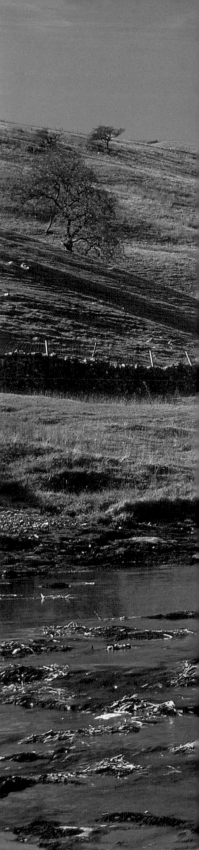

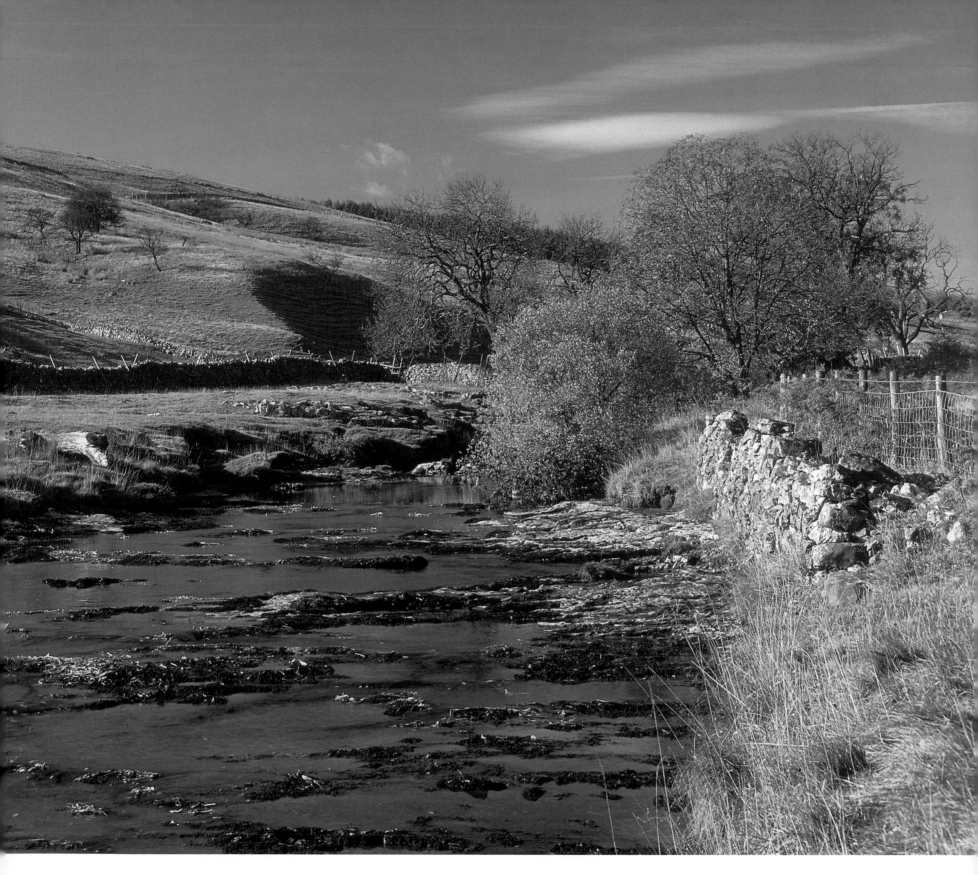

Autumn tree by the riverside

This picture sums up Wharfedale and especially Langstrothdale. The
nearly still waters of the Wharfe are edged by the wonderful shapes
of the limestone. The drystone wall shadows the river bank enclosing
the riverside trees. All this is set against a backdrop of golden fells
and a sky that seems determined not to be outdone by the sheer
beauty of the landscape.

Langstrothdale in autumn

This chapter on Wharfedale ends in the autumn alongside the River
Wharfe in Langstrothdale. Far more intimate than the larger dales,
and yet with the autumn colours falling more strongly on the
fellsides than the trees, there is real beauty here. The wildness of the
high fells is never far away yet, on a fine day like this with the water
flowing gently by, you can be at peace with the world.

Malham and the Three Peaks

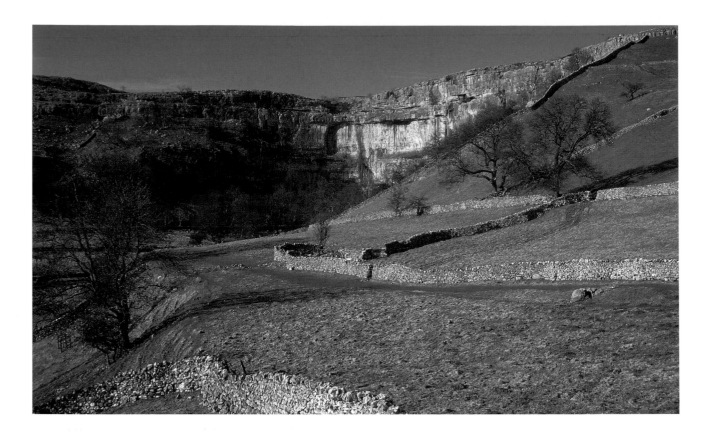

Malham Cove

Before the permafrost thawed at the end of the last ice age, this massive 260ft (80m) limestone cliff was in all probability a gigantic waterfall. Today we have been left with one of the most dramatic features of the Yorkshire Dales limestone landscape, created by the Craven Fault which formed the limestone uplands.

Towards the southern end of the Yorkshire Dales is one of the most impressive features of its landscape, Malham Cove. It is perhaps the most magnificent manifestation of the Craven Fault, the presence of which has done so much to create the unique landscape of the dales. We start here before moving across the moors to Upper Ribblesdale and around the Three Peaks of Pen-y-ghent (2,277ft/694m), Ingleborough (2,372ft/723m) and Whernside (2,415ft/736m). For the photographer it is "big" country with wide panoramas to be enjoyed everywhere. The limestone features and the results of glacial action really stand out; some of the finest examples in Britain are to be found around Ingleborough and Crummackdale.

The outstanding geology of this area is due to the massive limestone slabs which were forced to the surface during the last ice age. Limestone is usually a dull, white colour since it is formed from the remains of millions of tiny sea-dwelling animals over the millennia. This helps to make it stand out dramatically among the dark colouring of the surrounding dales. The most impressive limestone features occur in crags such as Malham Cove or in large, flat areas called pavements. The pavements are worn down by the effects of wind and rain into "clints", or flat areas, and "grikes", which are fissures or gaps in the rock. Because limestone is easily eroded by chemicals in the air and water it is quickly weathered into unusual and dramatic shapes. Limestone is also porous, so surface water often disappears suddenly into sink holes such as those found above Malham.

Among all the grandeur of the limestone scenery there is much to see and enjoy on a smaller scale. In addition, as elsewhere in the Yorkshire Dales, there is a wonderful array of wild flowers to admire together with the world-famous waterfalls at Ingleton.

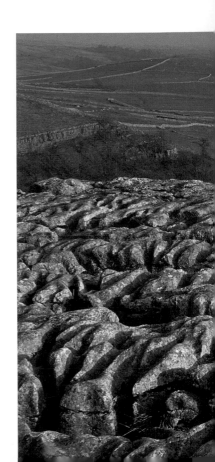

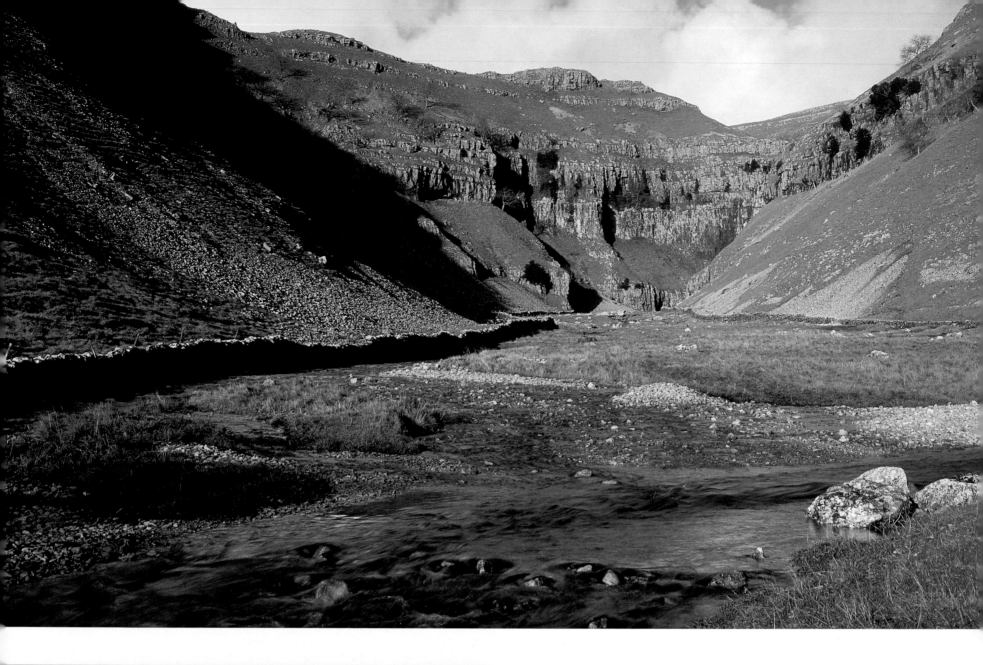

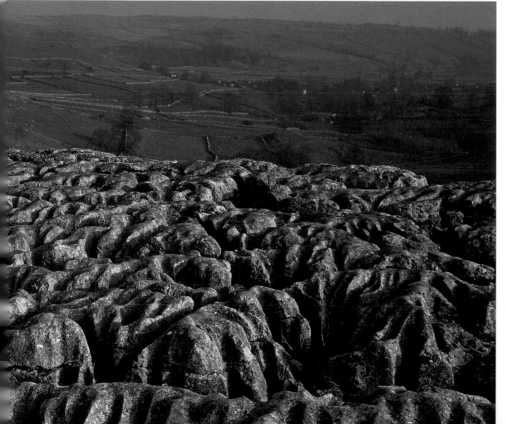

Gordale Scar

Close to Malham Cove, Gordale Scar is an equally impressive sight. Created over thousands of years by vast torrents of water that poured down from the fell, we are now left with an awe-inspiring gorge with magnificent limestone crags and high overhanging fells. Water still tumbles down through a stone archway and waterfall at the head of the gorge. It is common for walkers to make their way up the side of the waterfall gradually climbing on to the moors beyond.

Malhamdale from the Cove

The top of the Cove is now a great arc of limestone pavement. In this evening view, just before sunset, you can see across the pavement and out over Malhamdale towards Malham village. The late sunlight is just catching and highlighting the many drystone walls that criss-cross the valley below.

99

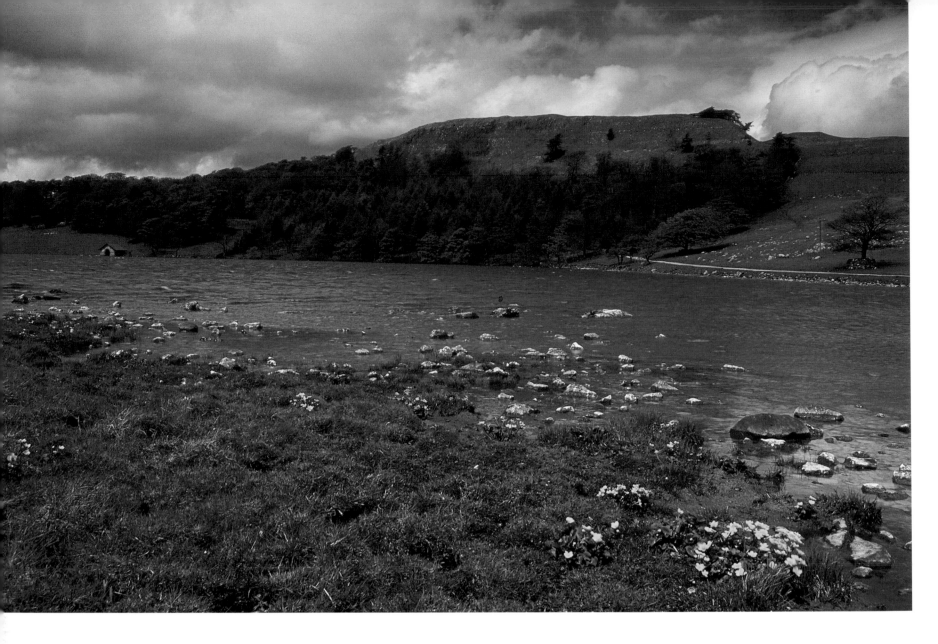

Malham Tarn

Malham Tarn is one of the few natural expanses of water in the Yorkshire Dales. Normally water will quickly sink through the limestone landscape but the tarn, which has a surface area of around 150 acres, has survived because it sits on a bed of impervious slate. There is a rich variety of flora around the waters of the the tarn and it is the home of a substantial nature reserve based on the field centre at Malham Tarn.

Water sinks

Water that originally flowed over the Cove or created the gorge at Gordale Scar still flows away from the tarn. A few hundred yards after leaving the tarn, the water reaches the Craven Fault where the slate ends and the limestone begins. At this point the water quite simply and dramatically seeps into the limestone rock. Following heavy rain, as was the case when this photograph was taken, the water literally pours into the ground at one of the "water sinks" located beside the Pennine Way.

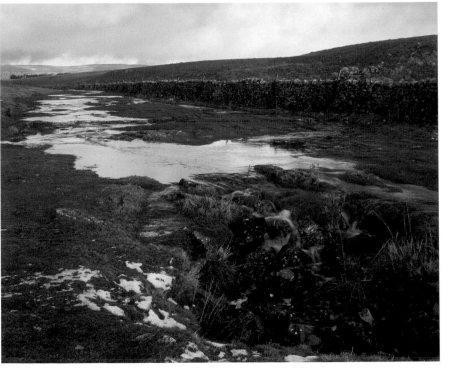

Limestone pavement above the dry valley

The waters that once poured over Malham Cove go underground at the "water sinks" leaving a "dry valley" between them and Malham Cove. The long lines of clints and grikes in this limestone pavement, which overlooks the "dry valley", are displayed in a spectacular fashion in the late afternoon light. In the distance, Dean Moor Hill (with the Pennine Way making its way around its flanks) lies to the left and Combe Hill and the Watlowes to the centre and right of the skyline.

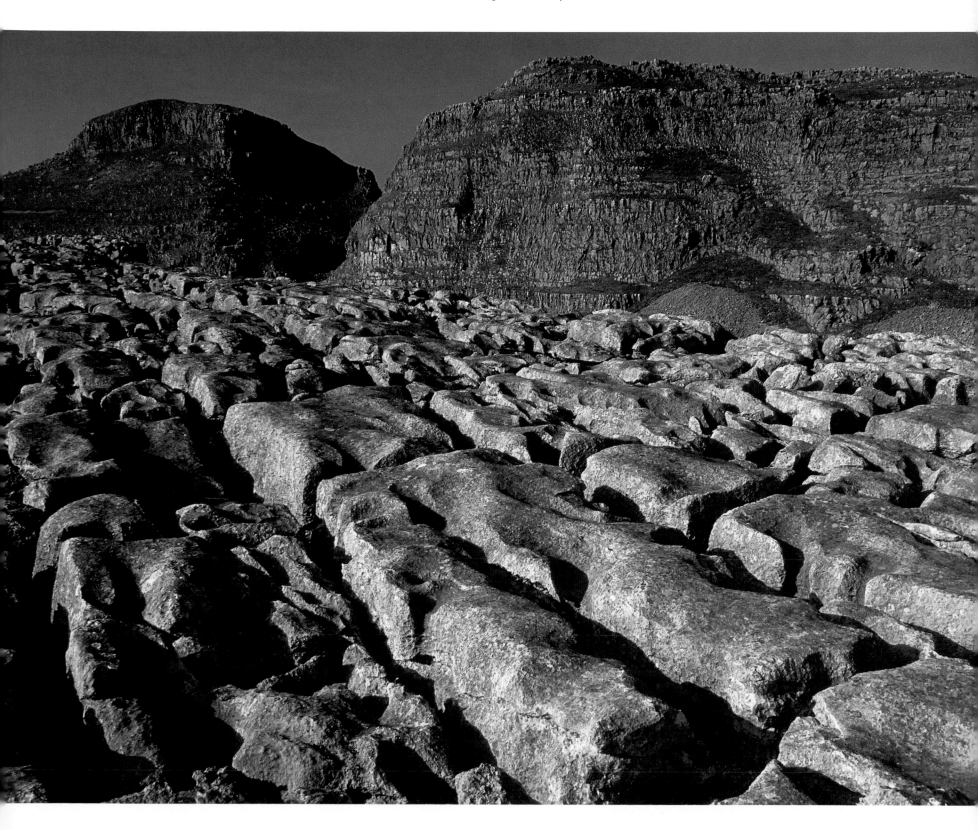

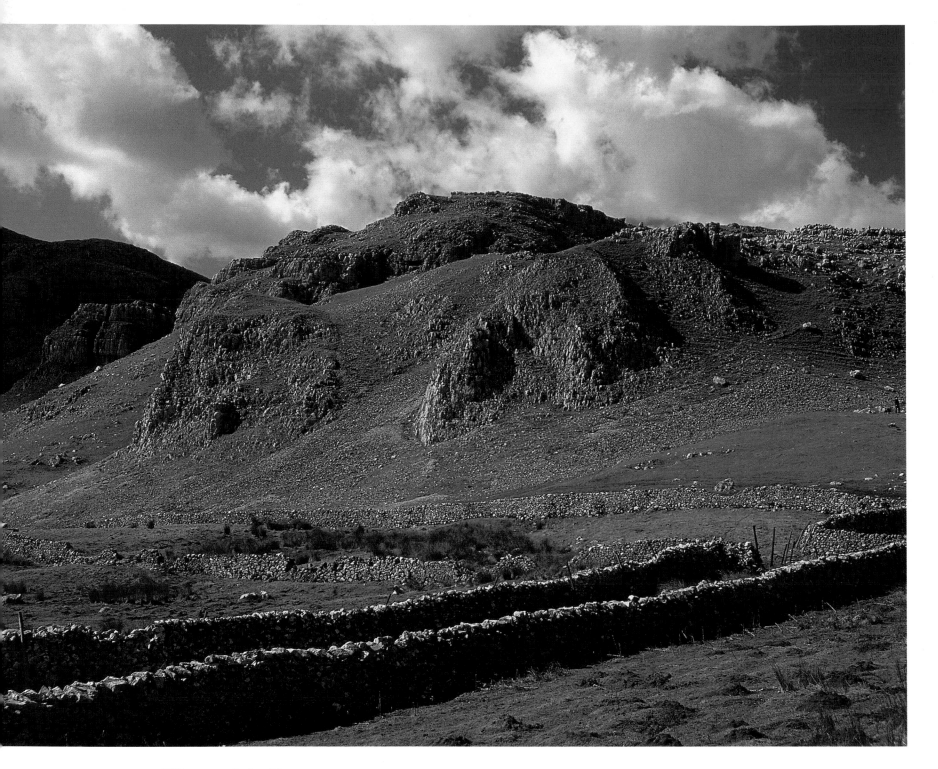

Warrendale Knotts

The crags of Warrendale Knotts stand guard over the old green road below, well to the west of Malham Moor and on the fells overlooking Ribblesdale. They are more rounded than the cliffs of Malham or Kilnsey, with large amounts of loose stone screes.

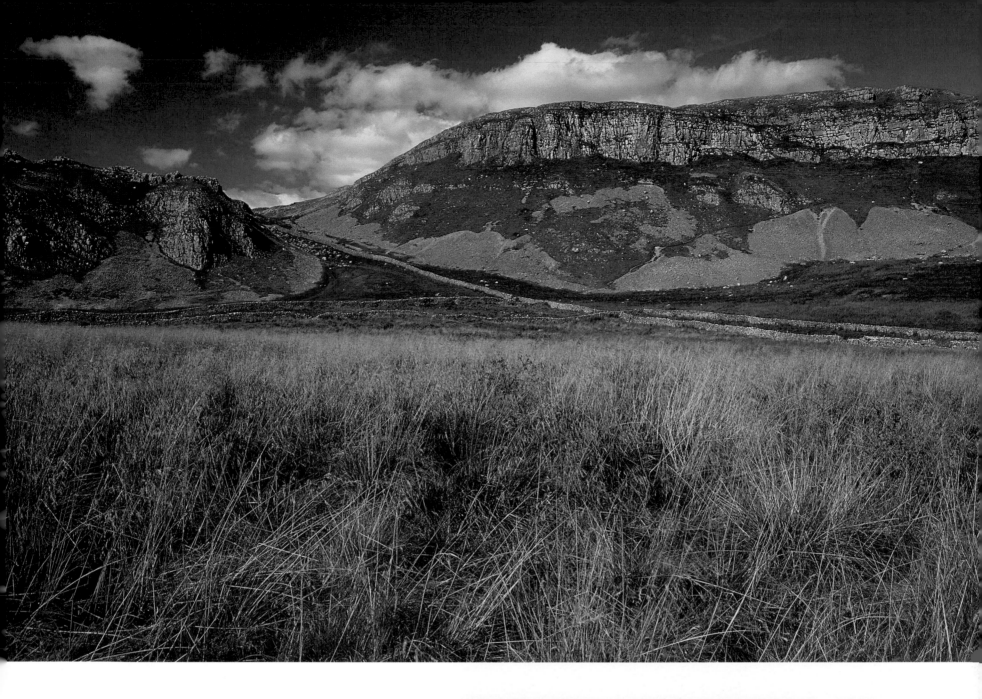

Attermire scar

Directly opposite Warrendale Knotts the impressive
limestone crags of Attermire Scar, with scree-like stone at its
base, seem to rise up from the moorland floor like some
great natural fortification. The whole of this area is riddled
with caves and a careful inspection of this scar shows it to be
no exception. Well to the right of the picture a dark
shadowed slit part way up the crag is actually Attermire
Cave.

Devil's bit scabious *(Succisa pratensis)*

Forever blowing in the breeze, the delicate rounded heads of
the devil's bit scabious can often be found at the foot of
Attermire scar and elsewhere in the dales. Its blue-purple
flowers appear between June and October.

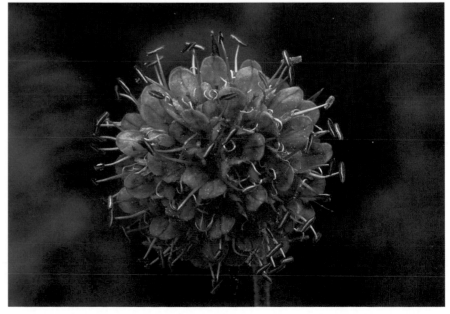

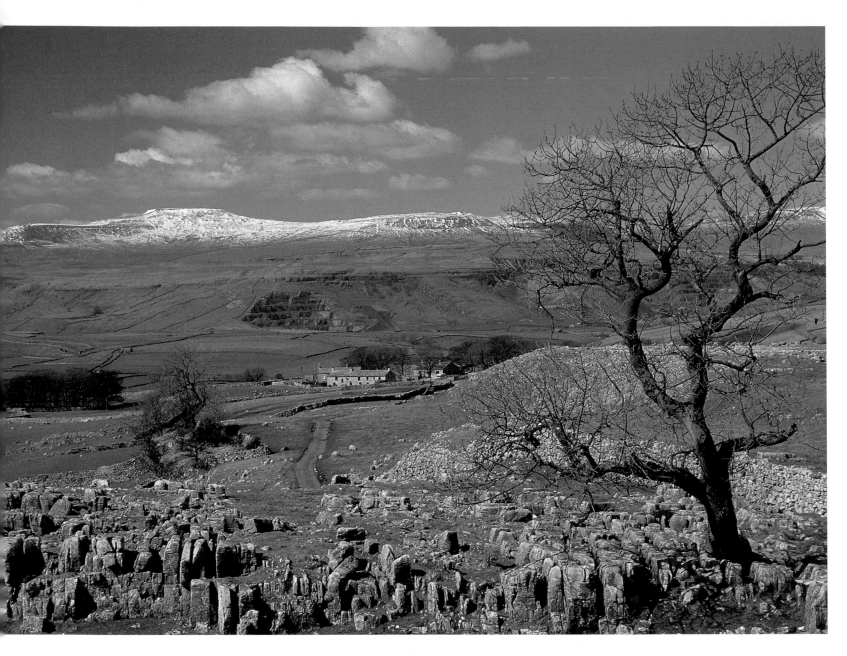

Ingleborough from the Winskill Stones

Follow the track from Attermire and Warrendale Knotts northwards and you will eventually overlook Upper Ribblesdale near the Winskill Stones. Seen above in the foreground, they provide a striking counterpoint to this view across the dale towards Ingleborough, which is covered in snow on the distant skyline. The hamlet of Upper Winskill is in the middle distance and the scars from quarrying, near Helwith Bridge, are evident on the far fellside.

Flank of Pen-y-ghent

It is often worth looking closer at a landscape and this shot of the flanks of Pen-y-ghent, with its crags and stone screes leading down to the ravine and the barn below, makes an impressive scene in its own right. Pen-y-ghent's name is Welsh and is a reminder of Britain's Celtic past.

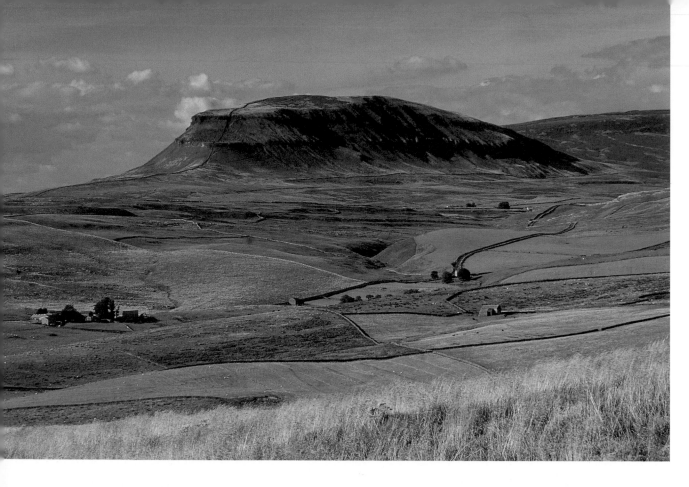

Pen-y-ghent from above the caves

Pen-y-ghent is also visible from the hills around Winskill. In the evening light of late summer the great bulk of the fell can be seen rising above the little farmsteads in Silverdale below. Almost defying reason, the course of a drystone wall can be traced climbing up the steep crags and over the summit itself. In times gone by, the boundaries of nearly all the parishes of the Dales were marked out by drystone walls and this is one such case

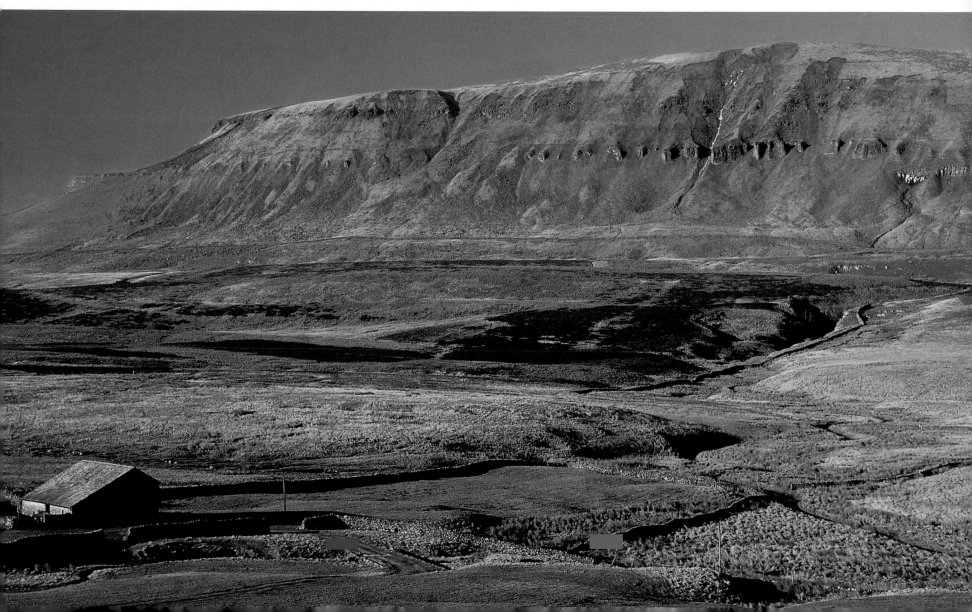

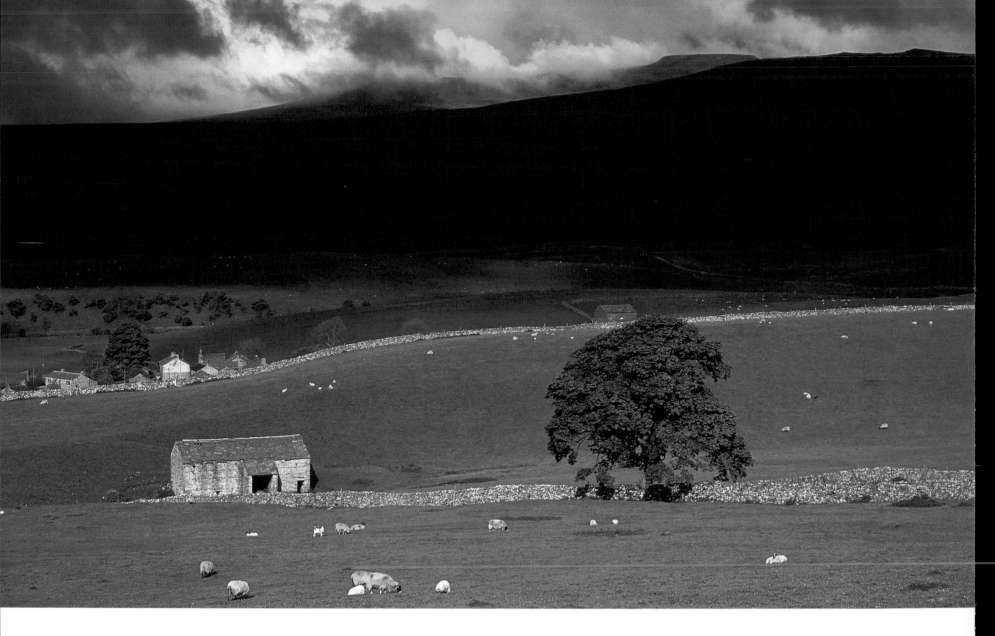

Ingleborough in low cloud

The early morning light and changeable weather often produce atmospheric landscapes. Here, the sky is full of drama with the light pouring through the clouds which are swirling around the summit of Ingleborough. The fells in the middle distance are in deep shadow from the clouds overhead, but are in complete contrast to the tranquil spring scene with sheep and their lambs grazing contentedly in the foreground.

Springtime at Low Birkwith

This lovely spring scene of sheep with their lambs gathered in this sheltered hollow near Low Birkwith speaks volumes about the dales. It is hard to believe that anything could spoil the quiet continuity of dales' life but this photograph was taken only two years after the terrible outbreak of foot and mouth disease had laid its curse on the land. It is gratifying to see how quickly life has returned to normal.

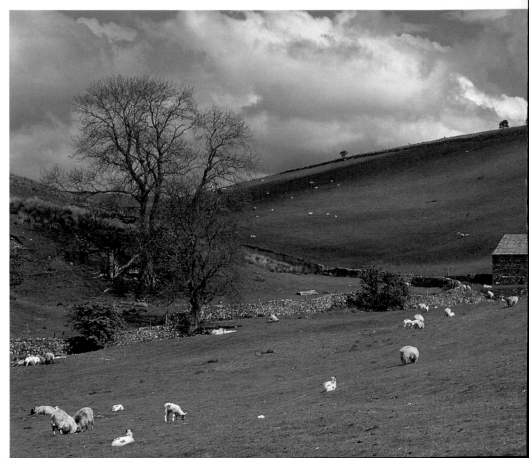

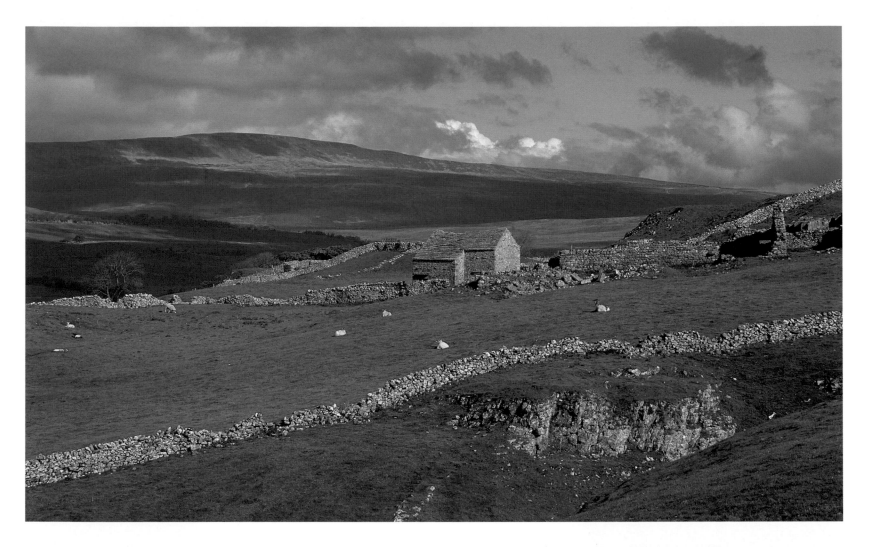

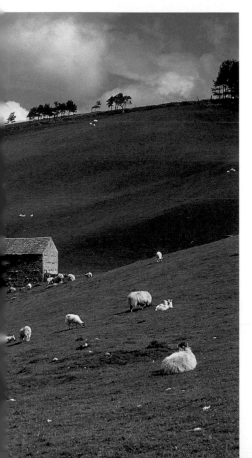

Looking up Ribblesdale to Whernside

The great whale-shaped hump of Whernside at the head of Ribblesdale marks the skyline looking up the dale from the fellside above Horton in Ribblesdale. The combination of little limestone outcrops, drystone walls and barns is typical of this part of the dale. At the top of Ribblesdale is Ribblehead, famous for the Ribblehead Viaduct, where the Settle to Carlisle railway line crosses the moor.

Marsh marigolds by an old plough wheel

This rusting piece of farm machinery makes a perfect foil and background to the lovely sweep of marsh marigolds, which I found at the side of the track near Selside. Marsh marigolds enjoy wet locations along the banks of streams or in swampy areas.

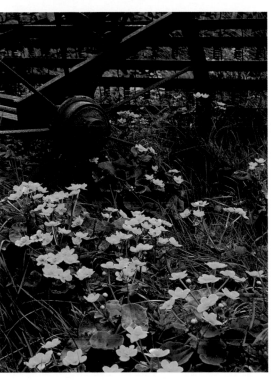

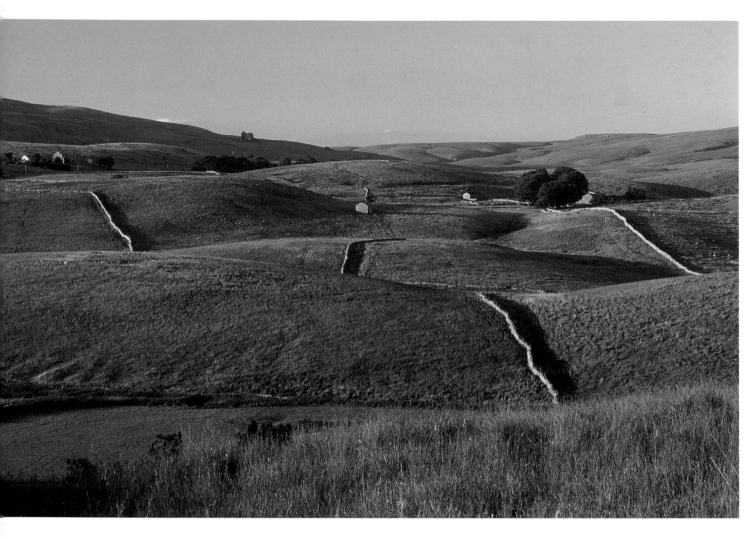

Drumlins near Ribblehead

The glorious late evening light shows off the undulating terrain at the head of Ribblesdale to its best effect. Known as drumlins, these rolling lines of hillocks are formed of boulder clay rocks and pebbles, and were created by glacial action. The sunlight has picked out the gable ends of the barns and the lines of drystone walls as they seem to wander over the rolling landscape.

Monkey flower (*Mimulus guttatus*)

In damp areas you might well come across the spectacular monkey flower. This plant is not a natural inhabitant of the dales but it is now widespread and can be found near many watercourses and in damp meadows.

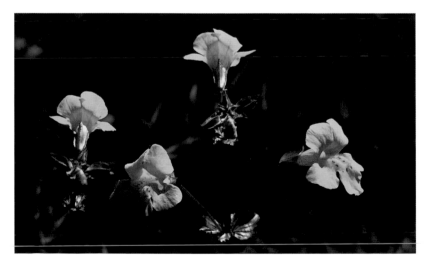

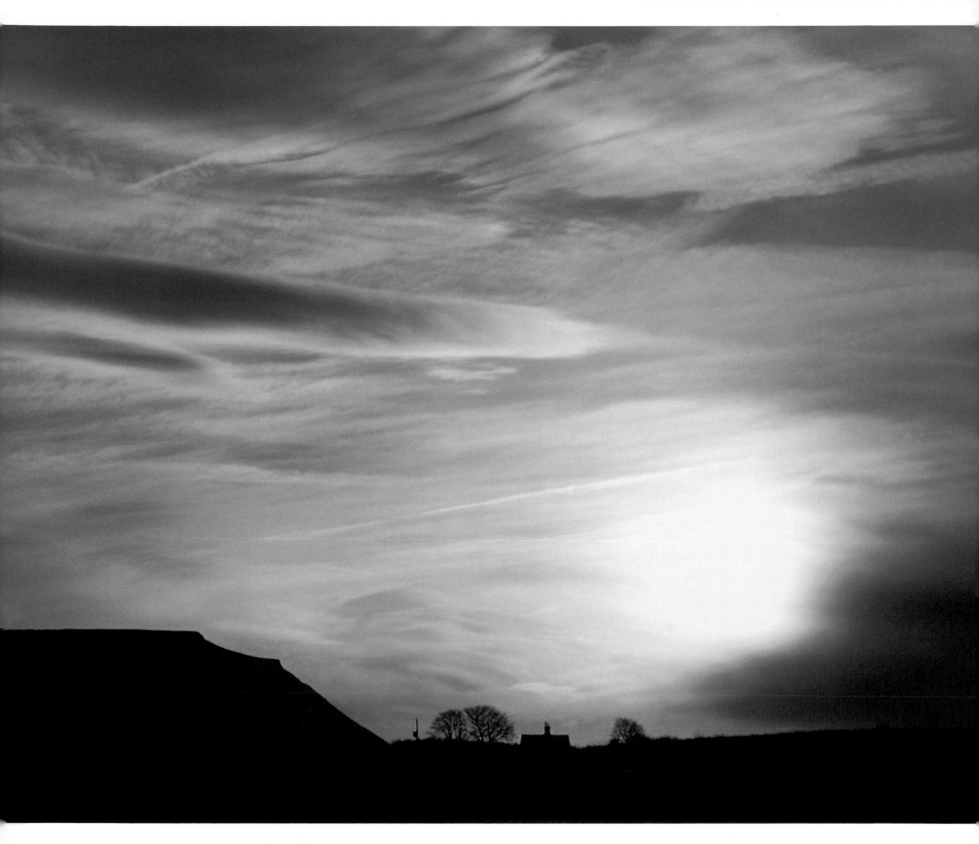

Sunset over Ingleborough and Ribblehead station

The stark and dramatic shape of Ingleborough with the buildings of Ribblehead railway station makes a striking silhouette in this photograph of a stunning evening sky. The sun has yet to set and glows in the sky so effectively, contrasting well with the cloud formations above. The colours in the upper sky, refracted through the clouds, only serve to enhance an already powerful scene.

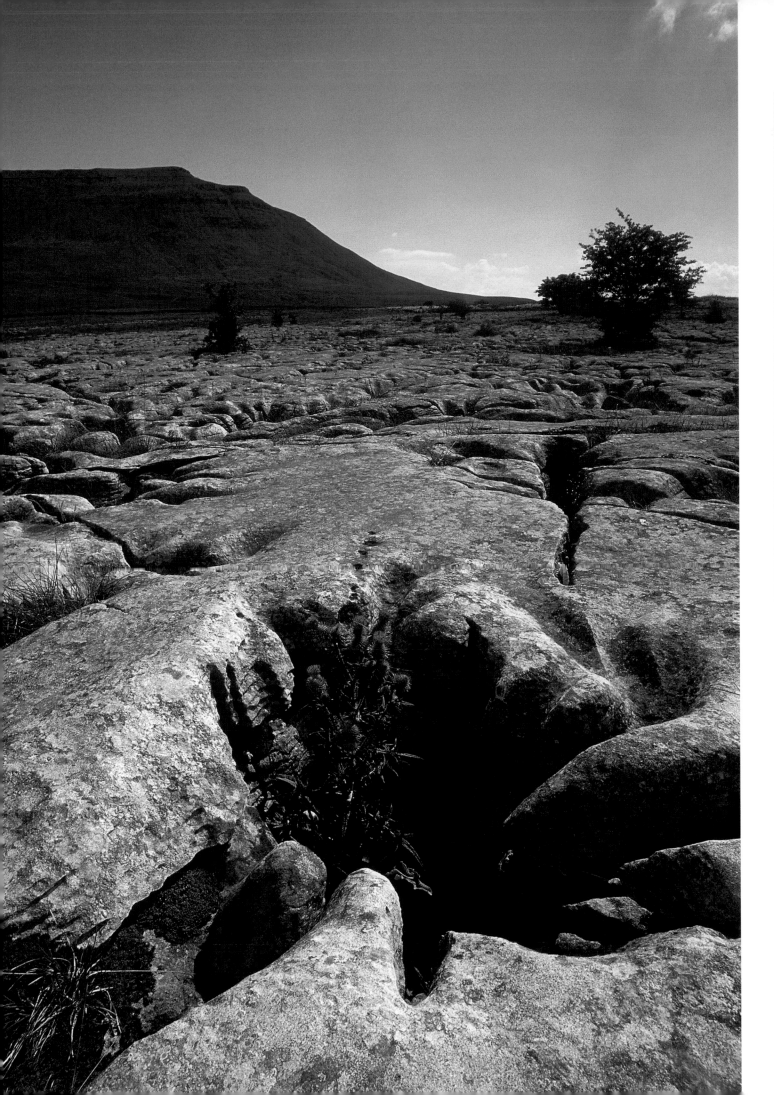

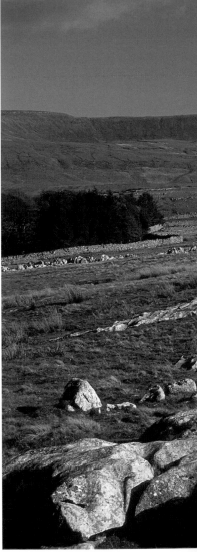

Ravenscar and Ingleborough

Under the lea of the northern face on Ingleborough lies Ravenscar, a series of limestone pavements that stretch out along a plateau of land under the fell. A lonely thistle flowers defiantly from one of the grikes, surrounded by the broad clints that are so typical of Ravenscar.

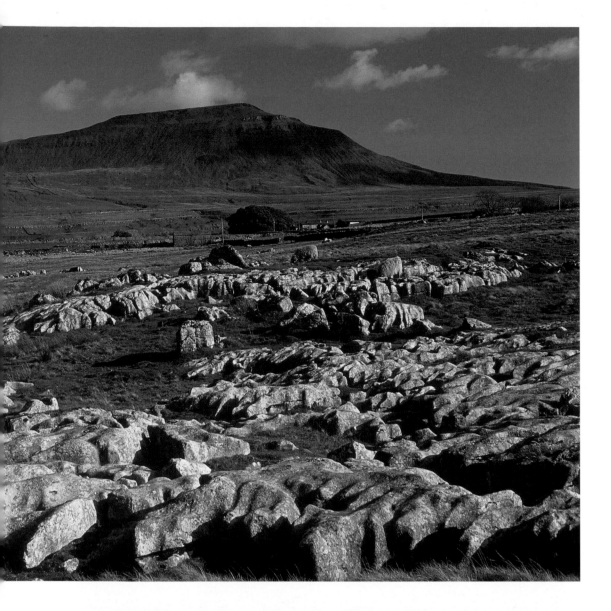

Across Chapel-le-Dale to Ingleborough and Ravenscar

Chapel-le-Dale and its village lie between the great fells of Ingleborough and Whernside. On both sides of the valley there are extensive limestone pavements; here we look across the dale towards Ingleborough. As the sheep browse peacefully among the limestone clints one can easily understand why the prehistoric Brigantine tribes built a massive fort on its flat 15-acre summit leaving the remains we find today. At over 2,300ft (700m), the fortifications were the highest ever built in England.

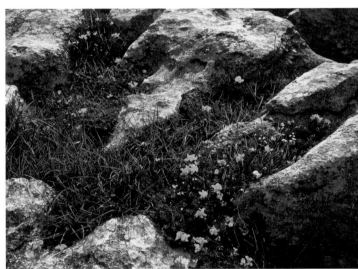

Spring flowers on the pavements

Bird's foot trefoil (*Lotus cornicultus*) thrives in the grassy grikes of the limestone pavement. The plant is so-called because its five leaflets look like birds' feet; it is a herb that thrives in dry sheltered spots, such as the grassy grikes of the limestone pavement.

Orchids in limestone pavement

The grikes, or fissures, in the limestone pavements harbour many wild flowers. Orchids are often to be found; these were caught in the low sunlight on a summer evening high above Chapel-le-Dale.

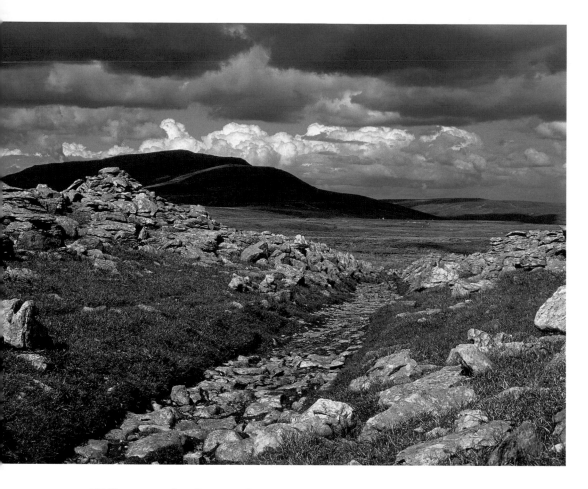

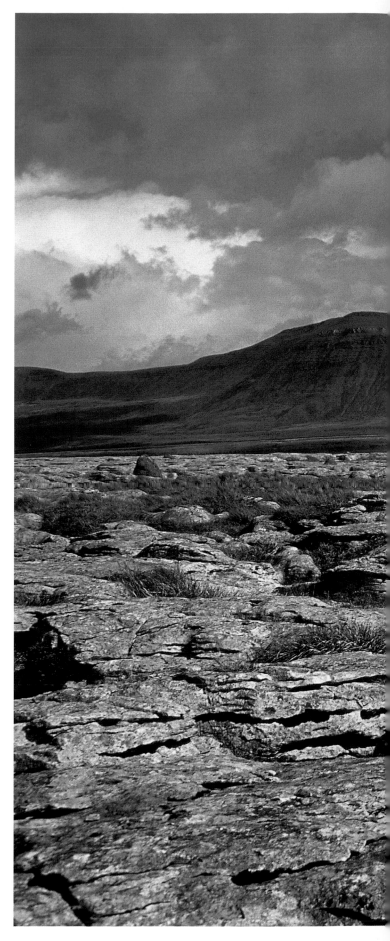

Whernside from the Old Craven Way

The stormy, changeable sky provides a dramatic backdrop for this photograph of Whernside taken from the route of the Old Craven Way – a packhorse route leading from Ingleton over to Dentdale. The atmospheric nature of the scene only adds to the awesome feeling of splendid isolation experienced on these fells.

Ingleborough from Scales Moor

Leftover rocks from glacial action never cease to amaze the visitor to the dales and this sight on Scales Moor, with Ingleborough in the background, is no exception. Although I have no idea if it has a real name, I call this the pear drop stone. Scales Moor has been left with a number of these unusual limestone "erratics", as geologists call them, and they certainly serve to enhance the landscape.

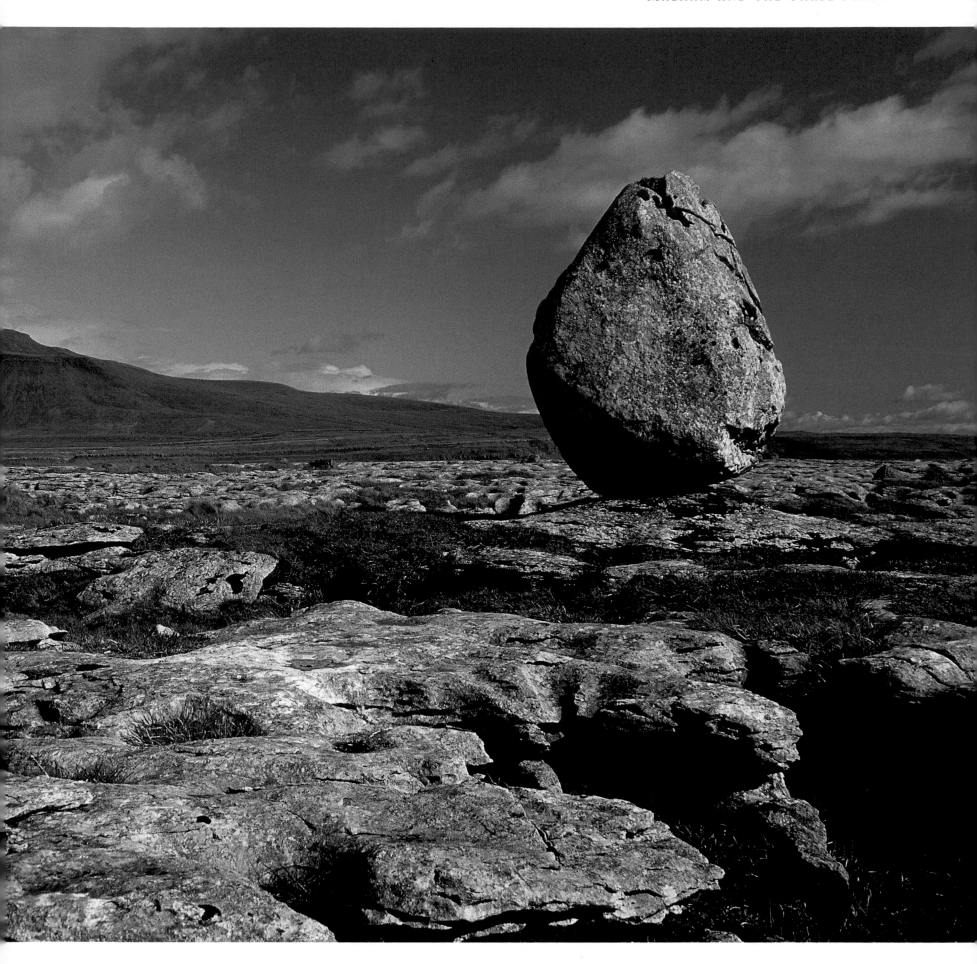

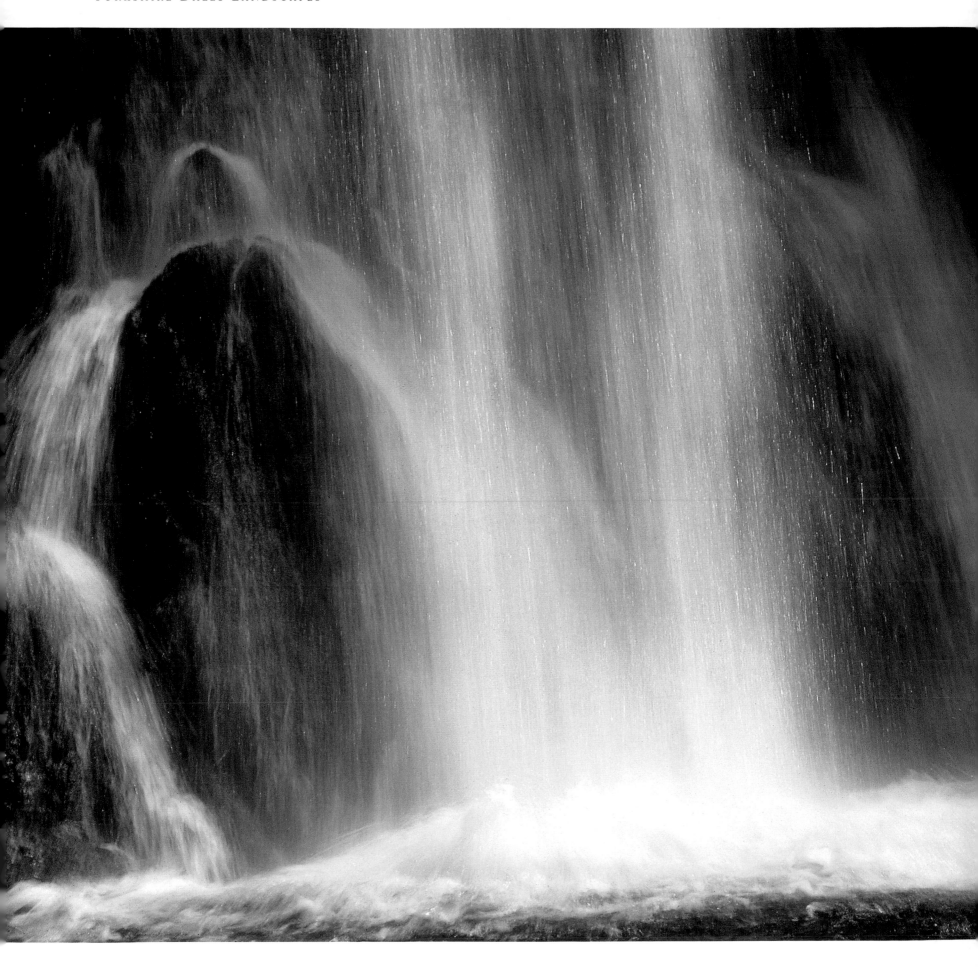

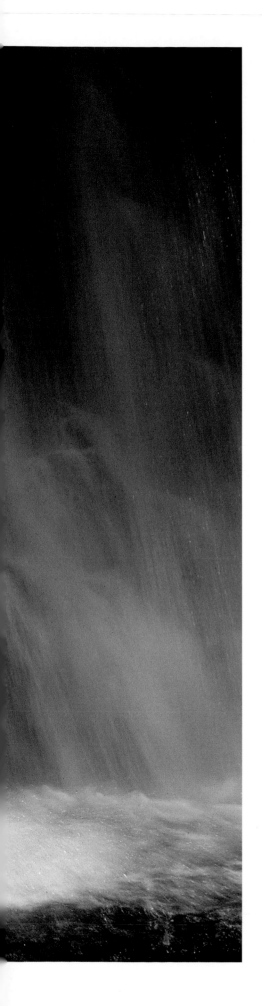

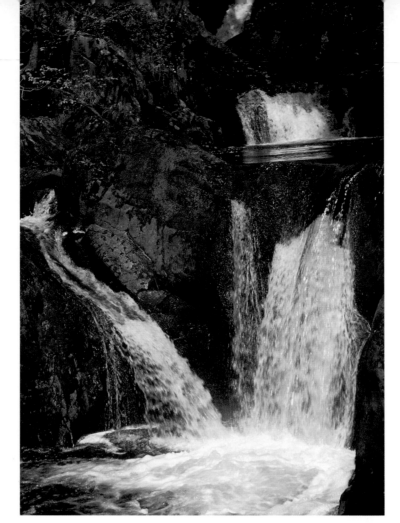

Twin Pecca Falls

The waterfalls in the two valleys which begin at Ingleton are some of the finest in the dales. As you follow the course of the River Twiss, one of the first waterfalls that you come to after crossing Pecca Bridge is the Twin Pecca falls, pictured here. In a series of steps, the water tumbles 98ft (30m) over the rock formations surrounded by the high sides of the valley which almost form a gorge around the river.

Foot of Thornton Force

The waters of Thornton Force crash down in a continuous cascade onto the boulders at the foot of the falls. This image of water and spray patterns is created by using a slow shutter speed to create movement in the water with the camera mounted on a tripod to ensure that the rocks are caught in sharp focus.

Thornton Force

You are almost out on to the open fell when you reach what is perhaps the most famous of Ingleton's falls. Thornton Force flows down a number of rock ledges before plunging over the limestone outcrop into a deep pool almost 50ft (15m) below. Over many years the water has undercut the softer earth below the limestone outcrop to such an extent that you can freely walk behind the fall itself.

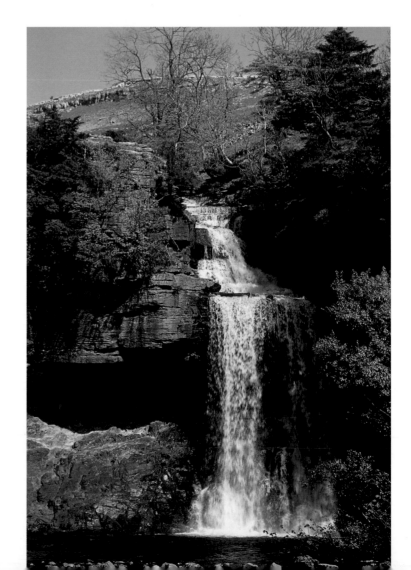

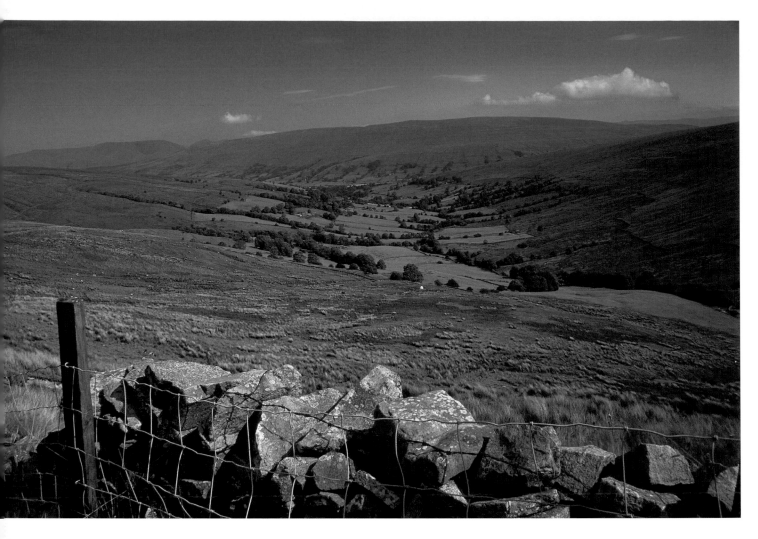

Dentdale from Deepdale

Take the road up Kingsdale from Ingleton and, once over the watershed, you will discover this panoramic view down Deepdale and into Dentdale. On the left of the picture the Howgill Fells can be seen in the distance. On this fine late June day, the freshly cut meadows add a variety of colours to a green and fertile landscape.

Meadow cranesbill

(Geranium pratense)

The meadow cranesbill, with its striking deep blue colour, can be found all over the dales, in many places lining the roadside in great swathes. To appreciate the real beauty of wild flowers, it is often necessary to look closely at the individual flower head. Here the lovely details of the structure of the flower and the veins that run through the petals are revealed at their best.

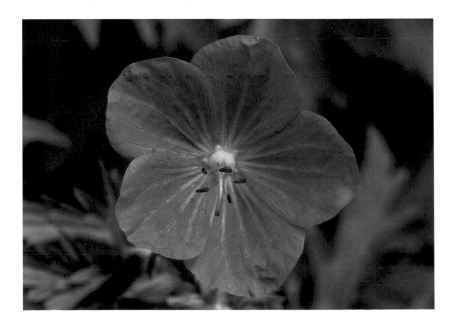

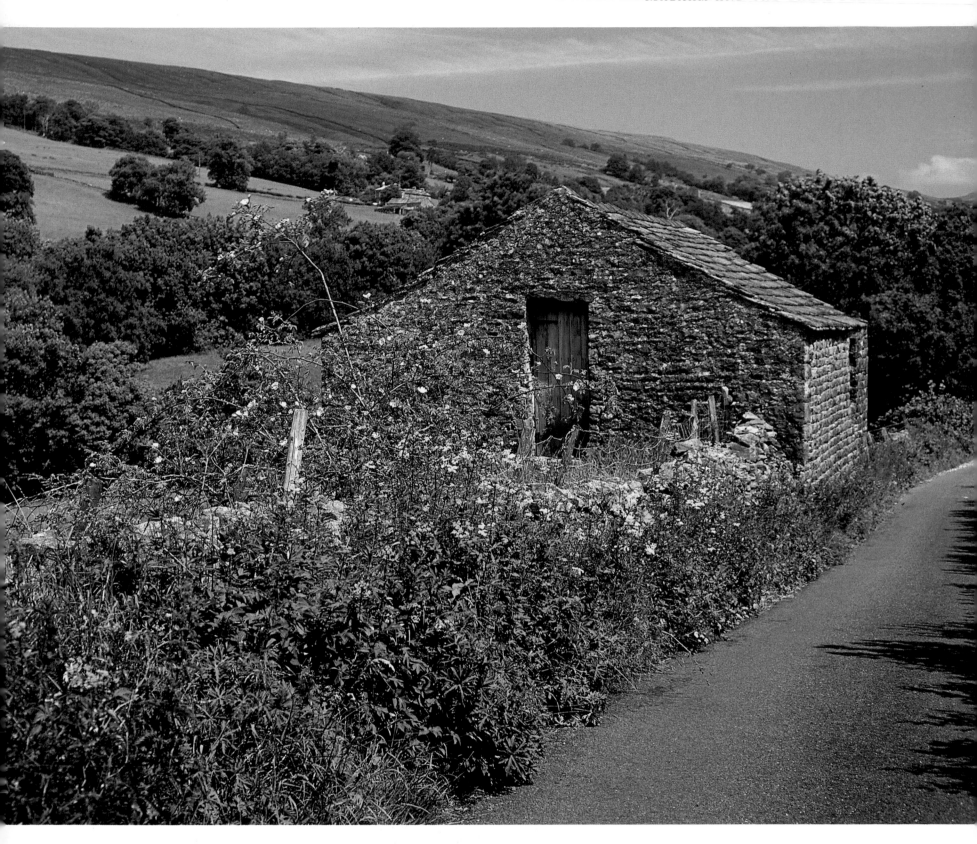

Roadside flowers

At this time of year the road verges along the valley in Dentdale are covered in a rich variety of wild flowers.
In this quiet lane with the old barn as a backdrop you will find common vetch, red campion, dog roses, meadow cranesbill and many more.

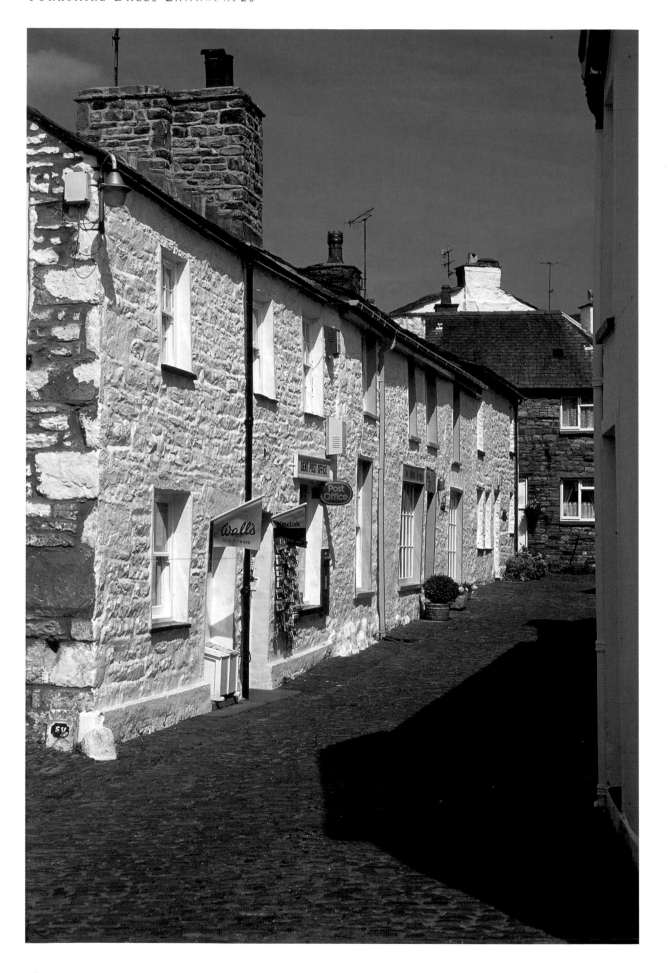

Dent Town

The village of Dent Town is the main centre and for many the chief attraction in Dentdale. It is a few miles south-east of the market town of Sedbergh. With its narrow but well-maintained cobbled streets lined with period buildings, this little gem is the quintessential place to stop and browse. Here the freshly whitewashed row of shops and cottages takes you back to a former age.

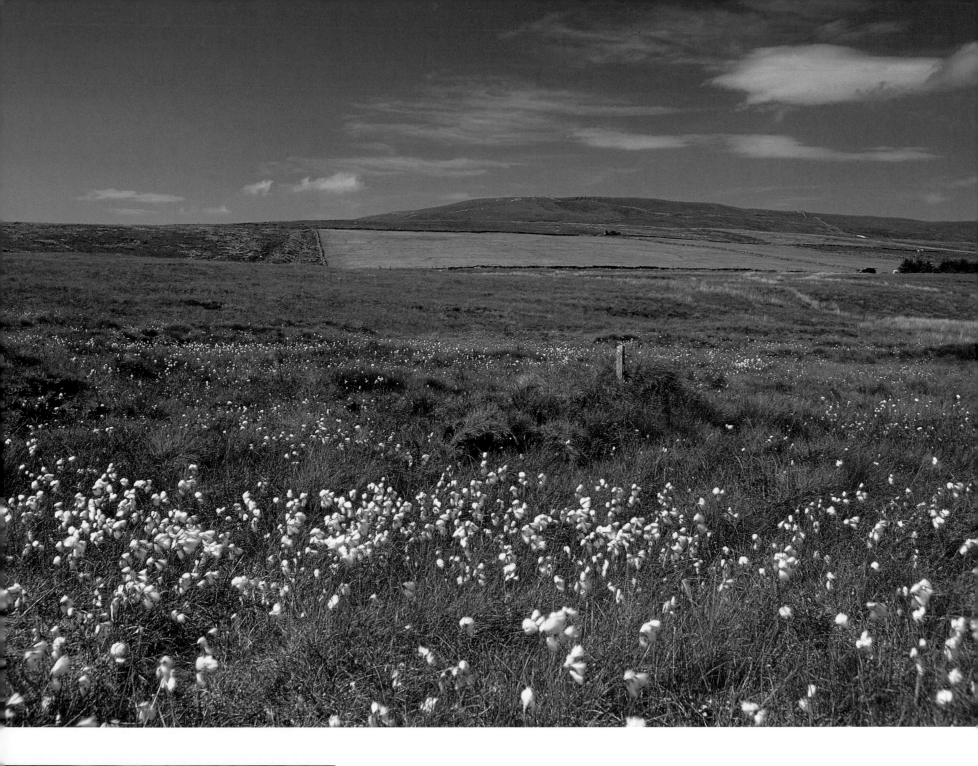

Cottongrass *(Cyperaceae eriophorum)* and meadows

High on the fells at the head of Dentdale is this attractive view across wild and
uncultivated moorland. In the foreground is a mass of cottongrass, blowing gently in the
summer breeze. The contrast between the cultivated fields on the distant fellside and the
wild moorland landscape below is unusual.

Cross-leaved heather *(Erica tetralix)*

In among the cottongrass you may well find examples like this of the cross-leaved heather,
which loves peat bogs and other wet habitats. Its large pink flowers appear in the height of
summer.

Crummackdale

Tucked away between Ribblesdale and Ingleborough is a little dale that epitomises all that is best about the limestone dales of Yorkshire. Crummackdale is not a big place – barely five miles long – but its small scale is more than compensated for by the views. From the fells around Crummackdale, you can enjoy some of the finest limestone scenery to be found anywhere. To enjoy it though, you will have to walk because roads are – thankfully perhaps – very scarce. The photographs shown here are taken following a route which starts from just north of Austwick village. You climb up onto Norber Fell and follow the line of the dale along its western edge. When you reach the head of the valley your route takes you down to the limestone pavement of Moughton Scar and eventually descends back into the valley.

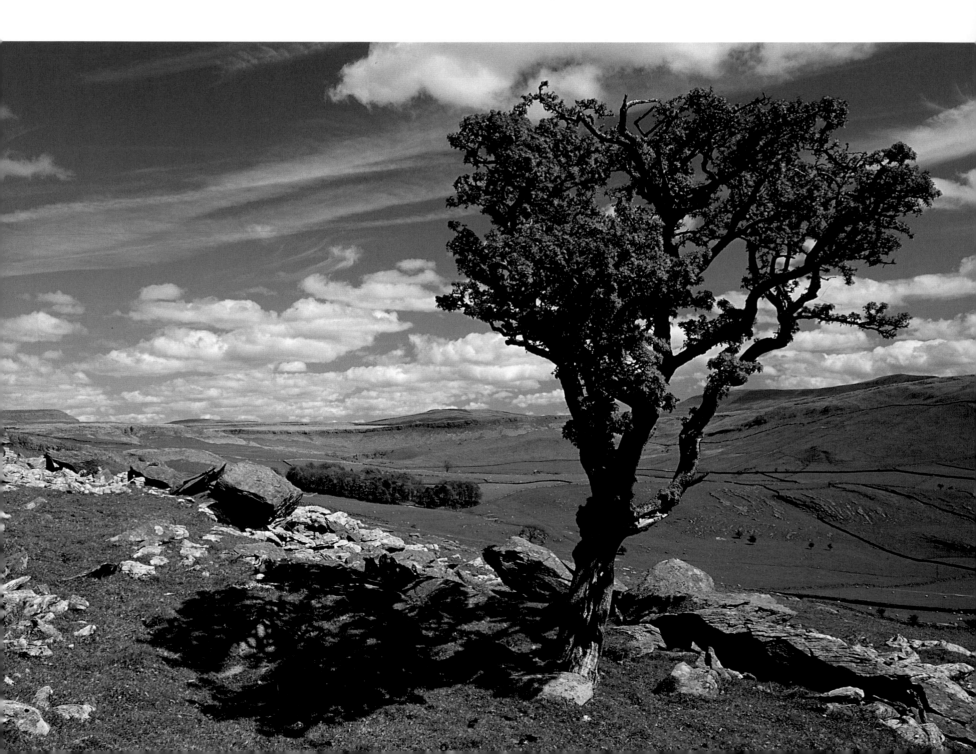

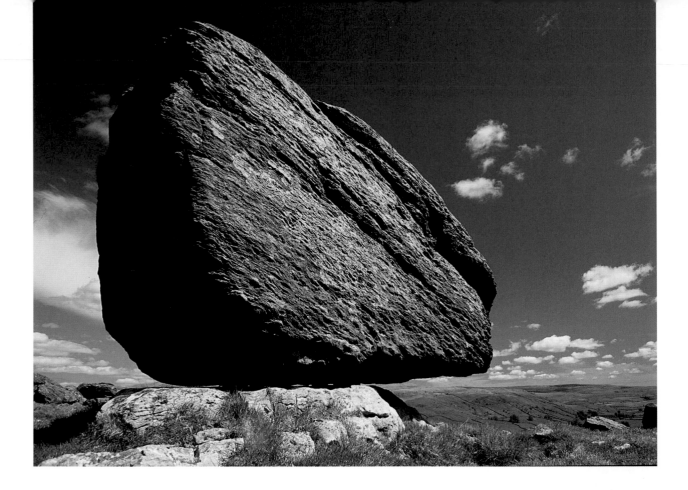

Norber Erratics

As you climb on to Norber Fell, you quickly come to a sloping plateau of land stretching into the distance and covered in boulders of varying sizes. Known as the Norber Erratics, they were deposited by glacial action on the limestone fellside. Over time, the weather has worked away at the exposed limestone but left the area at the base, which is sheltered under more durable boulders, virtually untouched. The result is a dramatic series of huge boulders perched on pillars of limestone.

The lone tree (left)

An impression of the vast panoramas to be seen on this route can be gained from this view of the upper reaches of the dale, which are bounded by the massive Moughton Scars. Taken from the western ridge this lone tree seems to emphasise the sheer grandeur of Crummackdale.

Rock sculpture (right)

The boulders can sometimes have a sculptured appearance which is emphasised if you look at them closely. This example overlooks the distant dale, with the fellside in between littered with smaller-sized boulders left by the glacier.

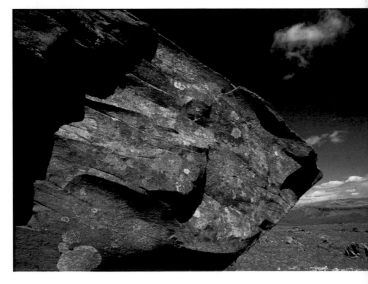

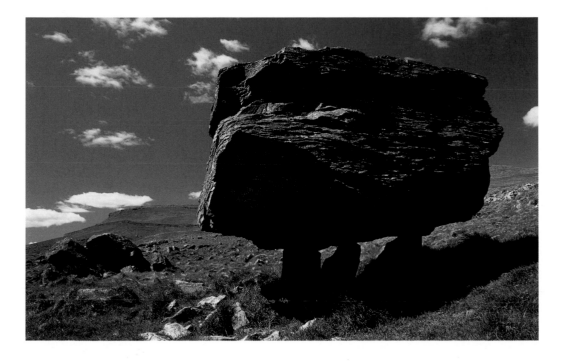

Erratic on legs

The plinths on which the erratics are perched can often create a surreal effect. This photograph of a huge slate boulder perched precariously on three or four slender limestone pillars appears to almost defy the laws of physics.

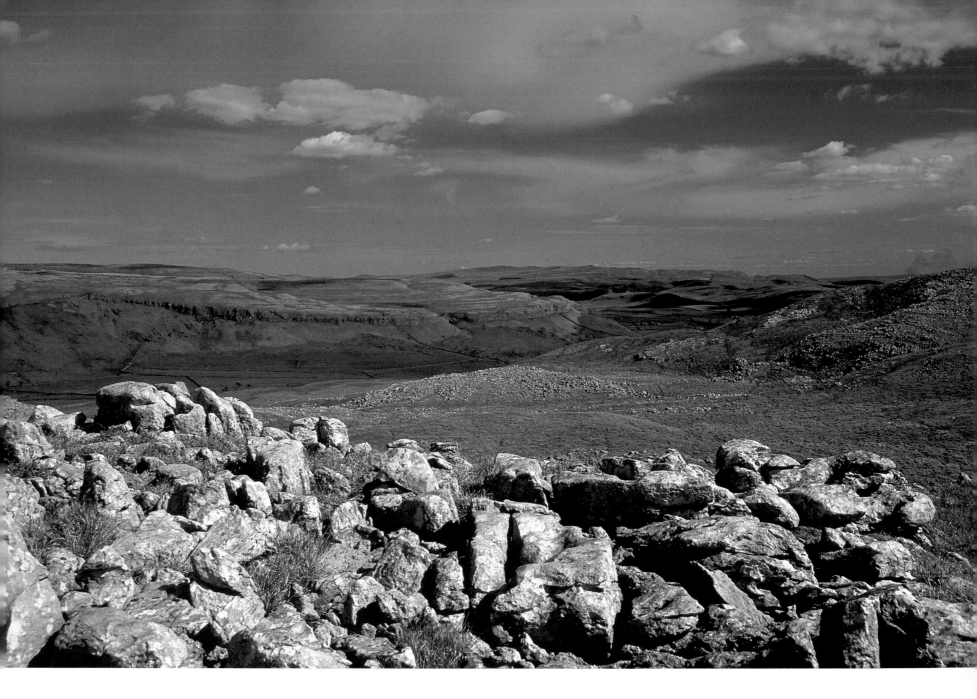

View down Crummackdale

As you make your way along the western ridge, the view gradually opens out and you begin to get a real feel for the place. This scene looking back down and across the dale, with Moughton on the left-hand skyline, is stunning – a vista of wilderness mixed with grandeur that simply takes your breath away.

The limestone pavement from Sulber Gate

At the head of the dale you come to Sulber Gate, from where you can look down on the almost unbelievable view of what is one of the most sensational of all the limestone pavements in the Yorkshire Dales. Literally stretching for miles, the pavement continues right on to the top of Moughton Fell itself. To the right, Crummackdale leads away southwards and, in the distance, some 20 miles away and well into Lancashire, is the unmistakeable shape of Pendle Hill.

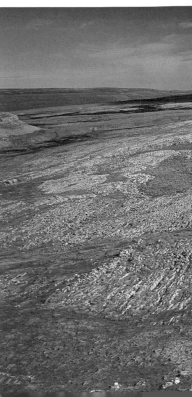

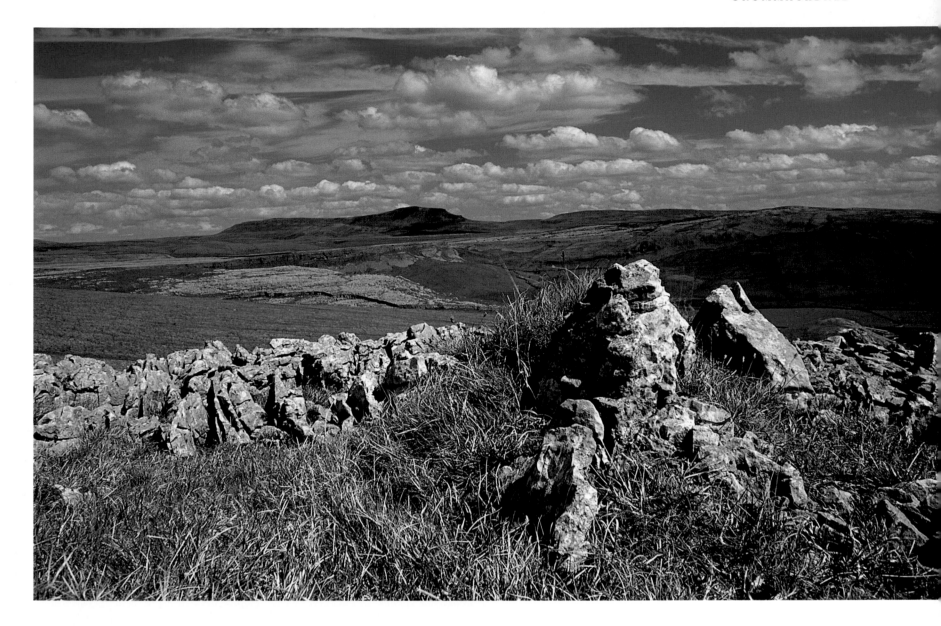

Limestone view to Pen-y-ghent

In this view, again with a glorious sky overhead, we can
see across the head of the dale, with Moughton Scar
in the middle distance and the great massive form of
Pen-y-ghent standing proud on the skyline. It is
difficult to believe that this landscape was created over
300 million years ago at the bottom of a tropical sea.

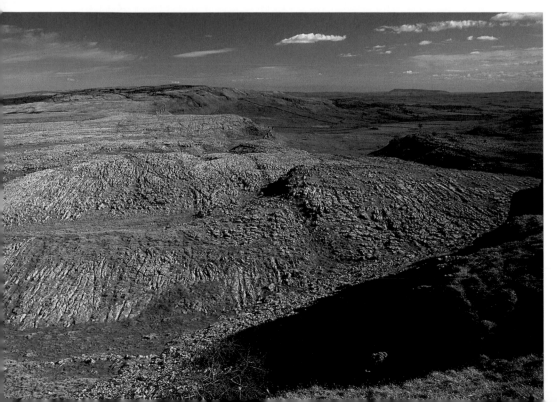

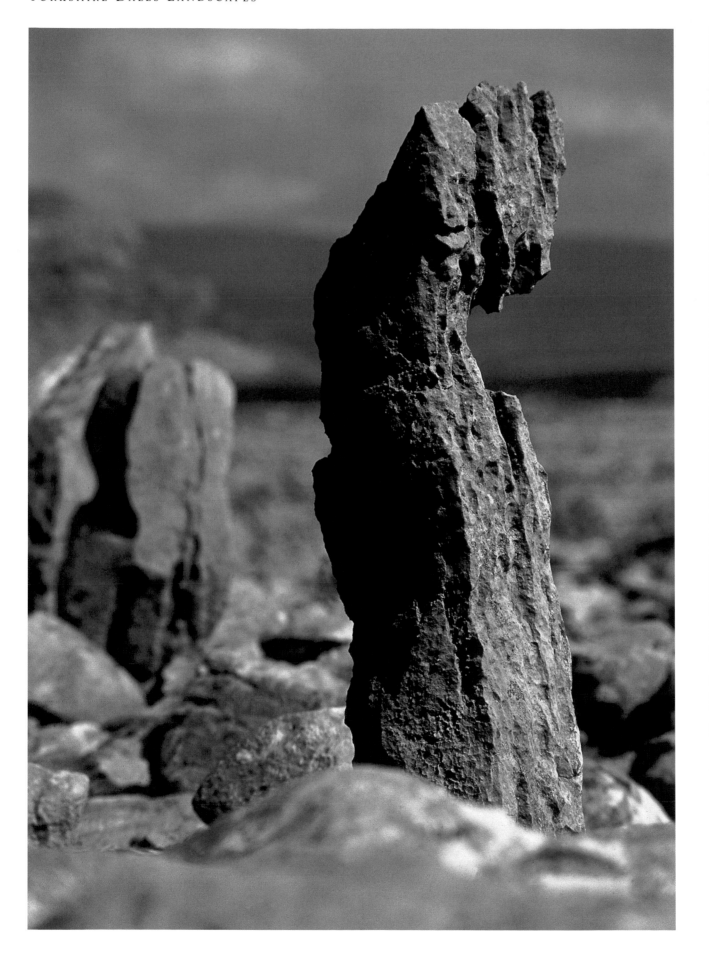

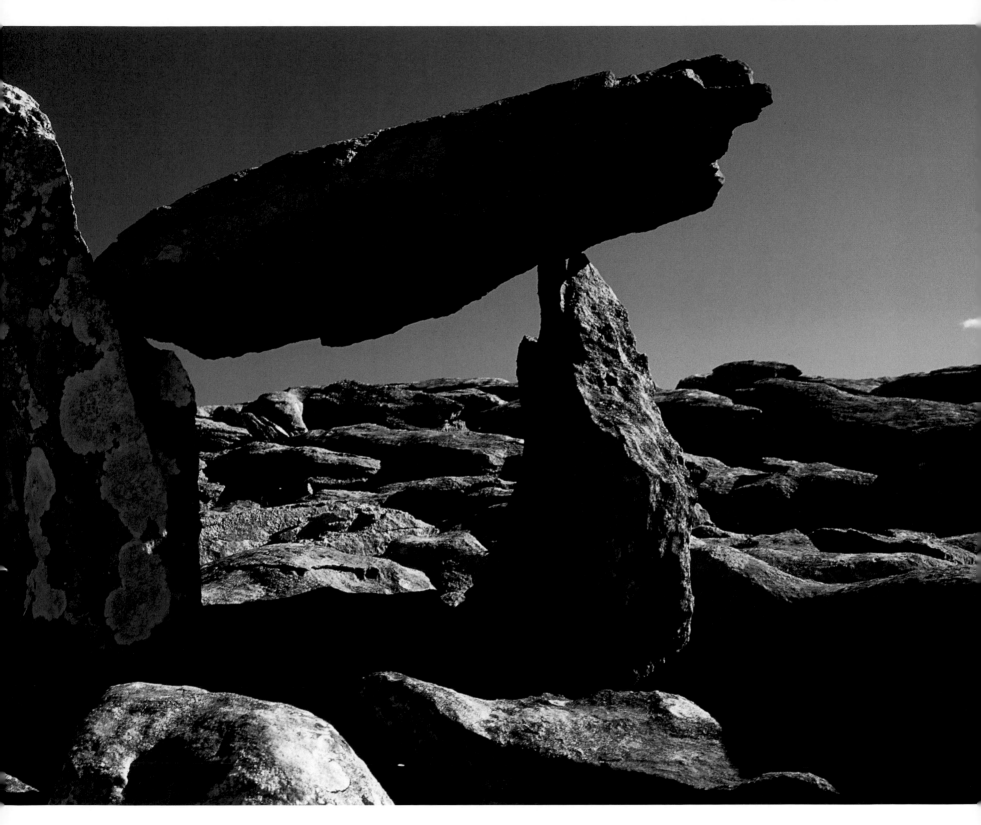

Limestone statue

Once down on the pavement, where you can look more closely at the limestone, the rock seems to take on strange formations and shapes. It makes you wonder how these stones got into such positions and how they got there. Strangely, the detailed rock formations do not seem out of place with the wider scenery.

Limestone arch

This photograph of a limestone arch is taken from a low position to get a good view of its base. The plinth stone is perched so finely that you would not think it could withstand the power of the elements, especially in winter, but it does.

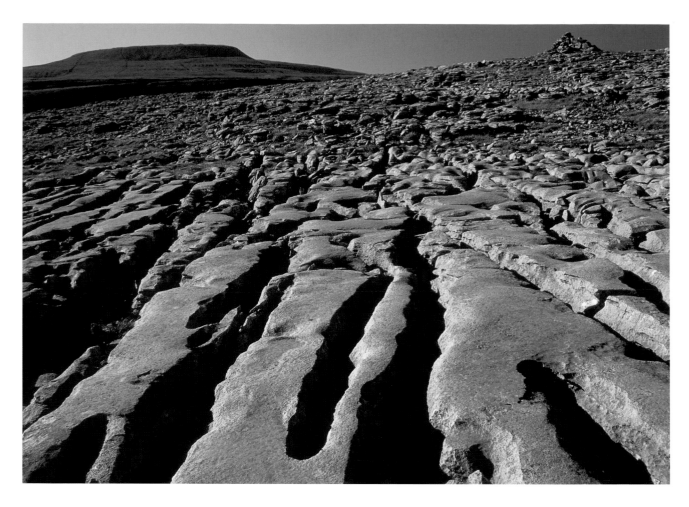

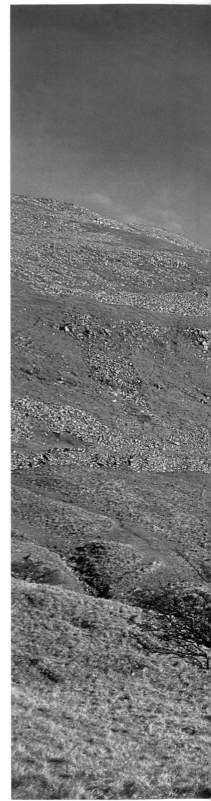

Clints and grikes in the limestone

Here is a fine example of broad limestone clints (the stone left in place after erosion) broken by the grikes (the cracks or fissures) into a fantastic pattern which extends across the landscape. In the early evening light, the white of the clints seems to glow in contrast to the dark shadows of the grikes. In the distance, the massive shape of Ingleborough seems to stand guard over the countryside.

Limestone columns

Some of the smaller patterns in the limestone landscape are amazing – like this table-shaped structure, where huge slabs of limestone are perched on top of slimmer pillars. There is such a variety of different shapes and structures in the limestone that you could spend a great deal of time up here trying to link the rocks with more familiar objects found in everyday life.

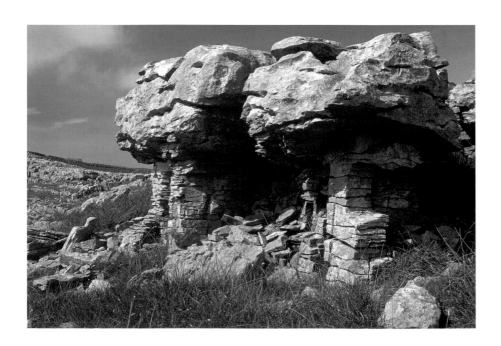

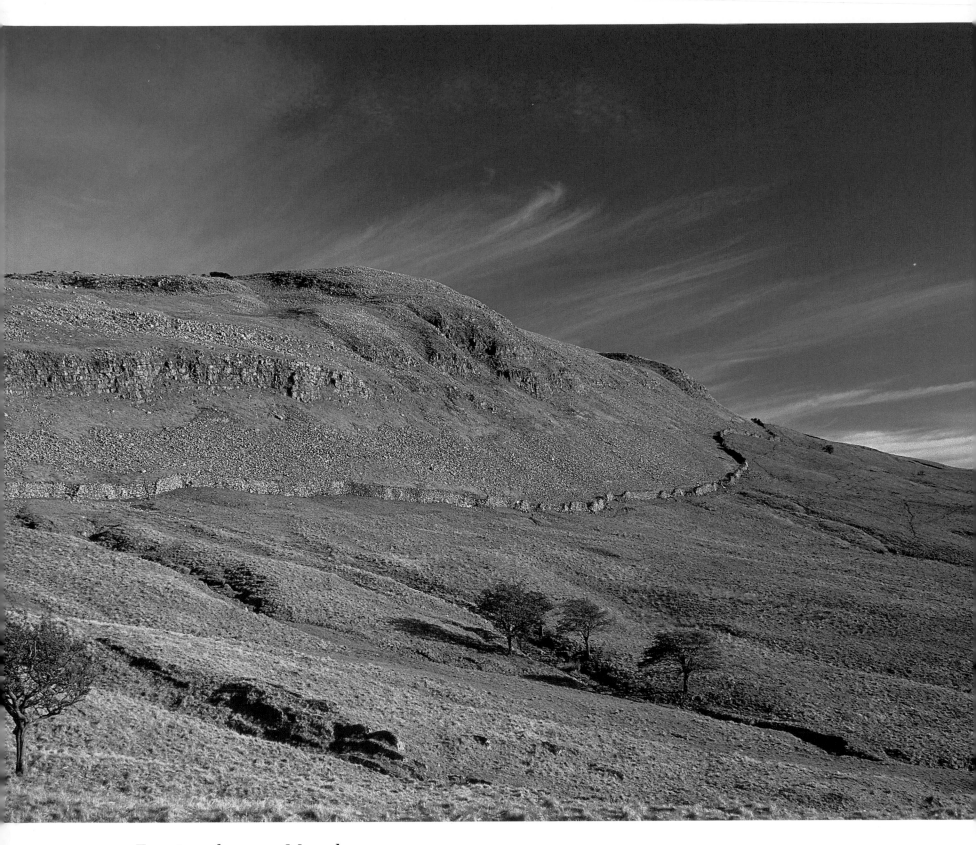

Evening sky over Moughton

Between Moughton Scar and Moughton Fell you come to an old packhorse route which leads you back down into the dale, across limestone meadows and eventually back to your starting point. This photograph, taken from the track, shows the mass of Moughton Fell combined with the lonely tree and a wonderful evening sky. Crummackdale is a place which draws visitors back time and time again. It is the essence of what the limestone dales are about on a grand but also intimate scale.

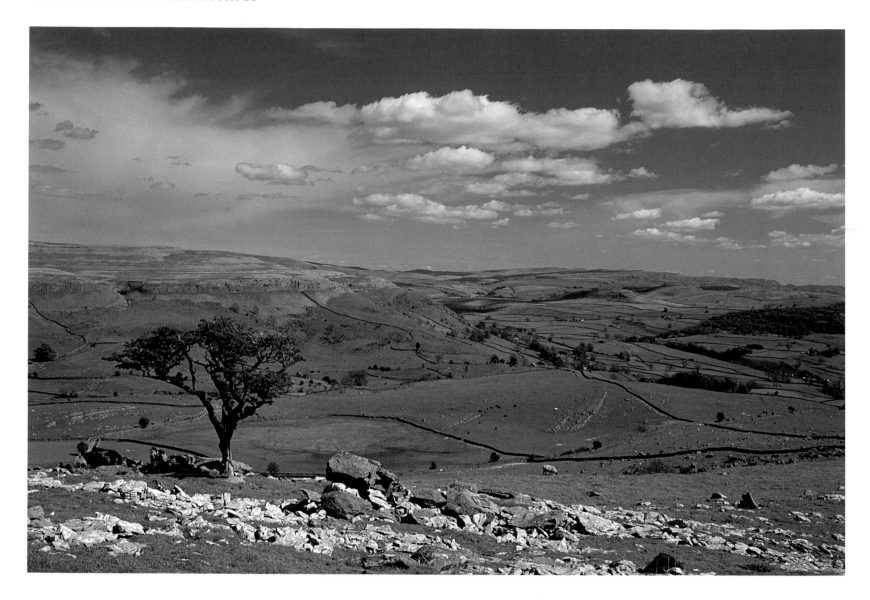

You always come away from a visit to the Dales with an abiding memory. This lonely, weatherbeaten tree set against the backdrop of Crummackdale looking towards the little hamlet of Wharfe is a good example of an image that stays long in the mind.